ART OF THE ORDINARY

ART OF THE ORDINARY

*The Everyday Domain of Art,
Film, Philosophy, and Poetry*

RICHARD DEMING

CORNELL UNIVERSITY PRESS
ITHACA AND LONDON

Published with the assistance of the Frederick W. Hilles Publication Fund of Yale University.

"Homeless Heart," from *Quick Question*, by John Ashbery. © 2012 by John Ashbery. Courtesy of Ecco, an imprint of HarperCollins Publishers.

First published 2018 by Cornell University Press

Printed in the United States of America

Library of Congress Cataloging-in-Publication Data

Librarians: A CIP catalog record for this book is available from the Library of Congress.

Cornell University Press strives to use environmentally responsible suppliers and materials to the fullest extent possible in the publishing of its books. Such materials include vegetable-based, low-VOC inks and acid-free papers that are recycled, totally chlorine-free, or partly composed of nonwood fibers. For further information, visit our website at cornellpress.cornell.edu.

Contents

Preface vii

Acknowledgments xiii

Introduction: In Respect of the Ordinary 1

1. Leading an Ordinary Life: Philosophy and the Ordinary 23

2. Something Completely Different: Steven Wright,
 Comedy, and the Uncanny Ordinary 52

3. How to Dwell: John Ashbery and the Poetics of the Ordinary 77

4. Artful Things: Looking at Warhol, Looking at the Everyday 119

Notes 167

Bibliography 189

Index 197

PREFACE

Art of the Ordinary is, at its heart, a long meditation on self-consciousness, or, rather it is a meditation on the intermittency of the self's attentions to itself, as revealed not in moments of extremis but in the engagements and encounters of one's daily life. At the foundation of *Art of the Ordinary* is the belief that the self is not a settled condition but something that is continually, though not continuously, shaped and formed in the relations with the world. Warns Ralph Waldo Emerson, "This one fact the world hates, that the soul *becomes*."[1] In its ongoing becoming, the self and its context is ever unsettled, perpetually reconstituting the present and reframing any relationship to the past. The recurring situation is that the self is at times more consciously aware and other times less consciously aware of itself as a bundle of its relations and changing perceptions of its place in the word. If selfhood is an ongoing negotiation, a condition that continually opens and reveals, reveals and opens, there is never an end to the need to sound its depths and discover its movements. What this means is that we are never wholly known to ourselves. We can only enact and embody our context; we cannot step

outside it. Or, as Nietzsche insists, "So we are necessarily strangers to ourselves, we do not comprehend ourselves, we *have* to misunderstand ourselves, for us the law 'Each is furthest from himself' applies to all eternity—we are not 'men of knowledge' with respect to ourselves."[2] That we cannot know to a certainty, that the grounds for knowing shift and change, results in a pervasive skepticism about the world, and possibly about one's place in the world. This form of skepticism is not an insistence that nothing exists but rather an insistence that what it means to know is not beyond question. What it means to know something is in fact *the* question.

These changes and developments mean that a relationship to even the most usual and familiar things keeps changing as well. This fundamental unknowing need not lead to some resignation or despair but can be what William James might well call "a program for more work."[3] That work then allows for one to be more *aware* of the self and what constitutes its constellation of identifications and resistances because more effort is invested in the process. Rather than the self simply occurring, we can come to know its mechanisms; we can trace the weave of its narrative. In many ways, psychoanalysis has held the same fundamental belief for quite a long time: the self is that which most needs to be discovered. And not the self in the most rarefied and ambitious of frames, but as gauged by our daily acts and encounters, which are themselves shot through with our sense of values, ethical, existential, and epistemological. Everything we do speaks the self, and the day is a book we keep on reading.

And yet, the things, people, the very situations that make up the ordinary recede from our ongoing consciousness like the sound of a ticking clock that one no longer notices or the hum of a fluorescent light. One defining characteristic of the everyday, of the ordinary, is a prevailing, pervasive inurement, and this inurement creates a blindness, a distance—emotional, spiritual, psychological—between individuals and the world. The question, then, is not simply, why is it that we do not maintain our attention? Rather, we might ask, why is there a bedimming distance to daily life that is so in need of redress? What does it mean that we are often least present to the very stuff of daily life? What does it mean that at least one other undiscovered country is the daily life we live in? Asking these questions is a means for exploring how our perceptions shape and are shaped by the ways we relate to others, the ways we relate others to ourselves, how we might conceive of the world itself—none of which we can be said to know if we do

not even know ourselves. In other words, I am this thinking thing, but it matters what I think about my thinking, for that informs what I will give myself to think.

Art of the Ordinary takes as its lens not the ordinary directly but the ordinary as it is presented and represented in art, film, poetry, and philosophy. These different methods offer arenas by which we can apprehend how different figures both depict and enact an attempt to encounter the ordinary, which by its nature recedes from active attention. The challenge is to discover or recover the everyday, but not then also convert it into Romantic terms.

Not unlike psychology, the work of philosophy is to true our sense of the world with the world itself. For Pierre Hadot, philosophy's task is to foreground the ways we encounter the world and the everyday as a habitable space: "Philosophy," he writes, "deepens and transforms habitual perception, forcing us to become aware of the very fact that we *are perceiving the world*, and the world *is* that which we perceive."[4] In both cases, the focus centers on what and how we conceive of that world and what we do to place ourselves within its flow. "How shall I live?" runs the most fundamental question of ethics. Thus, just as in psychology, we can turn to the places in daily life where doubts are to be had, places where questions bloom if we think to ask the questions. But what *is* an I that it asks such a question? If we are authors of our lives, in a sense, then we are also the primary interpreters of those selfsame texts. Is this to say we invent lives out of whole cloth? We weave with cloth and all its particularities, nonetheless. Whatever one makes of cloth is still made of cloth.

In a series of lectures delivered at Harvard in the mid-1980s, the philosopher Richard Wollheim asked the provocative question, "What is it to lead the life of a person?"[5] This is to say, he is more interested in the process than the product, that which we would call "life." Wollheim concluded by saying that "for a person, not only is understanding the life he leads intrinsic to leading it, but for much of the time leading his life is, or is mostly, understanding it." As will become clear (I discuss this issue of understanding a life as being a form of leading it at length in subsequent chapters), I am sympathetic to Wollheim's question, even if I cannot be as confident as he in those final claims about understanding. We might grant that to say to *lead* a life means to be active in its processes, self-aware of its motions, which is why Henry David Thoreau's observation about the mass of men leading

lives of quiet desperation is so poignant or why Socrates insists on the examination of one's life. The desperation Thoreau describes may be quiet, but that desperation reverberates at every turn for whoever feels it. Such is the way of desperation—its pique shoots through whomever is in its grip. The world of a desperate person is a desperate one. This is what skepticism feels like. It means not feeling at home when one is at home, and attention to the ordinary can create recognition just as well as it creates feelings of alienation. That pain can be the impetus to change, to discover the possibility of forming a habitable space in which to live. One of the elements swept away by skepticism is the sense of borders and limitations. This is its blessing and its curse.

Where I differ from Wollheim, then, is that question of understanding. What needs more room in thinking about what it means to lead the life of a person is an attention to the places where understanding becomes intermittent, where not only do we not know but we are implicated in how it is that we do not know, do not notice, do not acknowledge things and aspects of the world that are close at hand. The ordinary is that which passes out of view merely by staying still. Living is never something that comes to completion (though of course we know it always ends, despite our efforts to forget and even repress this knowledge). We never fully arrive at a place where we can have a stable sense of perspective. For that reason, we can understand that a central aspect of living a life means that we cannot understand it.

As I mentioned, I trace discussions of the ordinary and the everyday in various forms—in cinema, poetry, philosophy, and art—because these ways of thinking periodically take up the challenge of trying to encounter the ordinary and discover its capacity for significance in the way that these modes consider the process of perception. The words "ordinary" and the "everyday" as I use them are therefore not theoretical terms and include what one thinks would fall under the category of the familiar, the mundane, the banal, the usual, the habitual.

A number of Marxist French theorists have undertaken investigations of everyday practices, with Michel de Certeau being perhaps the most influential of these thinkers, especially in regard to his endlessly generative and perhaps by now canonical work *The Practice of Everyday Life*. There are, of course, places of interaction between de Certeau's study and *Art of the Ordinary*; however, de Certeau is committed to investigating the intrinsic formal

structures of social practices and interrogating the power relations that exist therein. To that end, de Certeau's discourse arises from the discourse of cultural analysis and even the social sciences. As valuable as that perspective is, *Art of the Ordinary* is ultimately more directly committed to a phenomenology of the everyday and a felt sense of the ordinary, which is why de Certeau, Pierre Bourdieu, and Henri Lefebvre do not play a role in the discussions that follow. My focus instead is on moments when key thinkers, writers, and artists create "usable paradoxes" (to borrow Fairfield Porter's useful phrase) in how they attempt to represent experiences of the ordinary. While these paradoxes offer insights into our understanding of everyday situations, they also serve as a kind of heuristic by which others can learn to approach their own experiences of the ordinary. The figures *Art of the Ordinary* considers (from Sigmund Freud to John Ashbery, from Alex Katz to Katharine Hepburn) hold that every thing and each situation bears the capacity for meaningfulness, and that art in whatever form, or philosophy in whatever form, or psychology in whatever form reveals the act of the mind finding itself. In essence, then, these activities provide models by which one can uncover meaningfulness. This is no small thing, for that which calls us to think is the means of increasing our sense of experience, our capacity for an openness such that whatever we are exposed to becomes a part of us. The composer John Cage, a figure who could easily fit into the nexus of thinkers *Art of the Ordinary* brings together, once wrote, "Our business in living is to become fluent with the life we are living, and art can help this."[6]

What is it that brings us to literature or art or even philosophy? Not information, surely, but rather the quickening of our attention, a deepening of perceptions. And acts of attention need not but can represent (that is, present to us and to others again) our experience (leaving, giving, frustrated, tentative, committed) of experience itself. The choice, if we think of it, can be our own. How optimistic this sounds; yet without such hope, hope born out of things as these, what are we left with? Confronted with the archaic torso of Apollo, Rilke declares, "du mußt dein Leben ändern": *you must change your life*. The figures of *Art of the Ordinary* have that same response, but they look at the play of light on a living room floor or a soup can or the dictionary rather than high art. Nevertheless, that imperative is an accounting of this willingness to be changed and not just by art but by participating in an open dialogue with the world.

ACKNOWLEDGMENTS

A great deal of *Art of the Ordinary* was written and then reconceptualized during my fellowship at the American Academy in Berlin. The experiences and conversations during that time transformed my thinking and this project. Every word is shaped by the months I spent there.

At different periods over the course of writing *Art of the Ordinary*, I had the good fortune of having two insightful and gifted research assistants: Zoe Mercer-Golden and Ilan Ben-Meir. I owe a debt to both of them for their fine acumen and their willingness to save me from myself. Joel Bettridge read every single word of this manuscript, and his comments, encouragements, and doubts helped deepen my thinking at every turn. I cannot begin to thank him enough. Joan Richardson and Henry Sussman read early drafts of early chapters, and they helped me move the work forward in new ways. Charles Bernstein and Luke Carson provided truly perceptive and engaged comments that strengthened this book immensely. An early, very different reading of Ashbery's *Your Name Here* appeared in the literary journal *Conjunctions* as part of an issue composed of short essays about each of

the poet's books. My thanks to the editor Bradford Morrow for the opportunity to try out my thinking in that forum. I want to thank the entire team at Cornell University Press. I would like to thank Peter Potter, who initially took an interest in *Art of the Ordinary*, and I owe deep gratitude to Mahinder Kingra for his belief in and support of this project. I have been lucky to have his guidance.

There are a number of people whose conversation and collegiality helped me at key moments. I would especially like to thank (in no particular order) Lanny Hammer, Marjorie Perloff, David Kermani, David LaRocca, David Lehman, John Koethe, Gerard Malanga, Marianne LaFrance, Megan Mangum, Logan Esdale, Karin Roffman, Don McMahon, Caleb Smith, Paul Grimstad, Dan Bouchard, Karen Russell, Richard Hell, Patrick Pritchett, Simon Cutts, Erica Van Horn, Michael Kelleher, Heinz Ickstadt, Alan Gilbert, Thomas Struth, Tara Bray Smith, Annie Gosfield, Roger Kleier, Norton and Elaine Wise, Leland de la Durantaye, Anne Dailey, Steve Ecker, Peter Cole, Adina Hoffman, Karlheinz Lüdeking, J. D. McClatchy, Patton Oswalt, Peter Gizzi, Uta Gosmann, Diana Tuite, John Tresch, Jesse Williams, Jean-Jacques Poucel, Jennifer Gross, Ulla Haselstein, Marjorie Welish, Ulla Dydo, and William Day. I would also like to thank the Yale Working Group in Contemporary Poetry and Poetics for years of intense, provocative discussions. I often had the benefit of spending time with Arthur Danto, Stanley Cavell, and John Ashbery while working on *Art of the Ordinary*. All three have been extraordinarily generous and helpful beyond belief, even when they were sometimes skeptical of where their thinking led me. I would also like to acknowledge the support of Susan Howe and Peter Hare, a rare couple who, together, could bring the sublime and the everyday into seemingly every conversation. The earliest sketches of *Art of the Ordinary* began in Peter's study, which I used just a few months after his passing. Using his books, sitting at his desk, helped spur me to think about the uncanniness of the ordinary, and to remember that because life is fleeting, every moment is worth trying to understand its potential for meaning. Above all, I need to thank Nancy Kuhl, my beloved without whom, nothing.

Art of the Ordinary

INTRODUCTION

In Respect of the Ordinary

> They said, "You have a blue guitar,
> You do not play things as they are."
>
> The man replied, "Things as they are
> Are changed upon the blue guitar."
>
> And they said then, "But play, you must,
> A tune beyond us, yet ourselves,
>
> A tune upon the blue guitar
> Of things exactly as they are."
>
> —WALLACE STEVENS

The various ensuing discussions of *Art of the Ordinary* explore acts of representation in regard to everyday experiences within art, literature, film, and philosophy. The specific acts are meant either to draw near the ordinary in order to encounter it better, intimately, in order to know it from the inside, or to wrestle with the experience of an estrangement from the everyday, and experience it as a feeling of distance. Ever present in the discussions that follow is the understanding that representing the ordinary is bound up in complex ways with an often self-reflexive interpretation because to represent the ordinary is always to be interpreting it through the process of representing it, and to interpret the ordinary is ever to discover it anew.

Acts of interpretation, insofar as they are readings of texts, objects, claims, and values, can bring inner processes of negotiation into a matter of public discourse. The array of possibilities for aesthetic understandings of what art can and cannot do, for how understanding does or does not have a debt to an observable reality, for how the tension between representation and experience creates or shapes affect, all become evident in interpretation. So, too,

does art make present relationships between consciousness and the world. Art offers occasions of contact. Such examples of contact provided by art manifest the art maker's sense of how the world hangs together. Then, through the ways that the work of art consoles, affirms, shocks, or surprises, the reader, viewer, or auditor can often chart his or her own sense of order, conceptualization, ethics, and value by engaging with that art. Interpretations—whether they are immediate or carefully weighed through reason and critical processes—are reactions, and reactions are a map of conscious and unconscious beliefs and expectations. The complex trials of recognition and resistance that make up interpretation—*reading*, in its capacious sense—entail attention not just to works of art but to the work we do in engaging them. This means one needs to direct attention to places of agreement as well as to places of disagreement, to moments of assurance as well as confusion, to instances of recognition as well as alienation. I attempt to trace how the ordinary is a context within which we are only infrequently aware that we are having experiences, making decisions, and wrestling with beliefs about reality and how a life might be led. I then discuss how certain thinkers and artists use their work to uncover the paradoxes located within the everyday so as to reveal that the ordinary is, at a certain level, always unknown.

The modes of interpretation that occur when encountering art inform and are informed by modes of interpretation that occur as art. Moreover, these modes also spill into the everyday elements of daily life, what we call "the ordinary," and these elements spill into how we read or how we look at art. Aspects of interpretation must be built from recognizable experiences or else art would have no value beyond fleeting aesthetic pleasure. Those negotiations that occur with art are also present in our dealings with people and with things. They shape the experiences that we call "reality," held together in the process of what philosopher Richard Wollheim refers to as "the leading of a life."[1] Wollheim argues that "leading a life" entails not just living but also trying to understand what life is as we live it, not in extremis but in life's everydayness. Thus, discussing the ordinary comes with a consideration of how we *think* about the ordinary as well as wrestling with beliefs about reality and how a life might be led.

A variety of artists, writers, and thinkers make the ordinary and its contexts their subject.[2] By bringing that ordinary world into focus, these figures work to increase a sense of what it means to live a life, to deepen an aware-

ness of what constitutes a relationship to the world as we find it. What more could attention turned to our acts of thinking afford us, but a deeper acknowledgment of how we live our lives? It may be a given, but reading, thinking, and all acts of interpretation are formulated to increase not simply what we know in terms of facts but what we can *say* about our experiences and understandings of things, even ordinary things.

To invoke the word "ordinary" in terms of describing reality is not to say that how we encounter such a domain is without negotiation. After all, to refer to "world" or "reality" is immediately to set oneself beside it, even if only in our imagination or by way of conceptions of a larger absolute. An attention to the ordinary is often construed as participating in realism. In this sense, being a "realist" is a vexed position because it entails some direct perception of ordinary reality as it is known or experienced. In terms of art, that is often taken to suggest an unmediated, direct representation of things. Herbert Read, in "Abstraction and Realism in Modern Art," a now-canonical essay reprinted throughout the 1950s and 1960s, describes realism and abstraction as binaries: "By *realism* we mean fidelity of representation, truth to nature. By *abstraction*, we mean what is derived or disengaged from nature, the pure or essential form abstracted from the concrete details."[3] Yet, even in realist painting, which has long taken the ordinary as its subject—rather than, say, the sublime—the artist focuses on something specific and plucks it from its original, lived context, and makes it part of the art world, thereby sharpening the attention afforded some particularizing detail. A real thing taken out of its found context and transformed into art is, by its nature, abstracted. With that, the thing or scene observed as well as the artist's act of attention is what a painting is "about." The artist sees a thing as potentially meaningful and by re-creating it as art foregrounds that capacity for meaning for other people to see and experience. This is to say, all things can bear the freight of meaningfulness, and so the ordinary is always capable of being read.

It might be helpful to turn to a specific moment in which the parameters of "realism" and its interest in the ordinary are complicated in art. I argue that Read sets realism and abstraction too far apart when actually the two modes are quite intertwined. At the very least, despite their conflicting stance on figuration, the two modes took on the philosophical question of what art does, at a time of aesthetic conflicts regarding the ethics of representation in the middle of the twentieth century. There are even examples

in which artists produced "realist" paintings that were informed by all the arguments for abstract expressionism.

Take, for instance, the painter and critic Fairfield Porter, who once described the well-known artist Alex Katz—a stylized, figurative painter often tied to the so-called New York School poets (John Ashbery, Kenneth Koch, Barbara Guest, and James Schuyler) as well as the pop art movement—as "a realist." Porter, however, has a special qualification for what the term "realist" might mean, and his argument can help situate the frame of a discussion about the ordinary. In the essay titled "A Realist," which first appeared in 1960, Porter marshals a case in support of recognizable figuration even amid the predominance of nonobjective painting and against the claim so common in the middle of the twentieth century that figurative work—portraits, still lifes, and the like—were somehow naive, if not outright reactionary. In his defense of Katz, however, Porter goes beyond merely a justification for figuration and indicates that a level of abstraction does exist in some art that is otherwise considered representational. He deems Katz a realist because someone looking at Katz's paintings can "recognize every detail in his paintings, and the whole too, though the whole takes precedence and the detail may be only an area of color, in short, abstract."[4] For Porter, although the painting is mimetic, abstraction lurks in the details rather than being exiled by their particularity and their reference to observable things in the world.[5] Peering at the details of the ordinary, we discover how we create patterns of abstraction.[6]

In his essay, Porter discusses Katz in regard to a specific painting, *Ten O'Clock* (1959).[7] Throughout his career, Katz's work has been consistently figurative, and this particular painting, composed of warm pastel colors and graceful though somewhat impressionistic brushstrokes, is of a woman, set a bit in the background, sitting on a couch, facing the viewer, while to her right are two rocking chairs resting close to her. Rather than being at the center, the woman and the furniture are just to the side of a tall window through which light is streaming. The interaction of the light and the window creates a shape on the floor of the room where the woman is. In essence, the shape of light crossing the floor echoes the window, and this conjoining of the light with the window is the dominant element of the painting. Porter, instead of detailing these aspects of the light, indicates that the woman's features are distinct and recognizable, but these individual elements—its shapes, its vivid colors—are part of the painting's overall composition. The

shapes and colors are what they are—distinct, discrete—and yet they are always part of the whole, or what Porter describes as "the manifestation of an integral spiritual whole."[8] In Porter's terms, realism describes a painting that does not merely represent a thing as it is, but finds a way to reveal how individual parts, taken together, express a larger spiritual whole. To recognize the whole, one needs to acknowledge the constituent parts. Nature is outside the painter insofar as the painter looks outward at material objects rather than solely inward to the products of his or her own imagination. But nature includes the artist's subjectivity when a thing is brought into a painting as representation. This act of inclusion or choice expresses the artist's subjectivity. When the viewer looks at the painting, he or she sees not the thing being represented directly but the artist's conscious and unconscious experience of the thing. More than that, the painter's subjectivity is bound up in *how* it is represented because it reveals all the sundry choices of composition. Even the artist's choice to paint a particular thing or a specific scene is part of the painting. In that way, the painting reveals the artist's affixing of subjectivity to things, a subjectivity that the artist believes the viewer will in some part recognize.

Since Porter gives us permission to think of the painting as more than the simple, unmediated depiction of a scene, we can say that the shape of light and its relationship to the window frames that light and self-reflexively suggests how ordinary things can be taken as projecting distilled abstractions and possibilities for emotional response.[9] Katz, looking at the scene (whether actually or through his memory), feels that the scene engenders some meaningful, affective response. The shape on the floor is composed of both the light and the focus provided by the medium of the window. Analogously, the painting is the interaction of the real scene and Katz's focus. In other words, the painting is both the thing seen by Katz and his framing of that thing. The viewer sees the painting and recognizes an affective response manifested as the painting, and has a parallel response—though the viewer's response is generated by the painting, not the actual scene. Yet, the painting's effect is fashioned out of prior experiences that the viewer has had. The viewer projects onto the painting an emotional quality, just as the painter projected onto the scene itself. The interaction of the scene and the painter gives the shape of the painting, just as the window and the light create the shape on the floor. We come to these projections by noticing, self-consciously, what we notice or, more slowly, through the process of making art. In every

case, we project their projection, and what we can uncover if we attend to the ordinary is this process of projection.

Porter was himself a figurative painter of remarkable talent, particularly of portraits of friends and quiet yet intimate domestic scenes ("interior" is a frequent word in Porter's titles), with his career beginning during the height of abstraction, or what that titan of art criticism in the 1950s and 1960s Harold Rosenberg called "action painting." In Rosenberg's seminal commentary cum tour de force manifesto for abstraction, "The American Action Painters," the critic argues, "At a certain moment the canvas began to appear to one American painter after another as an arena in which to act—rather than as a space in which to reproduce, re-design, analyze or 'express' an object, actual or imagined. What was to go on the canvas was not a picture but an event."[10] So often abstraction and realism are pitted against each other, yet Porter argued for ways that we can see these two tendencies as interconnected. The "action" Rosenberg describes as being so intrinsic to abstract expressionism can also be an element of the realist painting if we think of realism in different terms than accurate, precise depiction. For Porter, the act of looking is itself an event and thus realism is not the mere reproduction of a scene but the representation, even the reenactment, of the *act* of looking. In seeing a painting, the viewer looks at the artist's act of looking, which makes even Katz's painting "an event."

Part of Porter's case for Katz is that the use of recognizable figures in painting does not mean a continuance of a tradition that measured aesthetic value in how precisely a painter could reproduce an observable scene. In Porter's reading of Katz, looking is always an event, and abstraction need not be divorced completely from things that anyone can see and rendered solely as marks, stains, and strokes of paint on canvas. Abstraction exists in the tension between the artist's subjectivity and his or her attempts to sidestep it enough to confront the thing appearing before the eyes. The painting is the struggle among the thing seen, the artist's subjective perception, and the materials used to create the art. The tension is made manifest in the artwork.

In an essay from the early 1980s titled "Respect for Things as They Are," John Ashbery describes Porter's own work as being "intellectual in the classic American tradition" running from Ralph Waldo Emerson and Henry David Thoreau to Wallace Stevens and Marianne Moore. According to Ashbery, Porter's own paintings, like the work of the writers Ashbery names, "have no ideas in them, that is, no ideas that can be separated from the rest.

They *are* idea, or consciousness, or light, or whatever. Ideas surround them, but do not and cannot extrude themselves into the being of the art, just as the wilderness surrounds [Wallace] Stevens's jar in Tennessee: an artifact, yet paradoxically more natural than the 'slovenly' wilderness."[11] Ashbery suggests that for these artists, and perhaps Porter in particular, the art does not illustrate an idea; it enacts an idea. In that way, we can call Porter a philosophical painter, and we can work to see how his paintings are themselves best considered as thought. In any case, Ashbery presumes that art somehow shapes one's perspective on the world just as the jar in Stevens's poem reshapes the landscape simply by offering a point for anchoring perspective. The made thing, the work of art in this case, alters the flow of the natural world through the senses and provides a new perspective without actually altering the thing (or the landscape) itself. In other words, to refer to the Stevens poem that serves as the epigraph for this chapter (and that gave Ashbery the title of his essay), "Things as they are / Are changed upon the blue guitar." The process of art making absorbs things as they are, but there is a tension between trying to present them directly and the fact that the art's transformative process reveals itself, as the enjambment of Stevens's poem dramatizes. The way one sees begins to change with the introduction of new elements. A painting, or poem, or song can add to an experience of the world since it is a new perspective that supplements how a person sees the world. In other words, whatever else it may do, works of art help teach people how to look at things. The relationship between seer and thing seen shifts, and with that the experience of the meaning of that thing. A viewer can look at the scene the way an artist does—feeling it full of potential significance. Through painting, the everyday remains the everyday—it is the attention to the everyday that transforms through art. That is to say, the everyday does not change because of art; we do.

While Katz's painting can be seen as a whole in terms of its narrative content (the depiction of a woman in a well-lit room), it is at the same time a series of separate, individual acts of choice, evaluation, and decision brought together into a whole construction. The painter thinks: *this green rather than that one; this stroke with this speed and using this brush.* Painting as well as reading a painting enacts the process of looking at almost the atomic level— revealing how an entire view is made of seemingly countless constituent elements. According to Porter, the painting cannot be reducible to the representation of some specific, singular abstract idea or even the representation

of some concrete thing. In reading Porter's essay, we see his process of look-
ing at Katz's looking: response follows response. Each way of looking adds
another way of seeing the world, and in this there is a thickening of possible
perspectives—that way, an ordinary room with a window, morning sun, and
a woman sitting on a couch continues to become what it is as it gains its
specificity of meaning. The more one looks and then looks by way of other
people's responses (Katz's, Porter's, Ashbery's, and so on), the more elements
of that one moment on some sunny day step forward.

Ashbery, in his essay, notes that Porter is given to referencing Wittgen-
stein in letters to friends, and indeed it does sound as if Porter thinks of art in
ways similar to how the Viennese philosopher thought of philosophy: that
it is an activity and not a doctrine.[12] Art and philosophy can share the pur-
suit of trying to transform acts of perception. The line from Wittgenstein
that Porter felt central to his own aesthetics was "Every sentence is in order
as it is."[13] This seems to be a paraphrase or perhaps a creative misreading of
a passage from the *Tractatus Logico-Philosophicus*, "Alle Sätze unserer
Umgangssprache sind tatsächlich, so wie sie sind, logisch vollkommen ge-
ordnet," which is translated by D. F. Pears and B. F. McGuiness as "all the
propositions of our everyday language, just as they stand, are in perfect logi-
cal order."[14] In the letter from which Ashbery quotes, Porter goes on to say,
"Order seems to come from searching for disorder, and awkwardness from
searching for harmony or likeness, or the following of a system. The truest
order is what you already find there, or that will be given if you don't try for
it. When you arrange, you fail."[15] The task of the artist and perhaps of the
philosopher, too, is not to *impose* order but to listen carefully, look intently at
what is to be seen. At the same time, a consciousness of the ways that we
actively employ templates and categories for processing information is
brought into play, and so what is necessary is a consciousness of what ideas,
values, and beliefs we use to see and listen. Meaningfulness is present within
our everyday experiences, and means of expression, philosophy, and art (in
different but not unconnected ways) reveal the capacity for meaning in what
we use to express experience. Through this self-attention one discovers how
one orders the world, consciously and unconsciously.

In his discussion of Katz's painting, Porter insists that the painting's "re-
alism" is not measured simply by some precise mimeticism in its depiction
of objects, but by the way that the colors and shapes, the relationships among
the different parts within the frame of the picture, express and enact the

painter's relationship to the world, a relationship that is a form of respect for things as they are. Porter argues that Katz "is not overwhelmed by nature but stands outside it; it is outside him and includes his subjectivity. His vocabulary of colors is one in which between one color and another there is just enough space, or interval, because they are accurately chosen. This is like the space in an accurate sentence between nouns and verbs, between words and their modifiers. His opaque colors point like prepositions, definitely; or if there is ambiguity, it is the ambiguity of alternatives, a fixed and usable paradox."[16] The colors Katz chooses to use are indicative of a wealth of decisions and discernments not only about what he was looking at in that moment of that given morning but also about the material properties of what he uses (paints, pigments, brushes) to bring these perceptions to others. When we look at the painting as a series of choices occurring after the moment of initial perception and at the moment of trying to represent experience objectively and subjectively, we can start to discern the motion of the artist's mind, his idea of the world and his understanding of how the things of the world can bear and even communicate our subjectivity. The painting becomes a site for showing a subjective sense of the world to others, in that the painting reveals how thousands of small and large decisions of style, stroke, color, and shading exist separately but also as the painting's entire being.

The "usable paradox" that Porter refers to in his essay can be read as the opportunity for the viewer to then negotiate—or we might say *interpret*— another's subjectivity by way of one's own. That act of interpretation goes beyond merely *relating* to the content at some personal biographical level, as in saying that the couch in Katz's painting reminds the viewer of a couch he or she had in a home in some lovely and idyllic vacation spot, for instance. Instead, the endless decisions about how one looks at a painting, about which values one attaches where, come to entail the entirety of the viewer's response. Therein lies the painting's abstraction: the particular offers a model for general acts of perception. These choices happen just as often when looking at art as they do when looking at the world itself. Art is itself not separate from reality or the ordinary (or need not be), but is just as much a part of it as a rock or a speeding ticket or a leaf of grass. Indeed, our responses and reactions to such things carry with them the weight of an entire culture, and the social conventions and mores for thinking about our experiences. A sense of obligation (or lack thereof) to any thing or person can be read

through our actions and reactions, and these all point toward an understanding of reality that we share (or resist) with members of our culture at large. In that way, subjectivities ever become entangled. In its explicit call for interpretation, art foregrounds the role that such understanding and meaning are arrived at via a process, though these processes are ongoing in any kind of experience, from the sublime to the banal. In Katz's painting, one learns that a specific choice of a specific color carries with it a wealth of subjectivity: the painter's as well as the viewer's, which meet on the plane of the artwork. As Porter shows, with art one needs to be both outside the world and inside one's own subjective responses. This is true for the painter as well as for the viewer looking at the painting. Art and philosophy alike can provide the occasions for a person to be both inside and outside an experience of the everyday.

It is telling that Porter resorts to a trope of language in his description of the effect of Katz's realistic abstractions. Attempting to bring acts of perception into language reveals that these acts are always negotiations, and the slipperiness of these negotiations leaves room for a degree of mystery or ineffability. Language is the way that the attention is directed and yet also is the way that the mystery of unsettled interpretations can be encountered among the people that form a community—a community held together by a shared sense of how and what it interprets and values. The mystery is not resolved, but creates the possibilities for further discussion between people and with oneself. Again, in what Porter describes as a "usable paradox," this ambiguity—what we might call ambivalence, in the truest sense of the word—is a response to the ordinary itself. Porter stated in a letter, "A painting should contain a mystery, but not for mystery's sake, a mystery that is essential to reality."[17] What is more ordinary than a sunlit room at midmorning? And, therefore, what is more deeply mysterious?

The thread of thought I am developing is, largely, a response to the idea that the ordinary, the common, in its being all around us all the time, is that which is most deeply mysterious. As Porter indicates, the mystery is an essential part of reality. Such a sense of the mystery of the ordinary traces back to Heraclitus's observation, delivered by way of Marcus Aurelius, "[Men] are at odds with that with which they most constantly associate. And what they meet with every day seems strange to them . . . We should not act and speak like men asleep."[18] Although it might seem like a massive leap from Fairfield Porter to a pre-Socratic philosopher, they both share the theme that we do

not know the everyday because we stop investigating it. This is part of the paradox of the ordinary. Because of that pervasive mystery that is so often overlooked, everything has the potential to call for sustained attention, for engagement. We first must see the ways that the ordinary is mysterious, Porter and Heraclitus seem to agree, and then try to respond to it.

That contention leads not only to thinking about what constitutes "the ordinary"—the condition by which and in which we find ourselves daily—but also to examining the processes by which we examine such a condition. In other words, questions that are revealed in surprising, everyday places—as in a comic's routine, a Brillo box, or a Hollywood movie, for instance—are the means for finding the way that philosophy is shot through everything. What makes the everyday so ordinary is a prevailing, pervasive inurement that creates a blindness, a distance—emotional, spiritual, psychological—between individuals and the world. Saying that this book is a response to Heraclitus, a sustained consideration of the implications of his proposition about the mysterious ordinary—or what Porter once called the "revelation of the obvious"—means it takes the mystery of the ordinary quite seriously, expressly because it articulates a fundamental concern that the mystery itself can disappear all too easily.[19] This is part of the usable paradox of the ordinary: that even its mystery can slip out of sight. But let us think a bit more about what Heraclitus might offer in terms of an understanding of the ordinary so that it gives us a helpful framework for discussing the everyday.

Some evident hesitations come to mind, of course. For instance, what does "ordinary" mean to a pre-Socratic philosopher? Is his ordinary the same as our contemporary ordinary? These hesitations about historical specificity have validity but need not foreclose the discussion of a tradition of thinking about the ordinary altogether and the ways that we might see the ordinary, however obscure a topic, as reverberating at least from the sixth century BC right through until today. Consider the broadest strokes in thinking about history over the last fifty years. Increasingly, and for some time, due in no small part to Michel Foucault or Michel de Certeau (to offer but two of a legion of relevant names) we have seen a move away from emphasizing the exploits of "great men" and toward attempts to recover what daily life was like for everyday people in terms of material practices of specific historical moments. We need not dispute the value of such a materialist approach to see that it limits the ordinary to a set of historicized practices that bring us

no closer to what that lived and still living experience of the everyday entails in epistemological or even ontological terms. To deny speculation in favor of the empirical in considering the ordinary risks the repression of experience itself. What I hope to offer is something more like a tradition of thinking about the ordinary as an aesthetic encounter rather than a history of the ordinary.

We cannot know precisely what the ordinary means for Heraclitus, but then again, as he insists, neither could he. Since all we have of Heraclitus are fragments and quotations, it is impossible to gather his intent. We can, however, respond to the effect of his language, which is both familiar and startling in the ways that aphorisms so often are, in that they float free of the architecture of systems and arguments. In fact, many have argued that Heraclitus's aphoristic style was meant to create mystery and interpretative dissonance so that people would not be reassured by his insights but were forced to engage them actively. After all, his words, individually, no matter how elusive, were everyday words like any others rather than technical terms or neologisms. Any insights would be derived from thoughtful investment in how the words might earn their meaning, however tentative. His comment on the deeply mysterious ordinary is designed to get us to think of the ordinary as being paradoxical.

In his reading of Heraclitus, Karl Jaspers discusses the effect of Heraclitus's aphorisms in a way that suggests Porter's interest in "usable paradox." Jaspers insists that for the pre-Socratic philosopher "the common bond" existing among people "is elucidated in thought and action. In thinking we understand together, in acting we fulfill together."[20] Heraclitus provided philosophical occasions in which people would have to *actively* think about meaning; they would have to pay attention to the processes of language. The particular is able to be seen by way of shared language and ideas (one way of thinking of *logos*), and is not left isolated and passed over in silence because there is no way to discuss it; it becomes swept up in the overall composition of understanding in much the same way that Porter described the features of the woman in Katz's painting. Jaspers interprets Heraclitus as saying, "In action, the community of opposites resulting from conflict is opposed to the isolation that springs from complete rest and peace." The play of interpretations, or attempts to articulate value and experience, all are forms of actions. And even in trying to read Heraclitus's fragments these processes are activated. The very form of Heraclitus's fragments and aphorisms creates

interpretive conflict, and in that way enacts their argument about conflict being opposed to isolation. And according to Heraclitus's belief that the ordinary itself is so deeply mysterious, and that we cannot even know what our ordinary *means*, we are no more able to say categorically what Being means. Heraclitus also believed "all is in flux." If everything continually changes, final meaning is never achieved. Ralph Waldo Emerson, an aphoristic philosopher and great admirer of Heraclitus, extended this idea when he wrote, "This one fact the world hates, that the soul *becomes*."[21] Being, ordinary living, is a dynamic state, so its capacity for meaningfulness needs always to be redetermined and rediscovered.

In threading these thinkers together, I am trying to indicate a metaphysics of the ordinary that presents two claims. The first is that living is itself an ongoing activity that determines its parameters and its very meaningfulness not once and for all but moment by moment. The second is that in trying to focus attention on the ordinary, one needs to create the conditions whereby one becomes self-consciously aware of oneself in the context of the everyday as itself a condition in need of attention. The ordinary is not static but in flux. As a person continually changes physically (the body reforming itself over days and years as it grows older), emotionally, and cognitively (through the continuous accruing of new information and new experiences), the relationship one has to himself or herself and to the world also shifts. In this understanding of what constitutes life, the self manifests itself again and again only in its process of coming into itself, not in terms of what it has done in the past or in how that self was defined at one time. As the self is not fixed and is the process of a futurity perpetually realizing itself, the world constituted by such beings is a set of relationships continually in need of being reassessed and established anew. We cannot say we ever come to the absolute completion of any interpretation or perception. To find some way to discover and perhaps even recover the ordinary may provide some more transcendent hope as well.

Yet, in some ways the ordinary can never be approached, since to do so is to immediately transform its condition. The ordinary resists definition because it does not need to be defined—it is where any of us tends always to be. To become self-conscious of the ordinary, of the everyday, is to think oneself removed from its weave, to be outside it. We could see this as a way of being outside nature, to use Porter's language. This feeling of distance, of distinction, amounts to a form of skepticism in that it reflects a denial of one's

presence within the condition of the ordinary, the conflict coming between the world and our competing, fallible versions of it. This skepticism is particularly generative in that the ordinary is a situation to long for as well as a condition to escape from—the denial of the everyday intermingles with the desire to transcend the present ordinates in order to discover them. As the Romantics thought about the everyday, the heroic figure breaks free from its confines, but this is not the whole story. To break free of the ordinary is to be unable to learn from it, and this flight keeps one from discovering who one is among others in the ordinary world. A complete escape would be a kind of loss of the very subjectivity that Porter saw as being expressed in the various individual, incremental choices built into Katz's painting. The key seems to be to seek ourselves where we reside, an everyday domain.

Alienation of the self from the ordinary is an ongoing theme in philosophy. "We are unknown to ourselves, we men of knowledge—and with good reason," Nietzsche, a careful reader of both Emerson and Heraclitus, writes in the preface to *On the Genealogy of Morals*. "We have never sought ourselves—how could it happen that we should ever *find* ourselves? . . . So we are necessarily strangers to ourselves, we do not comprehend ourselves, we *have* to misunderstand ourselves, for us the law 'Each is furthest from himself' applies to all eternity—we are not 'men of knowledge' with respect to ourselves."[22] A continuity forms between Heraclitus's observation and Nietzsche's insistence that not only we do not know ourselves but also we—most or any of us who think about such matters—are the ones most distant from any perspective on ourselves. How like the idea that the ordinary is deeply mysterious sounds Nietzsche's contention, "Each is furthest from himself." In both conditions, a consciousness of self is absent. Given Nietzsche's admiration for Heraclitus, there are reasons enough to consider the two linked in this idea of a subjectivity isolated from the ordinary.

This sense of self-estrangement appears in American philosophy as well, particularly in another figure quite central to Nietzsche. In the first sentence of "Experience," Emerson asks, "Where do we find ourselves? In a series, of which we do not know the extremes, and believe that it has none."[23] If we are to tie this opening to the title of Emerson's essay, which signals the presumed focus of the author's thinking, Emerson seems to be suggesting that to think about experience, to try to experience *experience* itself, is to be unsure of where we are in regard to experience. But Emerson wants to know, not simply deny, the ordinary and suggests that the measure of life is in one's

ability to discover the paradoxes of the everyday. That we do not know where we are is a specific form of unknowing that could stand as the principal impetus to philosophy: the *decision* to discover some of these answers in order to begin to examine life itself and therefore to have some understanding of our own lives. Such examination and the self-consciousness that follows is undertaken as if our sense of ourselves need not be merely singular and fixed, but may point to larger possibilities of understanding what it means to be human. A willingness to begin such an undertaking of interpreting experience, perception, and beliefs—rigorously, tirelessly—and living the examined life means coming to question the things closest to us.

Nietzsche thought there is at least one important, if not telling, difference between Heraclitus's ordinary and the more modern ordinary, which is what Nietzsche describes, somewhat enviously, in "On Truth and Lies in the Nonmoral Sense." For the Greeks—or what Nietzsche called "the honest Athenian"—the ordinary could at any moment reveal the presence of a god because "when every tree can suddenly speak as a nymph, when a god in the shape of a bull can drag away maidens, when even the goddess Athena herself is suddenly seen in the company of Peisistratus driving through the market place of Athens with a beautiful team of horses—and this is what the honest Athenian believed—then, as in a dream, anything is possible at each moment, and all of nature swarms around man as if it were nothing but a masquerade of the gods, who were merely amusing themselves by deceiving men in all these shapes."[24] In this *magical understanding*, the ordinary perpetually has the capacity to be more than just ordinary. The everyday can at any moment be transformed and reveal its true nature as if some supernatural force could suddenly step forward from the everyday and transform its context. Thus, everything was worthy of attention. Nietzsche idealized the metaphorical capabilities to see gods everywhere, which he believed to be characteristic of the Greeks. In the modern era, however, without gods, the ordinary can no longer assert itself in extraordinary terms. The ordinary no longer offers a possibility of revelation of some hidden *entity*, some transcendental figure that specifies a context for experiencing reality. There is nothing left to wait for. So what claim can the ordinary make, in any of its incarnations and manifestations, for people's attention in terms of consciousness? It recedes, thus.

This is not necessarily as bleak, nihilistic, or pessimistic as some readers might be tempted to believe since it means that revelation or creativity comes

not from a supernatural realm but from human beings themselves, from acts of thinking and imagination. If Nietzsche believed it a crisis that the mythic gods were gone, Emerson offered an alternative source for animating the everyday. In "The Poet," Emerson describes poets as "liberating gods" because they offer tropes and metaphors by which to read the world as pregnant with meaning. Through the particularly human act of creating tropes through art as well as science, Emerson insists, "men have really got a new sense, and found within their world, another world, or nest of worlds; for, the metamorphosis once seen, we divine that it does not stop."[25] The world becomes "worlds," and understanding can become fluid by way of acts of imagination, acts that are in essence forms of response. Imagination is not a form of escapism, yet in its syntheses of perceptions it can reveal the multiplicity of meaning and experience present in the process of analogy and metaphor. According to Emerson, poetry activates the multiplicity of meanings built into language and reveals its usable paradoxes and communities of conflict as being an ordinary condition of language. But for Emerson, any form of imagination counts as poetry.[26]

The imagination builds itself out of the materials at hand. Art in its various forms, as well as philosophy, can offer concentrated and often self-conscious forms of the negotiations and interpretations of experiences that happen every time we look at any aspect of daily life—from memos to crying children to the flights of birds. Throughout the chapters that follow I do not make the case that the ordinary is actually extraordinary. Instead, I look at how attempts to represent or express the ordinary reveal the foundations of subjectivity in their potential for self-conscious reflection. In that way, art teaches us how to look at the everyday as if it is always full of meaning, even though—or especially because—that meaning is projected consciously (as is most often the case with the ordinary) or unconsciously onto the world.

What does the ordinary speak? we may ask in the hope of discovering what it expresses to us and about us. Since the ordinary is ultimately not intrinsic to things but is symptomatic of one's (or more collectively, a culture's) stance, one's deafness to the experience of certain aspects of daily life may have much to teach us. An everyday language that is left unnoticed and unattended to is often what makes a thing ordinary. Yet, to experience a thing any other way is to translate it from the ordinary into something else and therefore to displace it. Where do we find ourselves? In a situation that if we are to discuss the condition we are in, we risk being exiled from it. This place

is a kind of domain, a lived space formed out of habits of experience that we come to inhabit. Another way to say this would be to suggest that the things that occur below the level of active attention, that do not evoke and perhaps even prevent self-consciousness, may have as much to tell us about ourselves, and our language, as the things that otherwise explicitly demand attention.

As Porter's comments about Katz, Ashbery's comments about Porter, or Emerson's ideas about poets show, art, in various forms, can serve as a reminder of the ordinary or as a means of bringing the presence of the ordinary back into one's field of vision. Furthermore, considerations of stand-up comedy, movies, and other such cultural manifestations can provide useful and relevant occasions for thinking about thinking itself through the measure of surprise and recognition we discern in experiencing these things. This is not to say that everything is philosophy, but rather that philosophical occasions can appear anywhere. Indeed, if philosophy is to have any purchase on one's life, it must be able to appear in the most unexpected of places. What hope can it offer otherwise in bringing forth the condition of thought?

A contemporary possibility for finding "gods in the everyday" exists if we see the way that the ordinary world can provide tropes enabling the opportunity for aesthetic investment and intellectual engagement. Through this investment—the intertwining of the subjective and the objective—one might take things to be meaningful and discover the very mechanisms of meaning. For Nietzsche, Emerson, and Heraclitus, language creates a feeling of connection because the world is conceptualized in human terms; words tie us to things and language use ties us to one another.[27] Through analogies and metaphors, humans are able to acknowledge the world by the way it bears conceptual apparatus projected onto it. Porter, Katz, and Ashbery see art as a way of enacting the recognition that the ordinary is a locus for us to project emotion and the capacity for meaningfulness. Recognizing these projections as investments or as possibilities for locating the human presence within the world's materiality is to begin to think about how one might live in the world, an ordinary world, our shared domain, every day.

Throughout *Art of the Ordinary* a cadre of names returns again and again (Nietzsche, Freud, Ashbery, Wittgenstein, and others), and these provide the foundation for the various kinds of issues and questions I pursue. All of these figures find themselves in complex encounters with the ordinary—it may be said that they find that their voices, their locations, establish who

they are through and because of such conditions of "usable paradoxes." For some, such encounters offer possibilities for exultation. For others, and at other times, the situations offer the necessity for pushing against a version of the ordinary that has become narrow and determining in the way it orders the world against its perpetual change. Both responses entail considering the mystery of ordinary experience.

Emerson looms large over the discussions that develop throughout this book, because for him, more than for any other thinker, the ordinary is the site that engenders a confluence of loss and presence, distance and proximity. In my previous book, *Listening on All Sides*, I presented Emerson's thinking in terms of poetics, that is to say, a border position where aesthetics and ethics meet and are revealed through the language that one uses. I pointed to Emerson's attention to words and language and to the composition and articulation as places for indicating, even *enacting*, worldviews by showing the materials of one's thoughts and not simply the content. This Emersonian conception of attention calls on readers to respond to the present moment through one's words. This attention to language itself is how we can begin to investigate not only *what* literature or philosophy says but *how* it says what it says. "The secret of culture is to learn," he writes in an essay included in *The Conduct of Life*, "that a few great points steadily reappear alike in the poverty of the obscurest farm, and in the miscellany of metropolitan life, and that these few are alone to be regarded,—the escape from all false ties; courage to be what we are; and love of what is simple and beautiful; independence, and cheerful relation, these are the essentials,—these and the wish to serve,—to add somewhat to the wellbeing of men."[28] To think about our human lives, to discover who and what we are, we can turn to the places, sites, and occasions present in our daily doings. This is to say, the stuff of our lives is worth the attention of thinking, even in the forms of philosophy and art. Perhaps just as importantly, this attention reveals what is left unsaid.

Along with the recurring names, two figures are continuous throughout my discussion, often implicitly and perhaps just as often explicitly: Stanley Cavell and Arthur Danto. Their centrality here acknowledges that both have spent decades thinking about the ordinary and the commonplace. The yoking together of these two thinkers is therefore not so arbitrary, although there are other reasons for bringing them together. They are roughly contemporaries (Danto was born in 1924, Cavell in 1926) and even briefly

taught together in California. Perhaps more relevant to this discussion is that they each spent intensive apprenticeships in the arts—Cavell in music, Danto in painting—and entered philosophy only after turning away from the arts and entering graduate school. A contemporary of Danto and Cavell's, Richard Wollheim (born in 1923), a philosopher of the arts also heavily indebted to both Freud and Wittgenstein, is a recurring and crucial figure throughout what follows, and he too had direct experience as an arts practitioner: in 1969 he published the novel *Family Romance*.

These facts indicate something more than a common biography since all three have brought philosophy firmly into places where once it had been thought to have little presence. For instance, Danto famously declared Andy Warhol's work to have real philosophical power as early as 1964 and sought to provide through Warhol a means for transforming the definitive relationship between philosophy and art; Cavell transformed film studies by reading films as active philosophical texts. As I point out throughout this book, Cavell, Danto, and Wollheim have revealed the opportunities for thinking about the very philosophicality that is intrinsic to the arts: we might call it the work of the work of art. The philosophicality tends to be of a specific type: a form of coming to self-consciousness. Art in its various forms—painting, literature, film, and so forth—as well as philosophy reveals moments that teach us how to look at a thing or an experience. As we saw with Katz's painting, a work of art can be the occasion of looking at looking. The art becomes reflective of its own processes and its place within a relationship to all art. In similar ways, considering art or thinking about the processes of understanding and interpretation, the viewer or reader must reflect on his or her own processes for reflection. These opportunities for being conscious of oneself as a self-in-the-making are plentiful, if they are sought. Such forms of thinking reveal our relationships to meaning, which can then be extended to things that are also not art or philosophy. One can articulate one's own vexed account in the face of "usable paradoxes," and such possibilities for accountability make thinking, however abstractly, a way of inhabiting the world with eyes and ears wide open.

The first two chapters of *Art of the Ordinary* provide the overarching framework for thinking about the ordinary in general philosophical and psychological terms. In a passage linked to some claims I make in the next chapter, Stanley Cavell points out: "The practice of the ordinary may be thought of as the overcoming of iteration or replication or imitation by

repetition, of counting by recounting, of calling by recalling. It is the familiar invaded by another familiar. Hence ordinary language procedures, like the procedures of psychoanalysis, inherently partake of the uncanny."[29] The ordinary becomes uncanny once it reenters consciousness insofar as it looks the same but feels completely different—it is simultaneously familiar and unfamiliar because in giving one's attention to it, the ordinary is seen as if for the first time. The second chapter engages the possibility of philosophy's neglect of the ordinary as being in effect an act of repressing the everyday, and as Freud contends, the repressed returns in various, often unwanted or even disturbing ways. The investigation arises from a discussion of a few lines by the stand-up comedian Steven Wright, whose absurdist, ambiguous one-liners call into question those things that we take most for granted in the metaphysical reversals of his comic fragments. Looking at Wright's stand-up routine helps illustrate how philosophical occasions or "usable paradoxes" can appear in the most unexpected of places. This encounter with the estranged ordinary through the surprise of comedy forces to crisis one's skeptical stance to the world by turning that skepticism inward, forcing the self to doubt its own ability to be recognized. The anxiety that the world might not be what one thought it to be brings forth the concern that one may not be who or what one thought. The chapter weaves together various discussions of the uncanny in order to think through the interdependency between skepticism and the ordinary that Cavell describes.

In chapter 3, I begin to develop an argument about the role art can have in expressing the ordinary and focus the discussion on a later collection of John Ashbery's poems titled *Your Name Here*. This chapter takes the question of the uncanniness of the ordinary into the realm of poetry. Even though among poets formed in the kiln of modernism an emphasis on alienation might not seem unique, in Ashbery's poetry the conception of emotional distance takes on a specific tenor in that, for this poet, the alienation occurs within language, within our relationship to the language that we use every day. As he writes at the beginning of "The System," one of the three monumental prose poems that constitute *Three Poems*, a collection published in 1972, "The system was breaking down. The one who had wandered alone past so many happenings and events began to feel, backing up along the primal vein that led to his center, the beginning of a hiccup that would, if left to gather, explode the center to the extremities of life, the suburbs through which one makes one's way to where the country is."[30] This "wandering

alone" past "so many happenings and events" recalls a kind of alienation, and the kind of alienation encountered in or as revealed by Ashbery's poems is not a crisis (as in a situation that takes the poems' speakers by surprise) but is the poems' (and our) given condition. For instance, in "The System" it is never made clear what that system actually is. Even the aphoristic style of the piece, which as prose poetry draws on no clear prosodic pattern, troubles the formal and rhetorical conventions that serve to separate prose and poetry. It dismantles the systems that mark either prose or poetry. More-over, the poem periodically suggests but never delineates a narrative taking place. As the excerpt from *Three Poems* suggests, Ashbery's alienation trans-forms into what might be described as a loneliness, but this loneliness is not necessarily a negative condition, as I show in discussing central poems in *Your Name Here*. It can be a feeling state that delivers people to themselves, to a consciousness of the self that is both objective and subjective and yet from which people are continually distanced. As this excerpt from "The System" suggests, the place where one is trying to get is not in threat of exploding—only the way there is at risk. Yet it is the risk itself that provides as a way of locating "a central vein" a locus by which one shores up a sense of self.

Art of the Ordinary takes seriously the oft-repeated proposition that Ashbery's work is difficult and asks what that difficulty amounts to. That difficulty calls us to think—to consciously encounter the text and weigh its conflicts with an everyday sense of language. That thinking is motivated by a text's resistance to how one interprets it and fashions the community of conflict that Jaspers sees arising out of Heraclitus and his aphorisms. In this way, the poems force readers to think specifically about what the language Ashbery uses—which is, after all, our shared language—is doing. This difficulty both warrants and makes possible the conditions for attention, but it is not simply a general attention. The poems bring attention to the mean-ingfulness of familiar language, the ordinary language that Ashbery makes seem so extraordinary in what he leaves out. Or as he says in the opening section of *Three Poems*, "I thought that if I could put it all down, that would be one way. And next the thought came to me that to leave all out would be another, and truer, way."[31] Some part of thinking through language use is determining what is left in and what is left out in how we communicate ex-perience or how we make sense of what others say.

The final chapter focuses on the work of Andy Warhol and brings together his descriptions of pop art in *Popism*, his serial work of the 1960s

(particularly the *Death and Disaster* series), and his films (especially *Sleep*, *Screen Tests*, and *Empire*). I frame Warhol's notion of the ordinary as being something more than a critique or satire (or even saturation) of commodity culture and celebrity. I argue that Warhol's serial repetition and his emphasis on labor-intensive work seek to reclaim visual culture, signs, media, and images as being the experience of the contemporary ordinary and that these serve to teach people how to look at the world artistically. Rather than making these images and their visual information banal, however, Warhol's work confronts their banality as a site of possible contemplation. This chapter contributes to the still relatively slim body of philosophical engagements with Warhol's work. In addition, the chapter is an attempt to cross the boundaries of discipline and discourse to indicate the ways that questions about art and philosophy can arise from everyday life and experience.

While pop culture may be "always already" commodified, it also reflects values and beliefs that warrant some attention in ways similar to those in which "high culture" is so often afforded, which is the thrust of the work of an artist like Andy Warhol. For Warhol, pop culture is an existential environment in that it points to symbols and their associations that shape daily life. Warhol looked to the things at hand—from Coke bottles to soup cans— and realized, contra the abstract expressionists, that the ordinary world was not something to be eschewed or repudiated but instead could be accepted, in that Superman comics, photographs of celebrities, and all the commercial detritus of the contemporary could become vehicles and even markers of emotion and of human attachments. Warhol showed that the distance between the commonplace and art could be determined in new, far less agonistic ways. The everyday could elicit and be worthy of our responsiveness. As Arthur Danto maintains, "Philosophical understanding begins when it is appreciated that no observable properties need distinguish reality from art at all. And this was something Warhol at last demonstrated."[32] Art, in that it exists, is always part of reality. The more we see it as being a measure of one's relationship to things and to other people rather than as an escape from the world, the more art's meaningfulness, however complexly construed, provides the hope, let us call it, of uncovering and recovering from the repression of the everyday.

Chapter 1

LEADING AN ORDINARY LIFE

Philosophy and the Ordinary

The philosopher Richard Wollheim, who sought in crosscurrents of philosophy, art, and psychoanalysis the productive tensions of human thought and the fraught expression of its possibilities, asked in a series of lectures delivered at Harvard in the mid-1980s the provocative question, "What is it to lead the life of a person?"[1] It may be one of the most central questions we ask of ourselves, and it is at the core of trying to think about the everyday and the ordinary. Lives tend not to be led at the edges of consciousness, full of intensity and demanding concentration at every moment. Instead, lives for so many of us are full of events and decisions that are made without much thought: crossing a street, calling a friend, checking to see if the milk is spoiled, standing in line. Yet, just because these things are familiar, banal even, does not mean they should be left unexamined. The relationships we have with the world around us—people, things, events—particularly those most familiar of elements, are the ones most constitutive of the lives we all actually live.[2]

Wollheim's thinking enters into the discussion, then, because of his focus on the ongoing *process* of leading a life as something distinct from the *product* of the process, or that which we would call "life."[3] These are two different things for him. Life *results* from all the choices, decisions, and relationships a person undertakes through time. "Leading a life" is an ongoing action composed of countless threads of smaller actions. Wollheim posits, "The core of this process is to be found in three characteristic interactions: one, between the person's past and his present, and between his present and his future; two, between his mental dispositions and his mental states; and, three, between the conscious, preconscious, and unconscious, systems of his mind."[4] The model here, in its interlinking tripartite structure, is clearly Freudian. Although that might be evident, it is worth paying attention to the structure and concepts as well as their background, in that Wollheim's intent is to make us conscious of how we trace out a pattern of ourselves and our experiences so as to perceive these as coherent. "Leading a life" entails a consciousness of these interactions. Whatever else Freud might have done, he strove to show even the minutest, most banal actions to be legible texts capable of expressing dimensions of subjectivity that otherwise escape intent or conscious self-awareness. Building from Freud's premises, Wollheim then makes it clear that the process is determined by the forming and re-forming of relationships, all of which continually change over time and, in part, change because of time.

Of course, most of us are often not conscious of the patterns, tropes, and concepts we use in fashioning a life. In fact, one usually does not pay conscious attention to the fact that a life is continually finding its shape and that any life's context is not wholly constant. A life just happens, whether anyone pays attention or not. And yet this absence of attention to what a person is continuously doing distances him or her from such processes as Wollheim describes. The actions are unconscious or, perhaps worse, mechanical. I say "worse" because "mechanical" implies that although it is one thing to be *biologically* human, there is the more complicated matter that being human entails large metaphysical and humanist frames of conceptualizing thought, attention, and volition. Yet lacking the ordinary and everyday elements that are the stuff of living a life, such frames will remain incomplete. These may not be new issues, but they are worth returning to through new points of entry. Art, in its various capacities, and philosophy can offer these points

of entry to widened perspectives on the familiar through the paradoxes and complexities they reveal to be present in ordinary experience.

Nearly three hundred pages after he first asks his question in *The Thread of Life*, Wollheim concludes with the insistence that "for a person, not only is understanding the life he leads intrinsic to leading it, but for much of the time leading his life is, or is mostly, understanding it."[5] I am sympathetic to Wollheim's questions and his focus on determining what constitutes living and a life, even if I cannot be as confident as he in those final claims about understanding.[6] *Understanding* implies some stable purchase, a thoroughgoing perspective. Yet *understanding* sounds too conclusive if indeed the process of leading a life is also ongoing. What it means to lead one's own life continues to change and evolve as experiences accumulate; therefore, a relationship to oneself can never be complete. For that reason and for others, complete or full understanding in any real way is elusive, even if life is that which is most in need of being understood. The relationships that are so central to the process of leading a life never come to rest, so *understanding* a life can never really be complete. What we can hope for is the recognition that there are patterns—or that we create patterns when we look at the facts, events, and experiences of life.

Whereas Wollheim focuses on the *process* of living and sees "leading a life" as referring to one's awareness of these subjective forces that unfold over time, I want to shift the focus somewhat and ask questions about the context within which that process occurs and how one makes that relationship legible to oneself and to others. Discovering that context and how we represent it can reveal how "leading a life" includes not only a *conscious* relationship to the world within which it occurs but also a consciousness of how we make such a relationship.

It is not lost on me that the passage I just cited provides the last words of Wollheim's quite magisterial book, a passage intended to drive home its authoritative tendencies. Yet, aside from Wollheim's gesture toward a definitive conclusion, which may be mostly for the rhetorical flourish of ending the book, Wollheim remains engaged in the argument that leading a life is in reality an activity and that life itself results from that activity. Accordingly, a person is in essence a thing that undergoes a process, a process called living, that results in a life. Perceiving distinctions between the process, the agent, and the product offers a clearer view of what it means to be a self in

the flow of time, responding to the world in its part and as a whole. We might think of it as drawing a line. The line appears only through the continuous action of moving the pencil across the page. The length of that line, its character and integrity, is determined only when the pencil lifts up and the drawing is done.

In place of the definitive understanding Wollheim suggests, we might propose a different idea for "understanding life" and say instead that to *lead* a life means to be active in its processes, self-aware of its motions as one is undertaking them. Such active engagement entails seeing oneself as a thing undergoing (and undertaking) processes that will, taken all in all, lead up to a life. One can strive for attentiveness, so I would like to substitute "examining" for Wollheim's "understanding." The attempts to keep focused the awareness and attention so necessary to the process of examining are complementary actions that also require effort. In other words, one needs to be actively engaged as well as working to maintain that engagement lest it lapse. A byproduct of these efforts will be an altered, even deepened, relationship with the most ordinary things around us, as well as a different sense of how these relationships determine the cut of our personhood. To that end, seeking out the potential for meaning in objects and situations of the most banal and daily sort provides opportunities to perpetuate that attention.

The implication of cohesion to life is based on Wollheim's belief that every part of a person's life is brought to bear on every aspect of living, which is why it becomes vital to have his ideas present in this discussion of the ordinary. A life coheres even if one's identity is in flux, and that is how we recognize a continuity of a person's subjectivity. Wollheim does not want to leave the self as a network of somewhat atomized relationships existing among a subject's present and various points in the past and in light of its future (particularly in terms of the consciousness of death). Nor does he want to present the self as a collection of discrete experiences, but rather as a whole that holds together across time. The self's structural integrity arises from an architecture of consciousness in the form of memories, desires, perceptions, and fears. These are ultimately the ways a person imagines himself or herself reflexively. Later, in thinking about film, art, and how marriages are represented on-screen, we will see how those representations, when reflected back to us, create a possibility for self-consciousness that allows for this engagement with how one crafts a relationship to life. Any event or decision involving a person engages all these elements of desire, perception, and so

forth, with each response informing all the facts that touch and have touched a life. With any action or decision a person makes, one finds oneself at the center of all these forces. The shape of its becoming what it is, is formed from every action taken or not taken. Life is complete only when the agent, the person, no longer undergoes the process and its attendant transformations. This end of the process is what gives a life its boundaries and is what we call *death*.

I want to call to mind Wollheim's question—"What is it to lead the life of a person?"—and its contexts and turn these toward an exploration of an everyday domain rather than a strictly theoretical discussion because just that question is at the heart of thinking about the ordinary. Wollheim's terms, with some adjustments, and the concepts on which they depend can help provide the means for discussing the structure of the ordinary as a relationship between the self, its environment, and its experiences. The ordinary is the ongoing situation of a life, the context within which living is located, and to think about the ordinary means calling on a range of fields, discourses, and approaches because the ordinary is so varied. The ordinary recedes from thought because it is everywhere. The ordinary is not life in extremis but the opposite of this, and so feels, in its untrammeled ways rather, even definitively, unremarkable. That does not make it trivial, however.[7]

Leading a life depends on a perpetual process of negotiations between experience and understanding. The context that is the most relevant to leading a life is the one that is often the most overlooked: the ordinary. We might refer to the ordinary as the "invisible context." One's memories and desires and experiences are shaped by extraordinary occurrences, of course, but these are far outweighed by the ordinary ones, the events, encounters, and choices so familiar that we do not notice them as decisions or situations or experiences. Yet, just because these conditions and happenings occur beneath our level of conscious attention does not mean that they do not have some bearing on the process of leading a life. Opportunities for insight come in the most unexpected places, arriving as occasions and instances that might seem, at first glance, inconsequential. To overlook the ordinary, however, is to deny its potential to reveal the shape of human lives. To turn toward the ordinary and look at its role in one's thinking is not to ask the grandly philosophical "how shall I live my life?" but rather to ask, "what is the life I am leading?"

To say more about the context of the ordinary, the everyday domain, I turn now to one of Wollheim's contemporaries, Stanley Cavell, whose interest

has long been the ordinary. These two philosophers (along with Arthur Danto, to whom I will turn in a subsequent chapter) train their attention on the choices and decisions that occur within daily human lives so as to see how these lead to and reflect a possibility of values. Cavell is an especially useful thinker for these issues because he has so doggedly pursued the claim that philosophy is not outside our daily lives but can be revealed in how we use language in our interactions with others and with the world as a whole, or in its parts. How we might learn to see within the familiarity of daily events, nothing less than a compelling possibility for meaningfulness, is his hope for what philosophy might become.

As a gesture toward a definition of the ordinary, Cavell argues, "the ordinary is discovered not as what is perceptually missable but as what is intellectually dismissable, not what may be but what must be set aside if philosophy's aspirations to knowledge are to be satisfied."[8] Cavell gives us some idea of how part of what defines the ordinary is not only its seeming lack of urgency, but also that traditionally it has been seen as having no bearing on higher philosophical concepts. Cavell calls this "philosophy's disparagement of, or its disappointment with, the ordinary." Within such disappointment, everyday situations and events are set to the side as unimportant, according to what Cavell says in the passage I have cited, and therefore philosophy does not extend to the ordinary. Philosophy is so often brought to bear on limit situations and the sublime edge of justice, ethics, aesthetics, and ontology, while not necessarily tracing the presence of these questions in daily life and how the concepts shape perceptions of experience. No less a figure than Bertrand Russell voices the type of stance that so frustrates Cavell when Russell insists that "philosophy is merely the attempt to answer such ultimate questions, not carelessly and dogmatically, as we do in ordinary life and even in the sciences, but critically, after exploring all that makes such questions puzzling, and after realizing all the vagueness and confusion that underlie our ordinary ideas."[9] Within Russell's sketch, what room is there for the everyday, then, existing as it does outside the "ultimate"? It cannot be, Cavell wants to insist, that the ordinary is actually without a space for questions. And yet there is a paradox involved in finding the space. If we stop to ask these questions—there is room for choice, of course—we risk transforming the ordinary into something else, deferring any escape and, in effect, continuing to perpetuate an alienating philosophical discourse.

By its very nature, the ordinary is not troubling. It makes no demands and no active claims for attention. In other words, there is no place to lay one's attention, or a reason to do so. Philosophy, so the argument would follow, at least in its traditions and conventions, has a blind spot as big as daily experiences. That limitation constitutes the reason why Cavell has directed so much effort to finding alternative models of philosophy—such as those practiced by Henry David Thoreau and Ralph Waldo Emerson— or finding surprising sites for philosophical questions, as in old movies or in the very language we use to express ourselves rather than that special- ized discourse to which analytical philosophy, as a field, is so often given over.

Cavell has sought to move away from the analyses of logical propositions because he feels that such language is outside the flow of experience.[10] Much of what he means by "ordinary" is balanced against those particular abstrac- tions. He also seeks to avoid the tendency toward systematic thought so as to be able to approach language in its most at-hand contexts and on its own terms, with its own terms. In this way, Cavell seeks an alternative language for undertaking philosophy in order to liberate people's lives. Changing per- spective and seeking alternative routes for how philosophy might be done makes it available to thought or even wonder. Or, as William James extends the notion, "Philosophy, beginning in wonder, as Plato and Aristotle said, is able to fancy everything different from what it is. It sees the familiar as if it were strange, and the strange as if it were familiar. It can take things up and lay them down again." He goes on to add, "It rouses us from our native 'dogmatic slumber' and breaks up our caked prejudices."[11] James's undeni- able Romanticism, inherited to some extent by Cavell, justifies looking at philosophy's boundaries in order to reopen them in a way that lets thought and everyday life intertwine.[12]

As I mentioned earlier, Cavell's subjects include everything from Ralph Waldo Emerson's essays to television to Fred Astaire's dance sequences—the sorts of things to which philosophers traditionally would not give their time. For more than a century, Emerson's writing, for example, had been consid- ered simply too literary to be regarded as a form of philosophy, and Astaire's dancing or Hollywood movies were taken as subjects too common or popu- lar to be points of entry for philosophical engagement. Over time, some of these attitudes have evolved. The search for alternatives to traditional forms of doing philosophy represents a frustration with the conventional discourse

of philosophy. To address limitations of discourse, it becomes necessary to seek unconventional ways of approaching issues that have bearing on people's lives in direct ways. These alternatives make it possible for people to bring key questions to bear on the things around them—questions such as *who am I? What does it mean to live a life of my own?*—and enable a philosophical comportment to do so. In short, it gives a person the opportunity to trace what Wollheim calls "the interactions between [a person's] mental dispositions and his [or her] mental states" in connection to the objects and situations he or she confronts on a daily basis, and not simply in personal experiences but also in regard to a shared context of the everyday.

The ordinary, Cavell insists, still needs to be *discovered* by philosophy. In part, its place within a philosophical register needs to be established. This discovery requires first noticing what it is we overlook and then investigating how we look at things, asking, for instance, why do we miss what we miss? Why do we see what we see? Cavell has also suggested that to be able to hear the call of what otherwise might remain "dismissable," attunement, or a discerning and active attention to the various elements of the experience of what we describe as ordinary, needs to be cultivated. The bandwidth of philosophical thinking needs to be increased so that it can discern what such things that inhabit the domain of the everyday have to offer. Otherwise, the ordinary cannot be discussed and people remain intellectually isolated from the everyday, without access to a full consciousness of life as it is led. Models and sites for philosophical engagement grounded in the available paradoxes of daily life, if sought, offer some perspective on the meaning latent in the things all around.

Although we can see the ordinary, the everyday, around us all the time— the coffee cup on the desk, the tree beyond the window, the cars moving up and down the street—such things rarely rise up to questions of epistemology or ontology. There are not many opportunities for inquiring as to what, if any, ethical obligations might arise from our relationship to daily things and events. Because we rarely think everyday things ask anything particularly interesting of us, and the language that surrounds them and represents them (or presents them) is not a point of crisis, we do not think to ask anything about them. Art and philosophy and even law are arenas within which one discusses how even the most familiar things can show the gaps in understanding how to express or communicate. These gaps appear in the warp and woof of contesting interpretations. However, the risks of everyday expe-

riences, what Emerson would call "the near, the low, the common," are restricted from philosophy.[13] Or, if they are allowed as subjects for consideration, the language attending them needs to submit to the dictates of the discourse. In other words, these aspects of the world do not count in philosophical terms and are passed over in silence.

Echoing throughout Cavell's concerns about philosophy's disparagement of the everyday is Heraclitus's insistence, to which I pointed in the introduction, that the ordinary is that which is most mysterious. The seeming philosophical paradox is at the heart of thinking about the ordinary: the more familiar an experience—one so well known that it is left perpetually unexplored—the less we know about it. If the ordinary, then, is consciously kept outside philosophy's discourse, the everyday starts to seem like a threat. Looking at the representation of such things in philosophy, film, art, and literature offers a sense of how the ordinary can be presented so that we see it at a distance, and so we can see just how much interpretation attaches to all that we do or say, to others as well as to ourselves.

If Wollheim is correct in seeing the self as a collective network of interactions formed within the relationships had by an individual, it is crucial to have the most at-hand circumstances in view and accessible to us in a variety of discourses. The cost for cordoning off the ordinary either philosophically or in terms of engaged attention may be clear: it means that the things we see, the things we do, and the routine encounters we have every day cannot enter into a conversation of what it means to be a human being "leading a life" in the ways Wollheim describes, because some of the aspects by which we define ourselves, those very elements of how we go about our daily routine or enter into agreements with others, are repressed. In this way, philosophical issues are left at a remove from the condition in which most people find themselves. If we do not have the capability to give our attention to the things we most often experience, simply because there is no language or point of perspective from which to reflect on such things, there is no way to accommodate them intellectually. A similar case was made in the introduction in regard to Fairfield Porter and his desire to create an aesthetic experience of the ordinary. Porter sought to represent how abstractions are part of the everyday and that people work to create order and recognizable patterns by way of those abstractions. The overlooking of the ordinary is an abjuration or avoidance that impacts one's ability to regard its capacity to bear legible meaning. Acknowledging the ordinary can only widen the spectrum of

what we can address intellectually and can provide insight into how and when we create categories for interpreting experience. This acknowledgment facilitates a consciousness of self and its processes, which brings Cavell and Wollheim into dialogue with each other.

"Acknowledgment" is a key term for Cavell, just as he also contends that the philosophical denial of the everyday is a form of skepticism.[14] Such skepticism directed at the everyday forecloses what certain forms of experience may be able to teach us, including the forms of experience Wollheim might label as *leading a life*. Such skepticism puts an individual in a position of being separated from all the things immediately around him or her, creating a form of isolation. With such isolation, acknowledgment is, at best, limited. That is to say, a person who is removed from the flow of the everyday comes to feel as if there is no place for him or her, and he or she experiences a prevailing sense of alienation or disconnection.

Timothy Gould, long one of Cavell's most committed and enlightening commentators, reads Cavell's model of skepticism "not as a false theory but as a belated interpretation of the situation of human beings as knowers of the world."[15] Gould argues that this model of skepticism can produce "a deeper anxiety about our place in the world" because of its denial of the very world most people observe. This form of anxiety reflects a tentativeness about even having a place in the world. Skepticism of the type that Cavell describes holds the ordinary as being either illusory or beneath attention.[16] Such doubt of the meaningfulness of the ordinary can do more than become a dead end for coming to understand the most crucial philosophical and existential questions in terms of lived experience. It can create the suspicion that the everyday is itself somehow false. The resultant feeling is an almost neurotic fear that one is always completely mired in the falseness of the everyday. Thus, I would add that the uneasiness that Gould mentions also travels in another direction: it becomes an existential anxiety about the world's place within us, since the two—self and world—can never be discontinuous. If the ordinary is not what we think it is, can we be what we think we are? "For Cavell," Gould continues, "the task of overcoming skepticism is not to prove the skeptic wrong but rather to undo the ways in which the mind has suppressed its ordinary connections to the world." If that is the case, then, or so Gould posits, "the skeptic accepts the problem of the mind working itself out of a theoretical isolation as a cover—and perhaps as a

consolation—for the deeper and less manageable separateness of human beings."[17] Beneath the skeptic's intellectual conception of a separation of self and the world is a fraught, unsettled feeling that every individual is isolated and estranged. One's self is always within the world one inhabits, whether or not it feels otherwise, and this fundamental relationship between the world and the self is the impetus to overcome the feeling of alienation born of philosophy that suppresses or represses the everyday as a viable site for its engagement.

The feeling of "the deeper and less manageable separateness of human beings" becomes part of an uncanniness of the everyday that occurs when it is subjected to conscious attention, and I will turn in subsequent chapters to how this effect is acknowledged by the stand-up comic Steven Wright and John Ashbery in the ways that they use linguistic paradoxes. To develop that discussion, it is first necessary to show how Cavell finds examples that serve as expandable tropes for observing the seemingly impassable distance between human beings. One way that Cavell explores this separateness is by thinking about marriage and how it is represented cinematically. It is not only the depiction of epistemological gaps between people that Cavell finds illuminating, but also the way that the medium of film itself contributes to this distance from the world. Looking at how marriage is represented, particularly when its terms are being renegotiated by people not clouded by sentimentality and when the terms are chosen deliberately by people who know them, allows for Cavell to think about the boundaries of knowing the self and the other as they exist in intentional relationships.

An ongoing negotiation of forms of representation and intention sits within Cavell's idea of the "remarriage comedy," his term for a subset of screwball comedies of the 1930s and 1940s. In such movies, marriage is shown not as a static condition of settled consensus but as a contested and contesting ethical space between two people. Marriage is a paradigmatic relationship between self and other, which is why Cavell places so much weight on these movies and sets them in dialogue with the ideals of ethical interactions. Rather than depicting a relationship falling apart, a remarriage comedy reveals a felicitous marriage that does not simply ignore profound differences but rather perseveres because of the deeper investments called forth in navigating those gaps in values, beliefs, and principles that arise between any two people. The relationships fray in the remarriage comedies,

and then rearticulate their terms. Marriage is shown to be a daily management of disagreement and consent in light of a doubt that two individuals can ever know each other's mind, or even their own.

One of the filmic texts most central to Cavell is *Adam's Rib*, the 1949 film featuring Spencer Tracy and Katharine Hepburn and directed by George Cukor. *Adam's Rib* is clearly important to Cavell, and he discusses it in every stage of his career—from the revised edition of *The World Viewed* to his mid-career study of film, *Pursuits of Happiness*, to his later collection, *Cities of Words*. Through its representation of marriage as requiring ongoing negotiation of the terms of its cohesion, *Adam's Rib* gives its attention to the everydayness of marriage. The film takes the everyday out of the flow of everyday life and places it within an artistic/cinematic context by which we can think about it. The film, as art, offers a way of thinking about the issues of the ethical and psychological complexities of marriage by providing the occasion for seeing marriage's abstractions, and in that way the art gives us insight into the everyday.

In the film, the two stars play lawyers married to each other. Hepburn's character, taking on the defense of a woman who shot her husband over his adultery, engages the differences in men and women by indicating a double standard at play in how people respond to the crime. Hepburn observes that a philandering husband is socially tolerated, but a cheating wife is seen as "something terrible." In Cavell's reading, Hepburn's case is an attempt to excavate the ongoing legacy of a theological model of marriage in which woman, in the form of Eve, is created to dispel Adam's loneliness. From that patriarchal model established in the book of Genesis spring ideological values according to which women are considered possessions to be owned by men and their duty is primarily to support the male egos against all insecurities.[18] The film's connection to the Bible is suggested of course by the allusion in its title. Hepburn's character, Amanda Bonner, questions those chauvinistic values as well as the ethical system that deploys such sexist principles in the legal sphere and upholds them in the domestic, private life.

Amanda's arguments are a clear critique mounted against the ongoing implications of the received patriarchal model. She seeks to move past its limitations for imagining what constitutes the relationship of women to men because such imagination is made seemingly inaccessible to women. Amanda resists the model because she finds the law unjust in its lack of self-understanding. By questioning patriarchal authority in open court and ar-

guing against the unjustness of the ethical assumption that women are held to higher standards of moral action, Amanda also resists her husband's authority, since he is the opposing counsel. The moral dilemma is not limited to a gendered splitting of opinion: Tracy's Adam Bonner argues that regardless of the discrepant societal expectations surrounding men and women, the woman on trial, Doris Attinger (played by Judy Holliday), attempted to commit a heinous crime, and no matter the context or contingencies, no matter the conditions that drove her to it, the law must be upheld.

Cavell's thinking opens up a feminist reading—the movie itself fairly demands it—but he is more interested specifically in the ways that the film *deromanticizes* marriage as an idyllic, ideal situation and reveals its ongoing complexities of interaction.[19] Cavell underscores that marriage is a situation entailing more than romantic love, for marriage, according to Cavell, requires "a double ratification," the first established "by [marriage] itself, by its being chosen out of experience not alone out of innocence" and then, "by its acquiescence in allowing itself to become news, open beyond the privacy of privilege, ratified by society."[20] As a particular social contract, a marriage needs to evolve constantly and renegotiate its terms and parameters as it encounters new issues and questions and as each spouse grows and changes as they age. The double ratification that Cavell notes happens not just privately but also where attitudes intersect with larger social concerns or mores, and vice versa. Constant renegotiations are not just part of marriage; however, renegotiation does offer a flexible model for a variety of interpersonal relationships. The gaps that open up between how one side understands the other reveal that marriage is a relationship whose specific tenets are perpetually being determined, insofar as both spouses continually reveal themselves in the face of new situations. The relationship must be able to change in order to accommodate the views of the respective partners fairly and justly. The differences in values and beliefs are not ignored but are part of the texture of marriage. For Cavell, this makes marriage a local example of democratic processes that manage difference to preserve union.

Remarriage comedies show that because marriage is not necessarily permanent and immutable, it always needs to contend with the possibility of dissolution. In *Adam's Rib*, the private negotiations of values and beliefs occurring between two spouses—Amanda and Adam—are more fraught because they spill into the social arena of a debate in public court and then flow back into private lives. This acknowledgment of the complexities of the

ongoing consent on which a marriage depends is not limited to the dramatization of a case before the law—it appears in the Bonners' lives at home as well. Throughout the movie, we see the couple interacting both in the courtroom and in the intimacies of their home, thereby illustrating the contiguity, rather than the compartmentalizing, of these two domains. Just how much do these two realms blur together? The Bonners first learn of the case while reading the newspaper over breakfast in bed. The values and arguments are not just personal concerns, thus, or somehow cut off from daily life. This film in particular entails thinking about processes of representation because Amanda Bonner's beliefs are what prompt her to pursue the case as the defense attorney and to *represent* her client, and these beliefs color all her decisions, just as Adam Bonner's do for him, despite Adam's insistence to Amanda about her deep-down agreement with him about the law: "No matter what you think you think, you think the same as I think." The very act of taking on the case shows that Amanda does think differently and it is the patriarchal, masculinist assumption that Adam knows Amanda's thoughts better than she knows herself that is the very belief that needs to be challenged, especially since intention is what is at issue in the trial. Furthermore, Amanda makes her case for her client as an epitome for how all women are treated. Indeed, she is making a case for the agency of women as human beings separate from men. In effect, she speaks for all women, and what she needs to prove is not that all women think the same way but that they all think differently, and differently from one another, than what is otherwise assumed by men. By extension, the Bonners' marriage becomes a metonymic, if not allegorical, representation of all marriages, if not all ongoing interpersonal relationships in general.

In this reading, the film can be said to be taking on the issue of how gender represents itself as collective difference. The claim that both law and film, respectively, involve forms of representation is likely one that can be taken for granted. The two fields are extensions and indices of beliefs and recognizable values because the figures in these respective domains (art and law) are the models against which actions and behaviors are measured. Those models are regarded, looked at, and weighed in terms of people's real lives and their experiences. Representation itself becomes an explicit concern of the movie (even if an unintentional one) because the two main characters stand in for their clients and speak for them, which is what legal counsel

does. Art, too, in its use of recognizable forms and types is a means of representation. Law and art as forms of representation come together in *Adam's Rib* insofar as the characters are discussing general social ideas for what it means to be a man or a woman in society at the same time that the characters themselves, as fictive constructs, enact the very understanding of gender and moral responsibility they are debating. The characters themselves, as fictive constructs, represent contesting ideas, values, and beliefs—they speak the ideas that the audience lives. This aspect of representation takes on an additional dimension if we see it as also having the capability of being pedagogical insofar as what happens on-screen enacts ethical conflicts that viewers not only identify with but also learn from. The Bonners do not themselves represent a moral end or represent themselves as moral types, but the film offers a moral process from which viewers might learn by way of their identification with the general conflict rather than with the specific details. What the text reveals is a model for the process of judging, and it does so in cinematic space, which, as a medium, is destabilized by its susceptibility to the skeptical condition, a space, thus, where judgment is most necessary as well as most at risk.

That what we see depicted in *Adam's Rib* occurs on film, as a set of images, is crucial to understanding the implications of representation and the frames within which an audience's identification occurs. Cavell's thinking about the very nature of film as a medium complicates this identification even further because film, as a medium, distances even as it represents the world. The complication is an asset rather than a burden, for it means that psychologically, philosophically, and sociologically the mechanisms of the experience of film are not left as transparent. The complexity makes the process of interpretation part of the experience, which brings us back to the relevance of the trial in *Adam's Rib*. That is to say, cinema does not only entail the direct presentation of narratives and images; it does not simply dramatize social themes, psychological dynamics, and philosophical worldviews. Viewers have a relationship with the form of film as well as the events depicted; the fact of the medium is something with which an audience contends. This relationship is a necessary part of an experience of film. The distancing effect of cinema arises from the fact that a film presents objects and people recognizable to the audience, and yet as present as these are to viewers, in cinema the audience is not, cannot be, present to those figures within the

diegetic frame.[21] This is in contrast to a play, however, because in live theater the audience shares the same space as the actors, though it cannot have access to the actual characters per se. Although the *characters* circulate in a fictive space, what one sees on the dramatic stage is nonetheless objects and people, not images.[22]

Even the physical elements of film shape a relationship to the projected images. "What does the silver screen screen?" Cavell asks rhetorically. "It screens me from the world it holds—that is, makes me invisible."[23] With film, we are invisible to the world we see on the screen, and, in turn, we come to experience a specific type of isolation because the world we see projected cannot acknowledge us in return. Nothing the audience can do can obtrude directly into that world on-screen. That we can recognize the people and events and objects makes that distance, that estrangement, all the more palpable. We should add that in the movie theater, the feeling of isolation can be balanced by the experience of being in an audience. One senses that one is not alone in the estrangement. Worth noting as an aside, then, is that as the experience of watching a film while being part of a collective audience is becoming less and less the norm, and more films are more likely to be watched at home on smaller and smaller devices, that isolation becomes quite fraught. Such developments notwithstanding, in the next chapter I return to this estrangement and feeling of the uncanny as being a pervasive and familiar aspect of contemporary life. For now, it is enough to say that this feeling of doubt and separation engendered by cinema is what a lived skepticism feels like.[24]

Cavell asserts, provocatively, that "film is a moving image of skepticism," explaining that with cinema, "not only is there a reasonable possibility, it is a fact that here our normal senses are satisfied of reality while reality does not exist—even, alarmingly, *because* it does not exist, because viewing it is all it takes."[25] Stephen Mulhall helps clarify Cavell's claim when he notes that "our relation to such an image of the world [as that viewed on the movie screen]—to something which presents our senses with nothing less than reality but which is nevertheless nothing more than an image—exemplifies skepticism's understanding of our relation to the world itself; for the skeptic, what we take to be the world is but an image of it."[26] Even that world on-screen is, in essence, unreachable. In the sense that one could never enter into that particular, specific place where the Bonners live or where they work, it

does not exist. The perspectives that the cameras mechanically produce (through lens, editing, lighting, and so forth) cannot be experienced organically in any other situation; they are possible only on film, as a film, yet, as Cavell underlines, we nevertheless do see a world with these possible perspectives edited together. These otherwise organically impossible perspectives partake of and feed a skeptic's desire to transcend or deny human limitations. This is not to say that all filmgoers are participating in skepticism while watching a film, but rather they enter into a situation that enacts or manifests the situation of skepticism and the skeptic's fraught relationship to the world. For these reasons, what interests Cavell in film is not merely the drama or events of the narrative, but the very way that cinema creates the conditions of a relationship to the world within which an audience participates and enacts its interpretations. Any interpretation of the meaningfulness of what we see is held within the context of that problematic relationship between the viewer and the "moving image of skepticism." This situation of skepticism becomes important when we think of *Adam's Rib* because of that film's almost unavoidably self-conscious nature, especially as that film revolves around a court of law as a theatrical space.

Cavell hesitates, however, in referring to films as *representing* reality. There is no reality for which the filmic images stand per se—they are instead the presentation of a world that does not exist, and, furthermore, he insists that "no event within a film (say no gesture of framing or editing) is as significant (as 'cinematic') as the event of film itself."[27] That is to say, it is not simply that we see the images on-screen, but what participates in or attends the process of looking that constitutes "the event of film." This is, however, why we should not abandon altogether the idea that film offers representations. Rather, the representations are specific examples of general types, the sort of which we encounter in daily life. The film isolates these as images and then places them within the network of imaged objects and people on-screen because while film does not represent reality, the objects and people we see *are* familiar, even though distant or unreal. They represent semiotically, insofar as they call to mind experiences we have already had, actions we have read in the past, concepts and words known to us. In the space of a film, these are not merely repetitions of prior experiences but familiar traces of affect in a situation newly experienced. The interpretations that film calls for entail subtilizing the mind so as to recognize the

familiar all over again. The space of film imparts to these familiar, recognizable images a context by which they are to be read as significant, as bearing the capacity of meaning.

In *Adam's Rib* we have a film putting on trial—debating, questioning—marriage and its philosophical understanding of the ethics of relationships. Such a critique might be taken as morally subversive, but because of its witty dialogue and all its comic signals, the film does not present itself threateningly in terms of its implications for considering the beliefs and dramatizing the conflicts that cohere as marriage. Moreover, that the film is a comedy, and that a moral order is restored or reconstituted at the end, suggests a kind of commitment to the function of skepticism and dissensus. The social debate the film presents is recognizable and even familiar, which allows the movie's contemporary audience to be acquainted with the questions that come up in the film and accept its premises. Given that familiarity with domestic strife, *Adam's Rib* itself brings the personal into the shared, public space of the cinema. Its projection on the screen reveals the possibility of identifying with what is to be seen, not just in its narrative content but in the structure of the recognizable, familiar, and daily conflicts of personal and/or ideological values between two married people. All this is as if to illustrate, Cavell holds, that cohesion is possible only when all sides are actively investing their consent. In a marriage—and the form of the remarriage comedy depends on this understanding—the bond is most discernible when and where it is being tested, whether internally or externally. This challenging of the bond between *what we believe* and *what is*, in terms of an understanding of Otherness, mirrors the very experience of film itself as that same skeptical condition within which the audience is located.

In his reading of remarriage comedies, a reading extending from the skepticism attending cinema's very form, Cavell draws a lesson about the role of skepticism in all ethical relationships.[28] If, as the skeptic holds, one can never know to a certainty another person's thinking, that such limitations exist does not (or should not) mean we should stop trying to overcome them.[29] Nor are we forced to collapse into existential isolation. In marriage, the friction between beliefs and ideas that manifest themselves in both small ways and large ways on a daily basis points to the fact that we can never fully know another, even in the most intimate of relationships. Differences remain. Yet, the challenges skepticism presents can be the motivation to keep striving to learn about others in order to overcome doubt and uncertainty.

Through ongoing attempts to bridge the gap and find ground for consensus, no matter how tentative, contingent, and subject to change, a skeptic—one who does not succumb to a cynical stance that nothing can ever be known and sinks into inaction—also comes to acknowledge more fully the principal factors of dissensus. One never achieves or attains full knowledge or complete certainty, because whatever is attained reveals its limitations, newly discovered. The process is thus ongoing, and the fact that it can never be completed is its virtue, as the outward agency of thought is a measure of what might be called *the human*. Cavell would describe this process as a form of moral perfectionism.[30]

Such a view ties back to my earlier claim that understanding is an ongoing process, one always in need of further uncovering. If the self is shaped by its interactions with the other—and a stable understanding of the other cannot be taken for granted—knowledge of the self in ordinary situations needs continuous adjustment as well. I want to extend some of Cavell's thinking and put some additional pressure on a small but resonant moment in the film that reveals some of the underlying structures of language and subjectivity. At the end of *Adam's Rib*, Adam Bonner invokes "what the French say," insisting, "Vive la difference!" in regard to the "small difference" between men and women. This prompts Amanda to ask, "Which means?" Amanda, a Yale-educated attorney, would surely know how to translate the phrase literally. She is asking, it would seem, what the phrase means in the context of their conversation. She needs him to translate his translation. "Which means hurrah for that little difference," he answers, which, on the one hand, could be a sly but cheap joke about genitalia.[31] It could just as well be Adam's underlining of the fact that men and women are always distinct from each other, and the distinction is what enables each their own, separate identities. After he delivers his line, Adam draws a curtain between the couple and the audience, which drives home the fact that he is being flirtatious. He draws the curtain to be discreet. At the same time, the effect of pulling the curtain is to provide a clear metaphor for how privacy protects difference by removing self-consciousness. The curtain marks a clear line between the couple and the viewers. It screens Adam and Amanda from the audience, thereby literalizing Cavell's rhetorical question about what the "silver screen screens."

The very nature of subjectivity is dependent on differentiations between the self and the other. In chapter 3, I show how John Ashbery sees poems,

by their very nature as occasions for interpretation, as foregrounding difference at the level of how one understands words and their meanings, but such a discrepancy can be seen to happen in this dialogue as well. Adam's "hurrah" might be an expression of relief for the small distinctions that persist even within a shared context. He is glad to maintain his individuality. What would he be without his differences? What would Amanda be? Men and women, human beings in general, can live together independently and still live interdependently. Interdependence does not necessitate unquestioning faith or the illusion of certainty. It is strengthened by debate—the voicing rather than the repressing of difference. Law, the forum for social debate, may legislate the discrepancies for fulfilling desires and beliefs and may create grounds for commonality, but it cannot resolve or dissolve the fundamental differences that compose subjectivities. What we see in the trial, however, is the process of interpreting texts, which, we will come to see, is mirrored by the audience, who is also in the position of interpreting, evaluating, and valuing the interpretation within the movie (the conclusions reached by the Bonners). This all occurs even as the audience experiences the lived experience of skepticism, estrangement, and distance that is part of cinematic form.

The movie shows that no matter the conflict and tension between and among values and beliefs, what remains in place is a self's relationship to the other, even if the conceptions of self and other held by individuals continue to develop. In the ongoingness of marriage—or any relationship, personal or political—there is not a severing of connections because of the uncertainty of knowing the other or because there is always difference. A relationship sees conscious investment of time and work as the impetus to keep learning what constitutes those differences between individuals, even those as intimately tied as spouses. The idea that marriage entails an ongoing education is what makes the movie hopeful and even helpful. Comedy—and the back-and-forth banter between the two leads of *Adam's Rib* makes it clear the movie *is* a comedy—can serve to extend perspective precisely because it dislodges the familiar, makes its familiarity the very aspect to be questioned, while not dislodging or discomfiting the audience. It unsettles but does not overturn. As I will argue in discussing Steven Wright's work, comedy turns the act of representation in on itself, placing the audience inside as well as outside a process of identification and recognition. The commonplace realm of a film comedy focused on marriage can provide the audience the

opportunity to think about marriage from a vantage point that allows for broadened and even disinterested perspective. Just as the tensions between Amanda and Adam are brought from their home into the courtroom, mirroring to some degree the tensions between the spouses that they respectively represent, marriage is depicted as a trial: it is a situation in which values and decisions are perpetually brought under scrutiny and, in a just relationship, compromises are arrived at via contest and rhetoric. The agon is not for its own sake, but part of the process of progressing toward that consent to continue that protects the social context while addressing constituent needs and desires.

My choice to sketch this reading of *Adam's Rib* is, for the most part, meant to represent and even supplement Cavell's methods in light of his insistence that something like a romantic comedy from the late 1940s may provide the occasion for considering where tensions about central ethical and epistemological principles lie intertwined beneath what is most taken for granted. Cavell demonstrates the everyday, and the way it is represented can be as viable and as appropriate an opportunity for philosophical reflection as doubting the senses or interrogating forms of justice, analyzing Friedrich Hölderlin's poems or critiquing Immanuel Kant's critiques, because the ordinary is nothing so much as a relationship, a relatedness, between a person and his or her general condition. Actually, the condition *is* the relationship. Marriage is a condition, yet without the relationship of two married people, the condition no longer exists. To explore the terms of a relationship is to uncover the structure of a condition.

As intriguing as Cavell's arguments about *Adam's Rib* may be, I am interested in what motivates his reading and the implications beneath the methods of his particular reading, as these give conceptual support for my own insistence on the importance of the ordinary. In essence, I want to interrogate the implications for how Cavell's method of reading participates in self-consciousness, and so to make more of this interest in the link between knowledge, self-consciousness, and the ordinary, we might do well to look at Cavell's own processes.

Cavell's frequent return to this film as a text bearing philosophical importance echoes his recurring impulse to recognize the source or genesis of knowledge and self-consciousness. It is relevant to Cavell's thinking that the movie's title, *Adam's Rib*, refers to the creation myth of Judeo-Christianity. To investigate Cavell's ideas about the connection between the ordinary,

skepticism, and what he calls the will to knowledge, we might put weight on a moment or two in his essay about *Adam's Rib* included as part of *Cities of Words*. These moments display a generative self-consciousness that appears when he writes about philosophical engagement. The moments of the philosopher's own self-consciousness on which I want to focus, present, arguably, what Cavell believes to be the stakes for thinking about how philosophy distances itself from the ordinary and what motivates a quest for knowledge.

As he has continued to return to the film over the years, Cavell's readings of *Adam's Rib* have amounted to a great deal of weight being put on such an entertaining film as a vehicle for discerning the interaction of epistemology and ethics, as Cavell himself confesses, and some people would charge that he is stretching too far what might be seen as merely a light piece of escapist fare, albeit one with a clear social agenda. His response to the hesitations presented by his critics is enlightening: "Isn't it as a warning against such intellectual stultification that one should bear in mind that criticism, call it the reading of art, is itself an art, and one, it seems, that philosophers have not often practiced."[32] Cavell phrases this as a question, yet does not end the sentence with a question mark. He adds, provocatively, "Or one might ponder what the motivation, or temptation, to knowledge is. Perhaps it is the temptation to know and say more than we can know and safely say. Perhaps it is the wish to deny that we know all there is to know in order to say what is to be said." This particular demonstration of Cavell's own self-consciousness represents what can be so generative in Cavell's thinking: he pauses to consider the underlying motivations for analyzing texts and claims and for thinking philosophically about the most everyday situations. He sees these critical activities as humanizing pursuits, for they allow us to discover what it is that we value in the ideas and forms we scrutinize. They are humanizing because a person needs to engage actively, making choices and decisions based on reflection and interpretation rather than passively responding to stimuli. The exercising of cognitive and even emotional faculties is the manifestation of one's subjectivity. For Cavell, then, artful reading generates knowledge, whereas its opposite, "stultification," by definition, produces foolishness.

In essence, Cavell holds with Wollheim that "leading a life" entails trying to come to understand the things one does and why one does them. The debt both philosophers owe to Freud displays itself in that shared commit-

ment to self-consciousness as a goal for critical thinking. The self-consciousness evident in Cavell's self-defense is valuable for considering the everyday because self-consciousness is a measure of subjectivity in its acknowledgment of one's separation from others. Self-consciousness shows how a subject works to compose itself to itself, to give itself cohesion through what it seeks to include and seeks to exclude—its choices and aversions made detectable to itself and to others as well.

This moment of Cavell's self-consciousness that I want to explore is by no means the first to be found in his body of work, though it is perhaps better to think of Cavell as wanting to acknowledge his own interpretive process as being part of the event of film. In the introduction to *Pursuits of Happiness*, titled "Words for a Conversation," Cavell allows that he might be charged with "reading into" the (filmic) texts on which he focuses his attention: "'Reading in,' as a term of criticism, suggests something quite particular, like going too far even if on a real track. Then the question would be, as the question often is about philosophy, how to bring reading to an end. And this should be seen as a problem internal to criticism, not a criticism of it from outside. In my experience people worried about reading in, or overinterpretation, or going too far, are, or were, typically afraid of getting started, of reading as such, as if afraid that texts—like people, like times and places—mean things and moreover mean more than you know."[33] He concludes his point by adding, "My experience is that most texts, like most lives, are underread, not overread."[34] Cavell also constructs a generative analogy when he says that his readings are interpretations akin to a musician playing a score and that his interpretations might produce not a secondary text (secondary, that is to the text being read) but a tertiary one. "A performance of a piece of music is an interpretation of it, the manifestation of one way of hearing it, and it arises (if it is serious) from a process of analysis."[35] He moves from this analogy to offer a new claim: "Say that my readings, my secondary texts, arise from a process of analysis. Then I would like to say that what I am doing in reading a film is performing it." In this way, the reading is an interpretation in much the same way that the primary text is. Danto, in a review of *Pursuits of Happiness* (his one sustained discussion of Cavell's work), considers Cavell's efforts to perform a reading that acknowledges its own processes through his own writing, though Danto uses the visual as his own way of analogizing Cavell's efforts. He writes, "The reality Cavell addresses is like the address itself, a kind of 'universal talk' which the address

illustrates, so that the relationship between address and subject does not yield to the semantics of everyday discourse so much as present a kind of verbal picture of a kind of discourse, a reality made up of language, a social texture woven out of talk: a form of life."[36] Danto's comments echo my discussion of Fairfield Porter's view of realism as revealing the very idea that we are always caught (or always discover ourselves to be) within a series of interpretations and subjectivities. This layering of reality with the attempts of interpretation to draw near reality in turn always presents a new, and distancing, representation, which facilitates, if not motivates, a consciousness of being a self in relation to and yet always estranged from the ordinary. By dint of Danto's comments, we can see that Cavell's sense of marriage is a model by which a constant renegotiation is the result of getting to know someone better and better. Commensurate with a deepening familiarity, the fissures of understanding between people, no matter how intimate, become more and more evident, and rather than necessarily precipitating a turning away, such discoveries can lead to ways of living within difference. Living with these differences and tracing "the relationship between address and subject" together call for acts of creativity.

To return to Cavell's ideas of reading, let us look at the part of Cavell's claim in *Cities of Words* in which he says that criticism, or the reading of art, is itself an art. I take his use of the word "art" as a serious point and not, rather, a turn of phrase. The *art* of reading art entails reading creatively, the way an artist might look at events, people, or objects—as if they are fully capable of conveying meaning that requires active engagement to discover. In Cavell's claim, we hear a polemic arguing for the risk of subjectivity entering philosophy more fully. Reading's artfulness corresponds to the degree that it is not simply objective or empirical. All reading is to greater or lesser extent an act of interpretation; meaning is assessed in regard to the familiar definitions of words, the context in which the language appears, and expectation raised by cultural conventions. Reading, indeed all interpretation, creates from what it encounters; it does not merely *register* meaning. Much of that meaning is brought from the interaction between the reader and the text. To think of reading and interpretation this way means considering a text (of whatever kind—lexical, visual, or material) as a field or network of effects. Reading, as much as it *is* an art, entails attention to the affect generated through its exchange with the texts it deals with, as well as through its

sensitivity to the medium by which it generates its effects and impressions. In this regard, reading is not a parasitic act; it is a sympathetic one, one predicated on the idea that the *capacity* for meaning is a given and meaning needs to be determined, if not discovered. Cavell's claim also suggests that reading is not limited to just literary situations. Reading is an order of interpretation of the sort employed every day. For that reason, the stuff of daily experience can bear the freight of interpretation. Instead of being concerned about taking an interpretation too far afield, Cavell focuses on the very motivation to interpret texts.

Believing that the desire for boundless knowledge is what pushes human beings past limitations built into existing conceptual systems, Cavell calls for people to be creative readers, such as Emerson called for. Creative reading does not mean wholesale invention and does not imply a fanciful interpretation; any reader—every reader—needs to wrestle with the materials at hand. Instead, criticism in the way Cavell characterizes it means that reading any text, especially the texts of one's own life, becomes a balance of the observation of conventions and the determining of what a text, a person, or an object may be able to carry beyond the evident. Yet, this activity is undertaken without denying the role of subjectivity in the reproduction of meaning. Cavell's understanding of remarriage comedies presents them as models for how to acknowledge rather than dismantle different and differing subjectivities that shape an understanding of what is otherwise shared.

Ironically, the excesses of interpretation involved in reading, or any act of determining meaning, can be a symptom of skepticism insofar as the excesses are motivated by a doubt of there being limits at all to what the imagination can do or how far thinking can go. We look for what seems to be true and along the way discover the limits of interpretation—or discover where interpretation becomes invention. We might put Cavell's statement about "reading in" in other words: the imagination responds to the materials given to it. What we build from those materials determines what we feel we can do with them, and depends on what we believe we are allowed to do in regard to those materials. Yet, the potential of capacious or creative interpretation could produce a proliferation of interpretive encounters, which would radically widen points of approach for considering experiences and the process of understanding them. If any perspective is destined to be partial, the more we have of them, the wider array there is that we can

consider. These approaches could then be taken together and present a commonwealth of knowledge, to which everyone contributes. The overall belief is that only by collecting as many views and perspectives as possible can a text, experience, or object come more fully into view.

For Cavell, the usefulness of skepticism lies in this active denial of interpretive limitation. It reveals the attendant desire to test claims so as to open up avenues of knowledge. Looking closely at Cavell's passage that I have been discussing, we can see what the language expresses about the underlying contexts for his claims. In the passage, Cavell keeps his claim conditional or subjunctive in its recurring use of "perhaps": "perhaps [the motivation to knowledge] is the temptation" and/or "perhaps it is the wish." Underscoring such contingency is a way to invoke knowledge's limits while trying to imagine something past those limits. In that way, the form of Cavell's sentence enacts its content. Articulating the counterfactual requires acknowledging a present absence in the schism between what is and what is only imagined. Moreover, Cavell's first descriptor, "temptation," places in a moral context what he characterizes as the motivation to knowledge. Temptation links the will to knowledge with sin, recalling Adam and Eve's eating from the Tree of Knowledge, which is part of the myth foregrounded by the title *Adam's Rib*.[37] Cavell's suggestion might be that, in whatever form it takes, the temptation to knowledge is what makes humans *human*. That temptation reveals a willfulness to overcome limits born out of a skepticism regarding those limits. This will to go beyond limits also demonstrates human fallibility. The desire revealed in susceptibility to forms of temptation itself provides the necessary predicate for the creation of self-consciousness. One needs a self in order to desire.

In activating a complex series of tropes with his use of "temptation" in a discussion of knowledge arising within the context of a movie bearing the title *Adam's Rib*, I am arguing, Cavell redeems self-consciousness. Reframed thus, the fall did not result in an exile from Paradise so much as provide humanity's delivery into choice, desire, and conflict, all based on the difference of subjectivities. Within this frame, the fall from grace was a fall into the self. If these choices, values, and divergent understandings are what make up the human, then an expansion of their capacities leads to an expanse of what constitutes the human. In short, self-consciousness is actually a means of liberation, or at least agency. With this agency comes the need

for one to be responsive to one's own thinking and its differences from others' thinking. These differences proliferate so that the interrogation of one's own values and riverbed propositions arrives in the perpetual encounter with other people's conflicting understandings and misunderstandings. Self-conscious questioning reveals how one is also accountable for the meanings and even unconscious intentions latent within one's own actions.

In thinking about this reframing of the myth of the fall, the implications for gender ideology are powerful and do seem to provide more than an altruistic, liberal-minded, well-intentioned foundation for Amanda Bonner's arguments. This trope reinscribes the feminine as being the source of strong subjectivity based on the value of differences. Rather than laying fault and sin at the feet of women, it instead attaches knowledge, agency, and a drive to self responsibility to the sphere of the feminine by seeing that temptation can serve as a strength and not a failing. This need not be an essentialist gesture, either, specifying that women do or must act a specific way, or that men do as well. Nonetheless, it shows how foundational narratives stand in need of being continually redressed lest they prevent difference. Such narratives, if seen as dicta to be followed and not metaphors to be interpreted, risk lapsing into mechanisms of oppression.

If "temptation" is a loaded term, then so is the other one Cavell uses. "Wish" calls to mind Freud's belief that the wish is an embryonic form of desire. In *Thread of Life*, Wollheim helps nuance the Freudian concept of a wish relevant for getting at the implications of what Cavell is implying. Wollheim describes a wish as eliding the boundaries between desire and imagination, showing them to be dependent on one another. "I wish for something rather than merely desire it, when I desire it: and because I desire it I tend to imagine (in the appropriate mode) my desire satisfied: and when I imagine my desire satisfied, it is for me as if that desire were satisfied."[38] To wish something is to desire something and then to imagine that desire being met. Wollheim goes on to suggest that in the imagined counterfactual, the desire is actually resolved and that is perhaps going a step too far in his faith that a wish so fully dismantles desire. Be that as it may, intrinsic to the wish is the reality that something prevents the desire from being fulfilled, and will continue to prevent it from becoming so. In that sense, the motivation to knowledge, inasmuch as it *is* a wish, is the imagination of a condition—some future but possible condition—without limitation. To learn the existing

limitations attached to understanding and expression and then find ways around them is how we might think of a will to philosophy as an attempt at wish fulfillment.

In Cavell's statement, we see that he specifies that the motivation to knowledge is a wish "to deny that we know all there is to know" and if we can make such a denial, then someday we could be in a position to find the ways "to say what is to be said." Cavell's claim reminds us that we have not yet achieved a perspective from which we can say what is to be said. That is, we cannot yet fully articulate experience from all angles, preserving both objective and subjective points of view, the conscious and the implied being made fully evident, with no part of an experience left unexpressed. For now, the limits of our language remain the limits of our world.

If we look at not just the content but also the context of Cavell's comments—viewing *Adam's Rib* by means of an artful and self-conscious reading process—we are to understand that knowledge can come from watching ourselves derive meaning out of things that might otherwise *seem* to lack it. He argues that people, and not just philosophers, need to put the activity of the imagination at the center of considering what deserves attention. As we have seen, in Cavell's formulation, philosophy is motivated by a sense of lack or estrangement, a thought, by turns conscious and unconscious, that there is always more to be known about the world, about the self, and about others. What we do know points ever at what must be missing or incomplete.

What we need to add to Cavell's concept of reading is that the very process of attention enacted in reading—however broadly conceived—is itself a response that is shaped by subjective forces. The task becomes one of uncovering as best as possible what underwrites perceptions. Observing ourselves observing things, gauging our responses to events, and tracing the motions of our interpretations not only give us a sense of what we are interacting with but also reveal what processes fashion or produce how we respond. This formulation recalls the three interactions that Wollheim describes transpiring between one's "mental dispositions and [one's] mental states" and between and among "the conscious, preconscious, and unconscious, systems of [one's] mind," the interactions that stand at the heart of understanding life.[39] Interpretation, reading in the widest sense, is a form of understanding ourselves and tracing the thread of life through our relationships to things and objects. Looking at other things and other people, we see ourselves, looking. Criti-

cism and interpretation can make the tendencies of our own dispositions and the systems of the mind evident to ourselves. Questioning these things reveals the structural integrity of those relationships that form subjectivity in ethical, philosophical, and psychological terms. Art and philosophy, when focused on the everyday, can be the path back toward the things around us as possibilities for reflection.

Extending what Cavell's approach offers so as to include the idea that interpretation is itself an ongoing process thus offers a way of registering the intersection of subjectivity and materiality present in the most at-hand examples. By gaining some trust in the everyday and believing it worthy of and even susceptible to reflection, doubt, and examination, the intellectual possibilities available to people for thinking about fundamental questions only increase. The questions flow toward a central issue: one might ask, "What is the world to me, and what am I to what I call the world?" Experience is taken as a legible text that informs the terms of such questions and what answers they might deliver. Otherwise, means of thinking about the world remain "merely" academic or cordoned off from life as it is being lived and there would be no method of accessing much else. We might underline the root of the problem in this way: people become estranged from themselves when they have no way to think about themselves beyond the merely personal. In essence, thinking about "discovering the ordinary" and "living a life" are in many ways the same pursuit. Finding a language that can localize these efforts intellectually is not a sentimental or nostalgic Romanticism; it is an attempt to diversify the possibilities of what might count as knowledge. The proliferation of perspectives thickens the base by which and from which any sort of ethical, epistemological, and aesthetic decision might be made. We come to see that the world bears what we project onto it, and by tracing the ordinary, consciousness deepens because its insertion everywhere becomes evident. Cavell presents philosophy, or a philosophy awake to its own limitations, as a means to correct how the world might be experienced. In such a model of moral perfectionism, there exists the hope of progression toward some fully realized experience—even if that hope is always deferred. In the next chapter, I show that the everyday can resist being known and see what the threat of skepticism feels like. The threat and resistance is revealed and ironized in, of all things, a stand-up comic's routine.

Chapter 2

Something Completely Different

Steven Wright, Comedy, and the Uncanny Ordinary

> I know that the world I converse with in the city and in the farms, is not the
> world I think. I observe that difference, and shall observe it. One day,
> I shall know the value and law of this discrepance.
>
> —Ralph Waldo Emerson

If we are to talk about leading a life, it is important to find a way in, to discover a way of tuning into daily experiences. As I have already demonstrated, Cavell has shown the possibilities for thinking about ethics and skepticism that a movie can make available. Yet his focus on the structure of remarriage comedies also depends to a large extent on Northrop Frye's thinking about the conventions of Shakespearean romantic comedy.[1] Drawing on Frye, Cavell characterizes this dramatic mode as being built on the model of "a young pair overcoming individual and social obstacles to their happiness, figured as a concluding marriage that achieves individual and social reconciliations," with the innovation that occurs in the filmic iterations being that "the drive of its plot is not to get the central pair together, but to get them *back* together, together *again*."[2] We can see that within this model there is a hopeful response to skepticism in the ways that what is dramatized is the presence of obstacles that disrupt an ability to acknowledge otherness, or reveal that what had been an understanding of the Other, or reality, was merely delusional. The remarriage is thus the restoring of an order, but in a

transformative way. In essence, what changes is not the actual elements of that world depicted on-screen, but rather it is the relationships and understanding the people have of that world that have been altered. They have matured. The characters—and perhaps the characters represent the audience as well—learn that doubt and skepticism are to be negotiated and utilized, not, rather, denied or succumbed to.

As useful as the hope modeled by the remarriage comedies might be, and no matter how ultimately redemptive, there is value in exploring further the disorienting effects of skepticism's confrontation of the ordinary as well. This entails considering the rift itself rather than immediately moving toward transformation and redemption of that rift or schism between what we take to be the known and the unknowable that is, ultimately, self-reflexive. To move in the direction of these questions of estrangement and attention, I turn from Cavell's interest in remarriage comedies to, of all things, a consideration of the work of a stand-up comic, Steven Wright. I make this turn for many reasons, not the least of which is because comedy, in whatever its mode, often dislodges expectations through acts of recontextualization. Cavell's interest is in the narrative mode of comedy, whereas what we might call the local or even perhaps lyric mode of stand-up comedy can allow us another perspective on the moments of rift and disruption.

As most people recognize, the surprise of a joke can open our eyes to the absurdity of the commonplace. Comedy does not merely alienate or estrange, however, as the audience needs to remain in touch with what is being dislodged. Some of the wilder experiments of the surrealists do just that. Whenever the comedic goes too far afield, there is no longer a point of entry for the audience, and the funny merely becomes the bizarre. In those situations, there is not enough recognizable perspective to underscore the possibilities of a shared experience of the absurdity of the most familiar actions, objects, and ideas. As Freud himself noted, comedy needs an audience, which is why the company of others only adds to the pleasure of comedy.

Certain comic moments provide a unique perspective that summons the paradoxical from the familiar so as to throw into relief that which is generally taken for granted. We might say that comedy, at its best, can offer well-crafted thought experiments that operate on a variety of experiential levels and represent situations in such a way that we might observe them outside of reflexive or directive rationality. In what follows I concentrate not on what we might call wit, in regard to spontaneous jokes or conversational repartee,

but rather on the work of stand-up comedy. With its use of craft, structure, and subverted expectations, stand-up comedy draws on worldviews and can reveal additional possibilities of meaning in ways similar to any other form of art, even if its own methods and forms distinguish it from other forms, even other forms of comedy.[3] In roundabout ways, comedy provides an occasion for looking at perspectives built on expectations arising from how we think the world is. The comic's joke, made with an audience in mind, comes and one laughs, involuntarily, in excess of one's conscious intent. This interaction reveals a point of identification—the comedian knows how to make an audience laugh and the audience knows to laugh in such a context.[4] Intuition and those aesthetic responses provoked by comedy, signaled primarily in the form of laughter or smiling, can help guide thinking about experiences with concepts that define or redefine our relationship to objects or events. They look specifically at what we take for granted. Certain comic routines can provide forms of "creative reading" that do not transform what they discuss, but rather tune the attention so that multiple perspectives, the familiar as well as the new, can coexist. These flashes of insight on which comedy is built can open up observable moments for the issues I am raising because considering the ordinary entails revising our relationships and interactions with the everyday.

There are stylistic connections between certain forms of philosophy and certain kinds of stand-up comedy.[5] These connections are evident when stylistic elements are part of the experience that the thinkers are trying to generate. One long-held argument about why Heraclitus tended to be so hermetic in his aphoristic style is that he sought to present paradoxes in order to gather people's attention to the complexities of life as it is lived. Paradox, as an irresolvable condition that activates a desire to resolve its conflicts and contradictions, engenders reflection, thereby creating a possibility of investment. The investment takes the form of responses to the questions opened by paradox—a paradox much like the idea that what is most familiar is most mysterious. With this in mind, I turn to a stand-up comedian almost pre-Socratic in his terse delivery and his fascination with the usable paradoxes of the ordinary, Steven Wright.

Wright was born in 1955 and raised outside Boston. Discovered by a producer for *The Tonight Show* in 1982, he immediately stood out as a unique comic talent because of both his lack of affect and his reinvention of jokes and one-liners, as opposed to stories. Wright has cited George Carlin as an

early influence, but there is little evidence of that in his work, and Wright sounds nothing like any of his contemporaries (including such higher-profile figures as Jay Leno, Paul Reiser, and Jerry Seinfeld, all of whom were able to make a leap into television). Although there have been figures in the history of comedy who were masters of one-liners, comics such as Joan Rivers and Rodney Dangerfield, none before Wright had the swerve toward the surreal or absurd that is so characteristic of Wright's work. His first album, *I Have a Pony*, appeared in 1985 and was nominated for a Grammy, as was his second album, *I Still Have a Pony*, which was released in 2007. Although he won an Oscar for a short film he produced and made brief cameos in Quentin Tarantino's *Reservoir Dogs* and Oliver Stone's *Natural Born Killers*, it is the terse, austere style of his stand-up that has continued to make him so influential as a comedian. "I was Caesarean born. You can't really tell, although whenever I leave a house I go through the window," Wright says in a pithy but representative moment in his act.[6] Nevertheless, the existential irony as well as the linguistic turnabout that can produce conceptual shifts within the space of a sentence make Wright's comedic work, and his perspective, so distinctive. Peter Keepnews of the *New York Times* once described Wright's style as "Henny Youngman meets Samuel Beckett."[7] Wright is arguably as stone-faced as Buster Keaton, who of course starred in Samuel Beckett's *Film*.[8] The stoicism and limited emotional register offer little in his voice or body language to inform the audience where the change in perspective will occur, and never instruct viewers as to how they should feel about what he says. He also rarely gives evidence about how *he* feels about what he has said, and these effects are what allow for the possibilities of identification in that the audience has to be much more nuanced in their interpretive process in regard to what his jokes provide.

The facts of Wright's life are somewhat incidental to his work, in contrast to a comic such as Richard Pryor. Although Wright often uses the first-person singular, he rarely presents anything that reveals actual autobiography. One joke reveals the degree to which Wright is abstracted from the personal: "I got a postcard from my best friend, George. It was a satellite picture of the entire Earth. And on the back he wrote, 'Wish you were here.' "[9] This perspective resonates with the ways that Wright articulates a sense of estrangement from the world.

Rather than presenting longer narratives, Wright tells jokes and one-liners, and their humor is not at all straightforward. Instead, Wright's comic

observations are characterized by a paratactic series of statements and esoteric, even gnomic, insights. Consider an old bit from his stand-up routine that goes like this: "I've been doing a lot of painting lately. Abstract painting—extremely abstract. No brush, no canvas. I just think about it."[10] Those who know Wright's style will recognize the delivery: completely deadpan, monotone, and utterly surprising. Its economy is impressive and even disarming: "I went into a place to eat, it said, 'breakfast anytime.' So I ordered French toast during the Renaissance."[11] The form of this statement is impeccable and is a testament to the economy of his structure. The last word, "Renaissance," changes our understanding of everything that comes before. If one were to change any word in these two sentences the joke would not work. In that way, the joke works in much the same way as a poem, the meaning accrues by the way the sentences are constructed, with the last word providing a revelation that recontextualizes what we expected when we saw the phrase "any time." Such precise composition can lead us to think about form.

What comes before and after any given moment in Wright's act bears no immediate, logical connection to what follows; that is, his routines are not part of a larger narrative. The sentences move by juxtaposition. For those who do not know his work, it will need to be taken on faith that it is funny; and I am all too aware that writing in this way about his material I risk bleeding away its surprise, rendering it as anything but funny. The key here is not to explain its funniness, but to indicate what its funniness can reveal. The humor resonates because of what the lines reveal in a flash. What makes this comedy into a philosophical art is that it can reveal the "usable paradoxes" at the heart of ordinary experiences in surprising, insightful ways.

Take this example: "The first time I read the dictionary I thought it was a poem about everything."[12] To think the dictionary is a kind of poem seems funny at first—of course, it is supposed to seem that way. Because there may be something to what Wright says, the comedy is not derived from the audience feeling some sort of superiority to the comic.[13] The observation does not merely seem woefully slow. In fact, the premise starts to have broader implications the more one thinks about it. To think of the dictionary as a poem "about everything" can be quite a touching idea since the dictionary does include every word in a language, and, taken together, it does represent the world as we know it. The world of a dictionary is everything that is the case. What Wright does in his joke is to misapprehend that which is taken for

granted. Even though such substitution is a conventional comedic trope, in this moment Wright goes beyond mere confusion: he reads the dictionary as a work of art. In light of Wright's substitution, we might ask, what is a poem and what is a dictionary so that a dictionary could not be called a poem? This would require us to think of the definition of "dictionary," for which, ironically, we are tempted to turn to a dictionary to find a satisfying answer. And some dictionaries use examples drawn from other texts, including poems, to give a context for usage. The irony gets thicker the longer we think about this problem, which seems entirely apt given Wright's general tendencies to unsettle the most settled assumptions. Simply changing the conventions of genre that one brings to bear in reading the dictionary offers a transformed perspective that entails a different reading process. We can either come to see it as a poem or come to know better why it could not be.

Wright's joke asks the audience to *imagine* the dictionary as a poem. For a moment, the dictionary is transfigured. In essence, this transformation yields the following question: What would it mean if every word were part of a poem that constitutes the English language? It would mean that every word has a connotative meaning as well as a denotative meaning; it would mean that every word contributed to some larger meaning situated within its context that demands interpretation. That is indeed true of the words in the dictionary. To see the dictionary as a poem would be to reconceptualize each word as expressive, though it expresses not emotions—there is no single author or subjectivity guiding composition—but all the possibilities of meaning and naming inherent to the English language. In the Romantic tradition, poets are considered namers: "The poet is the sayer, the namer, and represents beauty," writes Emerson in his essay "The Poet," where he also insists, "Language is fossil poetry."[14] In that way, poets do categorize and provide taxonomies. Within Wright's "confusion" sits a latent allusion to poetic history. Dictionaries as well as poems are acts of naming.

Again, we might describe Wright's substitution as an act of creative reading. In fact, Wright's joke could be seen as a move that Marcel Duchamp might have made: the change of context forces us to ask questions about the arbitrariness of categories even as it helps us discover what we gain and lose through their imposed limitations. Indeed, if Wright said his lines about the dictionary being a poem in an art gallery or in a lecture hall, or if they were lines from an actual poem, we might give them their intellectual due. Just because he says what he says in a comedy club or theater does not

mean that the ideas need be any less evocative. In fact, his lines suggest the possibilities that might occur not only when we ask questions about the very things that usually seem beyond question but also when we interrogate our confusions and misprisions or confront those made by others. By asking us to explore what context offers and determines, Wright's joke shows how examining our confusions can reveal the way that those confusions are predicated by a priori distinctions, and often those distinctions are themselves never explored. If there were no distinctions, contexts could not be confused, misread, or misapplied. The blurring of distinctions in the joke as well as the fact that it provokes a response because of its absurdity (the estranging of a shared familiarity) reveals that by challenging the boundaries people are motivated to invest in distinctions or rules governing context and shows how, why, and when such things hold. The result, if we think of how Wright's joke illuminates the hiddenness of the everyday, yields a better sense of how and why we make categories at all. In the case of a dictionary, there needs to be a resource that provides a stable collection of definitions to which people can refer in order for there to be shared agreement of words' meanings maintained across regions and subcultures. Still, as Wright's joke can suggest, interpretation always occurs with words. It is not just that Wright's joke opens the recognition that the dictionary does not fix or stabilize language, or that words are always prone to interpretation, confusion, and slippage of meaning that makes this line so resonant. There is a link between words and meaning that is not easily determined by the utilitarian. There can be an aesthetic response to defining and categorizing the world that does not invent but, like a poem, relies on an increasing sensitivity or even literacy in regard to how we manipulate and negotiate names, meaning, and experience. The attempt to name and stabilize is akin to finding the language and form for a poem that articulates an experience but does not reduce it to mere description. It is, Wright reminds us, a poetic impulse to try to find a language for experience.

Before delving further into the implications of what Wright says, I want to be clear that the connection I am forging between his comedy and the philosophical issues I have been discussing is not wholly arbitrary. Wright first made a name for himself just when a boom in stand-up comedy was happening across the United States. Much of the comedy of that period was fairly conventional in tone and delivery, built out of observations of the sorts of things that happen to everyone: traffic, lost socks, and so forth.[15]

Jerry Seinfeld, now a household name, was one of the great lights to appear on the scene at this time, and in many ways his craft and delivery are the most representative examples of this period style of observational humor. Seinfeld and Jay Leno, another now-famous figure, were the most talented exemplars of this style of observational comedy.

These routines were built on observations of the commonplace events of people's lives and were amplified to absurd lengths. For example, in one of his early routines, Seinfeld describes how clothes sit at home in closets and drawers waiting, hoping every day to be picked out and worn by their owners. In the life of someone's clothes, a washing machine is a nightclub—the shirts, moving around, dancing with the underwear as if they were in a disco. It is easy to see the absurdity in Seinfeld's bit. Washing machines are not *really* nightclubs. The bit is filled, obviously, with hyperbole and anthropomorphism. Yet, within the edges of the joke, one recognizes that the clothes enact an all too familiar need to be loved, to be made to feel as if they have value and purpose to be desired, or perhaps more precisely said, hoping to be found by someone. The routine is funny exactly because clothes are not human beings, but it is the dissonance between their ontological reality and the human characteristics projected onto them that heightens that feeling of the absurd. What makes the bit in Seinfeld's routine so disarming is that the disposition and emotional need to be chosen, to be found desirable, are so widely recognizable. The response is laughter, but within that laughter is something more than a recognition of the ridiculous. There is the acknowledgment of how the absurd elicits the uncomfortably familiar and even intimate, *especially* if Seinfeld's lines are heard at a comedy club or in a theater. These places may not be discos, but they are where people go when they are on dates, and so those emotional needs are actually active in at least some members of the audience.

We might make this general claim about comedy: some comics describe the most average events and behaviors as they might appear to someone from some distant place—strange and incongruous. This characterization resonates with Wright's friend sending him the postcard with "wish you were here" written on it. Quite often that method results in the realization that what is taken in daily life as serious, if even noticed at all, really can come across as silly.[16] Yet, this generalization seems inadequate to every instance of comedy because within that lies the suggestion of superiority. We might make a finer distinction, however, in the effect of these changes that bears

with it a sense that the changed perspective has threat attached, specifically a threat to what we had believed to be the ways things are, or how we want them to be. Wright said in an interview, "Comedy is noticing things. All the jokes are from just noticing. And I think those philosophical things are from noticing the world. Like a heightened noticing part of my mind."[17] Familiarity and expectation are upended so that a new context widens possibilities of meaning, but we see in Wright's comments that a certain amount of self-consciousness comes with this. Yet, what I am suggesting is that at his or her best, a comic like Steven Wright can create a liminal context within which opens the possibility for insight into the nature of what we take for granted as well as what might sometimes be actively overlooked. This is what I mean by taking comedy seriously.

The same description of a comic who simply changes context to create humorous observations can be applied to Wright's comedy, but what differentiates Wright is his style. Seinfeld develops a premise, constantly adding to it, then offering transitions from one bit to another so that the audience is led along, but his replacement of terms is clear, yet temporary. We know what he is doing by allegorizing the clothes, and because of that the clothes never *completely* transform into something else in the imagination. They maintain their incongruity. Wright, however, is aphoristic and his "bits" are paratactic statements. He offers no transitions, and his style of delivery is unwaveringly monotonous; the oratorical neutrality forces the audience to put aside tone as a measure of personal subjectivity in order to focus on Wright's language and concepts. Noël Carroll has argued that jokes are essentially completed by the audience because the audience is required to provide the interpretive activities that make a given joke work.[18] The joke's structure predetermines the interpretation, but the audience still needs to provide that interpretation. In Wright's comedy, I argue, there is arguably less direction provided to the audience, despite his close attention to craft and structure: the economy of form. What is missing is the biographical material or the clear intentionality that emphasizes a primarily personal orientation. There is, of course, a persona in place with Wright's comedy, but the persona seeks to minimize itself with the artifice of no artifice. Because the lines are delivered so economically and the form so actively minimizes its ornamentation, Wright's audience is prompted to deal with the concepts themselves. Wright's recontextualizing of terms becomes evocative because the changed contexts require additional attention and a corresponding in-

vestment of imagination to determine their implications. These elements are what make it philosophical.

In an atypical extended bit that nevertheless showcases what is so distinctive about his material, Wright offers a slight sense of narrative while still layering paradoxes that provide philosophical and, perhaps specifically skeptical, insights. He relates that in high school, on some nights he and his girlfriend would go to the planetarium where he worked and lay out on the roof and look up at the stars. "It was like being in a galaxy sandwich," he says, adding, "I'd bring my harmonica, and I had a pair of glasses. I painted lines across the lenses so when I looked up at the sky, the stars would become notes on the lines and I'd play the sky. One time a shooting star went by. I almost broke my neck."[19] What is compelling about this bit is the various textures brought into play, as well as Wright's willingness to say things in a stand-up routine that are perhaps more poetic than funny, at least in a strict sense. In the first part of the routine, the audience would readily recognize the poignant irony of the young couple on the planetarium's roof looking at the night sky. One might be quick to see this in conventional Romantic terms with the teenagers wanting to experience nature and sublimity directly, rather than through the representations provided by the planetarium. The couple's actions seem to underscore the limitation of what human beings can do in regard to representing nature. This scene Wright offers would be a naive, even sentimental, Romanticism taken on its own, though presenting it as a trope is not something that is actually done in the bit. The text lets the audience make the interpretation. It implies a trope without actually offering one explicitly.

Wright then undercuts the Romanticism through a funny but somewhat awkward (funny *because* awkward) simile: "it was like being in a galaxy sandwich." Wright acknowledges being caught between the represented galaxy and the natural one, which only emphasizes the feeling of mortal finitude and limitation. In his simile, he also creates an incongruity by the juxtaposition of two words, "galaxy" and "sandwich." This phrase conflates the unimaginably vast with something homely, something that fits completely in the hand. Given that Wright is describing the feeling of being in a liminal state, between the artificial and the natural, between the interior representation of a night sky and the exterior night sky itself, we might read this not as an awkwardly made simile but rather as a simile made to convey the feeling of awkwardness. At the very least, the silliness of the phrase

"galaxy sandwich" cuts the treacle of the sentimentality, if it is indeed senti-mental. Moreover, that the structure of Wright's routine undercuts itself suggests a larger intentionality. In other words, we are, at some level, given permission to trust or "go with" the sentimental rather than dismiss it because clearly Wright is using it self-consciously.

From there, however, in the next moment, Wright offers a powerful and even haunting image of the stars as notes that can be played. Even there, however, Wright makes the instrument a harmonica, which as a word has a funny sound and seems not the most poetic of musical instruments to have at hand. Still, that trope reconfigures what came moments before. If we take the teenagers going to the roof as a sign that nature—the real thing—is su-perior to the artifice of what the planetarium offers, then Wright's glasses reverse that hierarchy, ultimately recontextualizing nature, particularly the stars, by placing it within a human order. The lenses of Wright's glasses translate the stars into music, perhaps slyly punning on the idea of the music of the spheres. In essence, we might see this as a human denial of the limita-tion and finitude invoked by being part of a "galaxy sandwich." Art, we might say, is one way that Wright can confront and transform the alienation and threat that the sublime engenders. Here, Wright has layered various types of art: the glasses make the stars into a visual pattern that he then reads as a musical language, and this all comes to us by way of a poetic trope. But once again, Wright undercuts the ambitions of the joke, demonstrating his own self-consciousness, which reinstates his human limitations. Rather than resting on the aesthetic pleasure of the glasses that change the stars into music, he interrupts that aesthetic pleasure with a punch line about the shooting star. In the last line, Wright's joke about nearly breaking his neck brings back to the fore the practical mechanisms if not the awkwardness of a harmonica, while at the same time taking the focus away from the stars and bringing it back to the limitations of the body. Ultimately, he cannot escape the prevail-ing sense of alienation and estrangement. Thus, beneath the humor of this routine is a clear pathos of trying to use human experience and art, specifi-cally, as a way to overcome the threat and constant persistence of human limitations. As a coda, Wright adds this final moment of estrangement: "I said, 'Lucinda, will you always love me?' She said, 'I doubt it. I don't even love you now.'" If the material that had preceded that moment was seen as being inflected by young, romantic love, it is revealed as ironic because that love does not actually exist. The track ends with Wright alienated from the

universe that he cannot control and, discovering that he was absolutely wrong in his understanding of the girl he thought loved him, estranged from someone he loves and trusts, but apparently does not really know.

As we saw with the joke about the dictionary or about ordering breakfast, Wright's process of misapprehension is actually a strategic misapplication of terms and conditions, and its recontextualization yields new or widened concepts of what is taken for granted by raising questions about what lies beneath the confusion. This displacement is at the core of some lines from his routine that I want to spend time discussing because so much of the idea of the uncanniness of the ordinary and the everyday inform them: "I got up the other day and everything in my apartment had been stolen and replaced with an exact replica."[20] What calls Wright's particular lines to mind—I have not forgotten them since I first heard his routine more than twenty-five years ago—is not the degree to which someone may or may not find these lines humorous, though the humor is its measure of an aesthetic worthiness. Wright is, after all, an influential and even canonical figure of contemporary comedy. Rather, if we take the bit about everything he owns being replaced, mysteriously, with an exact replica—if we take its funniness seriously, that is—the feeling state described in Wright's bit warrants thinking about its latent philosophical content because it is fraught with skeptical impulses in regard to one's experience of that which is closest to hand.

In Wright's bit, the claim generates this question: If everything has been replaced with an exact duplicate, and it happened while the speaker was presumably asleep, how would he know? That is the central problem of the joke: a dilemma of two different experiences of reality. Is what he experiences real or illusory? This is the fundamental question of skepticism. Even if we see these lines as merely funny, and therefore avoid putting pressure on them, the philosophical implications still might come up if we ask, *why* is it funny? Is it because Wright is ironically worrying about something that does not matter? Although it is definitely the case that Wright intends to be funny—that is his profession, after all—his intention does not necessarily limit how a listener might take what he says. What he says means more than he intends, and this capability is what makes art, even the art of comedy, so fecund. Such fecundity is not limited only to artistic expressions; art merely reveals that pervasive and latent potential everywhere. The rich possibilities lie within all uses of language. The context of art simply foregrounds language's capabilities.

Let us look from a variety of angles at the implications of the claims here in what Wright says. If there is no material distinction between what was stolen and its replacement, what difference would be made in the substitution? The problem here is a philosophical one. The pragmatist's response would be that it makes no difference, and we can move on. "What use would it be to worry about differences that make no difference?" a pragmatist would be inclined to ask. The pragmatist's question and its pointed impatience entail dismissing the validity of Wright's feelings as well as his claim.[21] That question hurries past the possibilities that could come from offering attention to cases where there are not strictly pragmatic or utilitarian ramifications. Any investigation into belief and the terms for understanding difference is swept aside.

To sidestep the nuances of dilemma that Wright's bit sets up, the dilemma within which any of his auditors become enmeshed, is to suppress and perhaps repress anxieties that might be something more than merely a cast of mind. The impulse to disregard what Wright says is a familiar one of the sort that anyone might encounter in dealing with a feeling one has but cannot quite explain, however real the feeling seems. Ignoring Wright's observations might be a missed opportunity for thinking about a person's subjectivity being enacted by its responses. In Wright's bit, he represents his own life as if he were other to it, both subject and object, caught someplace between avoidance and acknowledgment of what one might reveal to oneself in reading oneself as *Other.* As Freud contended, this condition of being both a subject and a self-reflexive object is ever present in the human psyche and constitutive of the unconscious. Often we work to deny that split of consciousness, creating a blindness where that denial exists. In literature, Oedipus and Lear, for example, are the most explicit figures of this self-inflicted blindness—both are incapable or unwilling to see themselves as others might. This blindness is what philosophy needs to address. Nietzsche, prefiguring Freud, insists, "So we are necessarily strangers to ourselves, we do not comprehend ourselves, we *have* to misunderstand ourselves, for us the law 'Each is furthest from himself' applies to all eternity—we are not 'men of knowledge' with respect to ourselves."[22] This self-reflexive estrangement creates a dislocating experience of just the sort that resonates throughout Wright's lines and is present even in the lines from the interview with Wright I cited earlier about comedy arising from a "heightened noticing

part of [his] mind." If that estrangement prompts people to try to discover the means for moving beyond the ego in some brief or necessarily limited capacity, that alienation can have a positive effect as a pedagogical force available to each of us in the world.

This separateness between perception and experience speaks to how Wright, in his feeling that everything he owns has been replaced with an exact replica, notes a shift in his immediate, local environment—a space that speaks to him and in a sense as him. His joke also provides a glimpse into the ways we can think about the import of our own response to what Wright notices in the sudden and indescribable change of his relationship to his surroundings. In any event, against what would be the pragmatist dismissal of the problem, the conversation about Wright's concern can continue in regard to the fact that Wright felt *some* difference between the originals and the replicas. To dismiss his concern is to miss the insistence of Wright's anxiety and what it could come to indicate about real ontological and experiential situations in terms of the ordinary. Wright's own things suddenly feel strange to him, despite that there is nothing apodictically different about them; he is at odds with his experience of his things because something has created a dissonance between him and his belongings. He seems not to be able to say what that difference is, and cannot arrive at it rationally. We might then think about what his feelings suggest in terms of his stance toward the objects and what he takes to be their more or less tentative ontological status. Consider, therefore, what Wright, however indirectly, implies about the possibility that there is an aspect of the ordinary that is nothing less than uncanny, that the familiar can in fact feel strange in its sudden possibility for otherness. We can think about the occasion for engagement that Wright's bit affords us: the things in Wright's apartment are not what they are, or were—they are now duplicates, substitutions—despite that in every empirical way, they are the same as what they replaced.

One could dispense with the problem by saying that Wright is simply deluded, but that would be to deny the implications of what he feels and to overlook the familiarity that the audience's laughter signals. Indeed, if his words are just the ravings of a madman, no one would be likely to find what he says funny; the audience would feel, at best, uncomfortable, or at least annoyed that they paid money to see a crazy person rambling. The fact that at some level the experience he describes of the comfortably familiar being also

incomprehensible is one that is emotionally recognizable by the audience. His routine describes the feeling that we cannot be certain about anything, even our own things.

Skepticism is brought to haunt Wright's lines even if one asks, "how do we know it (the theft/substitution) was not just a dream that *felt* real and the feeling continues because whatever initiated that feeling is taken to be real, although it is nothing more than illusion?" We could imagine, for instance, Descartes posing just such a challenge as a heckler in the audience. But the skepticism in such an understandable response is matched by Wright's skepticism that what seem like his belongings are not in fact his belongings. It is not that the things are not his to own as possessions, but rather something about these replica-objects points at the distance between the things and his experience of them, between what they were before he went to sleep and what they were when he awoke. We do not need to decide between skepticisms, as Wright's triggers an interrogation of what we take as certain while at the same time raising questions about how we settle our doubts. The paradox is this: if we attend to our feelings, we could be misled by our own psychology. Yet if we hew strictly to rationalism and empiricism, we become estranged from what feelings and intuitions can tell us about our relationship to the world.

This experience of skepticism is different from that identified by Cavell as being intrinsic to film, which I discussed in the previous chapter. Wright's routine is closer to literature than film, so the audience is not in the position of doubting the very things that it is witnessing. Although he does not specifically use the phrase "interpretive environment," that is what Cavell describes in terms of what the film audience responds to. Instead of this environmental experience, in Wright's routine, an audience wrestles with what Wollheim would describe as the "thought-content" of Wright's lines, but this content too is significant even if it does not produce a general condition of comedy.[23] The recognizability of the thought-content can, however, establish an encounter with a subjectivity that is both familiar and yet alienated, and this is the very state that Wright's lines are trying to express. Their form, thus, is their content and is part of the modernist form that Cavell finds to be an essential aspect of cinema as well.

The problem that Wright poses to us calls to mind a footnote in the second edition of Kant's first *Critique* about what the philosopher refers to as a "scandal of philosophy." Kant writes, "It always remains a scandal of phi-

losophy and universal human reason that the existence of things outside us (from which we after all get the whole matter for our cognitions, even for our inner sense) should have to be assumed merely on faith, and that if it occurs to anyone to doubt it, we should be unable to answer him with a satisfactory proof."[24] Is not this "scandal" where we arrive at with Wright's example? It describes the fear that on any given morning we will not wake up in the same place that we went to sleep, that we will not be the same people on waking as we were when we went to sleep. This premise of sudden change is at the heart of too many horror movies (from *Rosemary's Baby* to *Invasion of the Body Snatchers* to *Get Out*) to deny that the fear exists. It is indeed pervasive. One need not be Gregor Samsa to recognize that. The possible responses to that fear and to what rests on that scandal of philosophy give one the opportunity to discover where justifications eventually might come to an end and where an investment in a given belief system begins rests on what some might call faith. Yet those limitations mean the anxiety is never settled; it is only negotiated. How one chooses to respond to the fear is a recognition that one takes responsibility for the belief system one chooses.

The lines of Wright's that I am discussing also have what is known as a "tag," that is, a twist that follows a punch line and is attached to the same premise in a comedian's routine. Wright takes the bit one step further with a tag that anticipates this idea of responsibility and recognition and its possible impossibility. "I called my friend and I said, 'look at this stuff, it's all an exact replica; what do you think?'" The friend replies, "Do I know you?" In part, this is funny because it ironically articulates the possibility of a deep despair born out of unchecked skepticism. The irony arises from the unexpectedness of the friend's question, which points out how things are even worse (or stranger, anyway) than imagined. The despair encompasses an underlying insecurity that not only our things but also the very people we know might vanish at any moment, transformed into something wholly apart from our understanding. This neurotic concern reflects a repressed anxiety that things are not what they seem, or—no less disturbing a possibility— that we ourselves are not able to see correctly or judge or make sense of what we experience.

The anxiety of such a realization that modulates by degrees into dread and even what could be called horror, if horror is one response to incomprehensibility, is also part of Steven Wright's discovery about his home suddenly not being what it seems to be. Where he should feel safest—his home—is

shown to be a site of confusion and uncertainty. Yet, the dread or anxiety is balanced by the flatness of Wright's delivery. His affect does not change. In fact, he does not say what his response to the friend is. Indeed, some of the humor comes from the realization that if what Wright says is true, even if only in terms of his own experience, why is he not more worried? Because Wright does not state or even really show his emotional response, the listener must supply one. In so doing, the audience member's response is more than sympathetic or empathetic; it is a form of identification. The neutrality of his affect provides a foil for how any audience member might feel. Audience members contrast that flatness with how they each imagine any of them would feel in that situation. They become readers of their own affect by imagining matching to the stimulus those responses they each believe would be most apt in such a situation. The audience must imagine themselves in that situation, and in that way enter into a powerful identification with someone else, deepening the possibilities of recognizing the experience as their own. At the same time, Wright's neutrality, taken as Heraclitean stoicism, can signal that such a feeling of the uncanny is not new but is, in fact, ordinary, a fact that the audience also has to reckon with. Their laughter performs an acknowledgment of the incomprehensible, an acknowledgment paralleling the acceptance demonstrated by Wright's neutral demeanor.

The exchange between Wright and the person he turns to for legitimation occurs over the phone and, so to speak, the call fails. In a sense, the connection is incomplete or broken. There is no discernible measure for how Wright might be so different that the friend would not know him, other than his friend's lack of recognition. This suggests that, metaphorically, the friend cannot hear Wright; it is as if they speak a different language. To extend this idea, we might look at a key word here, "friend." The person on the other end of the line is not a friend in the usual sense of the word. The issue, then, is how to account for the distance between Wright and this other person. He cannot be counted as a friend, because either he or Wright has been transformed. In the space of the exchange, the person on the other end of the line becomes someone other than who he was. He begins the dialogue as a "friend," but by the end of his response has become a stranger when he asks if he knows Wright. Either Wright applied the word "friend" incorrectly or something occurred that changed the person's condition from friend to stranger. No matter what, the audience experiences that transformation just as Wright does. The realization that this person is not who we

thought he was occurs to the audience at the same moment it does to Wright—when the person asks, "Do I know you?" It is worth mentioning that Wright's bit ends with a silence following the friend's question, as if there is nothing more that could be said after that—or as if there is nothing that could be heard, given the gap between Wright and his interlocutor. Indeed, the next bit, coming after a long moment in which Wright does not say anything at all, is this: "It's a small world, but I wouldn't want to paint it." Although this observation is a big leap from what Wright had been talking about, even this bit describes a world defined by its limits; yet even within those limits the world's perspective is too big to be able to imagine it all fully.

I want to return to the broken communication between Wright and the friend. The friend does not recognize Wright and, quite likely, cannot understand what Wright says about the theft and the replicas. The response is "Do I know you?" and so the issue is what it means to know someone. If Wright said, in the most colloquial sense of how to respond to such a question, "Yes, you know me. I'm Steven, your friend," would that somehow change anything for the other person? Most likely it would not, because the question is not one that would be asked of a friend. The person Wright calls asks a question that indicates no kind of recognition; he does not ask, "Who is this?" which implies that the possibility of recognition exists, once the person identifies himself or herself. The response that this person gives, at once tinged by what any of us might take as a confrontational tone, indicates the called person does not even recognize Wright's gestures of intimacy.

It is as if Wright and his interlocutor no longer share the same *Lebensform*, which is another way that the friend is no longer a friend. Wright's friend cannot know Wright because they are speaking what amounts to different languages, since the context and the references are too disjunctive for each other. Even in their exchange they are out of sync with each other. Wright stands outside the *Lebensform* he had presumed was his own. Perhaps this is the same friend who had sent the postcard "Wish you were here."

The audience, however, is a community that can make sense of Wright's discourse. They recognize Wright; they can tell what he is saying even when his delivery is markedly free of affect. Aware that Wright is on stage, the audience takes his language differently than it might if someone in "real life" rang up and said the very thing Wright does.[25] Having been initiated into Wright's way of thinking and speaking, along with the fact that it occurs on stage—and thus is neither, strictly speaking, communicative nor

utilitarian—the audience has a different understanding of how he is using language than the friend has.[26] They are part of the language game. The audience can *recognize* Wright even if what he says generates in them a series of questions that bear on how we determine experience and validate belief. The laughter offered by the audience in response to Wright's bit is a measure of the limits of accommodation. They laugh because the situation does not direct them toward an expected or programmed response. They laugh because they do not know what else to do in the face of the disrupted expectations. Though the laughter does not foreclose accommodation as an option eventually, we might take the laughter as a way of also expressing the degree to which the audience, collectively, acknowledges and expresses those limits to Wright himself as well as, perhaps more importantly, to one another.

Freud, in "Humor," an essay published in 1927, states that for humor to exist, the comic (*der Humorist*) and the audience must have a special relationship. In seeing or hearing the comedian's routine, the viewer experiences a process of identification. According to Freud, the viewer encounters the comedian "in a situation which leads him to expect that [the comedian] will produce evidence of affect: he will become angry, complain, express pain, become alarmed, be horrified, perhaps despair of himself, and the viewer/listener is prepared to follow him, to allow the same emotions to arise. This emotional preparedness is frustrated, however; the other expresses no affect, but rather makes a joke. Out of the saved expenditure of feeling comes the comic pleasure for the audience."[27] In the case of stand-up comedy, a comedian on a stage (or via a recording) offers the description of a given event or observation to an audience. In effect, according to Freud, the comedian articulates a feeling that the audience not only can identify with but can actually start to experience. Instead of succumbing to the dictates of the emotion, the comedian controls the emotions, and thus the experience itself, with humor: the comedian transforms the experience into humor, mastering the way that he or she relates to what happens, making it into a text/aesthetic experience created for others' perception.[28] Just as the audience identify with the premise, so too can they echo the processes of mastering the emotions and asserting the ego over adverse circumstances in their own minds as well. Freud described this as a triumph of the ego over an all too pathological compulsion for suffering.

In thinking about Wright, we can see his comedy as response to the suffering brought about as a feeling of alienation and an inability to acknowl-

edge or be acknowledged, which we saw in the previous chapter as being a core component of the skeptical condition. He first acknowledges it and then transforms it. Rather than dictating the transformation, however, Wright lets the context transform the feeling of alienation, just as he transformed the stars using his painted glasses. Acknowledgment is what is at stake in Wright's bit, and his routine reveals two possibilities of recognition: total lack (as in the case of Wright's friend) or a tenuous accommodation (in the recognition of distance signaled by the audience's laughter). Wright cannot accommodate the things in his home with how he feels and he seeks some acknowledgment of the validity of his feelings. The person he calls does not grant that validation, though in not acknowledging Wright the question the other person asks ("Do I know you?") verifies Wright's sense that he is out of phase with what he thinks he knows. Acknowledgment is a double proposition in that not only is there a person in need of having his situation recognized by others (and whatever failures or successes that might go along with that) but there is also the corresponding obligation of that person to acknowledge himself to others. Wright wants to be acknowledged, but in doing so needs to take the reality suggested by his feelings seriously and accept it. This structure of acknowledgment requires attempts to make oneself, one's experiences, one's ordinary, known to others by first learning them for oneself. To express oneself—and expression needs conscious intent—one must come to know oneself.

In large part, varying degrees of recognition and misunderstanding are always unavoidable between and among people.[29] As Wright's bit indicates, the structure of these groups is not stable, because noticeable gaps in understanding continually open up in any exchange, the more pressure one puts on words and phrases in the pursuit of complete communication. Yet, that completion is never achieved. Even the form of the dialogue between Wright and his friend suggests this chagrin about the imprecision of language use. Wright asks the friend what he thinks and the friend asks a question that is not a direct reply to Wright's question but that seeks information necessary for context, as if to say, "How can I say what I think about your experience if I don't know who *you* are?" What the friend is thinking may very well be the question he asks (e.g., Wright: "What do you think?" Friend: "What I am thinking is, 'do I know you?'"), and he is therefore demonstrating his confusion rather than trying to solicit the questioner's identity. If that is the case, he cannot accommodate Wright or his experience because knowing

someone entails knowing something about how they communicate and express themselves. As a stranger, Wright's ordinary (and all it includes) does not immediately share in the ordinary that belongs to his friend, and what results is a condition of estrangement, an estrangement born out of the fact that Wright already feels estranged from his own home. Yet, we are not left with a sense that language always fails and people are always marooned in their own subjective experiences. With the audience's complex response indicating simultaneously difference and similarity, the audience acknowledge Wright through their laughter and their ability to recognize his feeling of estrangement through the process of identification that I have already described.

It is important that the experience Wright describes—feeling as though everything has been replaced with an exact replica—occurs at his home rather than the workplace or some other space. We might say, then, in returning to the text of his comedic routine, that Wright's dislocation conjures a sense of the uncanny. In Freud's terms, the uncanny, the return of the repressed familiar, the double that is intimate but estranged and made alien, is apt to disrupt that rational ordering of consciousness that results in repression. Although Freud does not say it in quite this way, the uncanny is the inversion of the familiar. The destabilizing return of repressed materials marks the uncanny.

The lines from Wright that I have been focusing on begin with his feeling that his home is not his home, as everything has been replaced with an exact replica. This feeling that home is both familiar and mysterious is a central aspect of the uncanny. Freud and numerous commentators have thought carefully about the fact that the *Unheimlich*—in English, "the uncanny"—means more literally the "un-homely." In German, the word *Heim* (or "home") remains present in the term for the uncanny while always being negated by the use of the prefix *un*—one cannot forget that the homely is transfigured and struck out, continually, because the text presents it. After he assembles an extensive series of extracts in his essay, Freud notes an inherent tension in the term *heimlich* that pits the word against itself. Because *heimlich* can refer as much to *home* (*Heim*) as it does to *secret* (*Geheimnis*), "we are reminded that the word *heimlich* is not unambiguous, but belongs to two sets of ideas, which without being contradictory are yet very different: on the one hand, it means that which is familiar and congenial, and on the other, that which is concealed and kept out of sight."[30] What we can

make of this tension, its doubled and doubling—troubled and troubling—proposition is that the familiar, the ordinary, is always at some level a secret. It is kept at an emotional distance, even though or perhaps *because* it is always at hand, always around us.

Cavell suggests that since philosophy represses everyday language and ordinary experiences through its skepticism about the ordinary, these too can come back in a variation of the return of the repressed and in that way the ordinary carries a vague degree of anxiety. He insists, "The uncanniness of the ordinary is epitomized by the possibility or threat of what philosophy has called skepticism, understood . . . as the capacity, even desire, of ordinary language to repudiate itself, specifically to repudiate its power to word the world, to apply to the things we have in common, or to pass them by."[31] The intertwining of skepticism and the uncanny reveals an anxiety that the ordinary is outside of attention precisely because it *might* reveal that it is not what we take it to be: stable, consistent, reassuring. If we define ourselves in relationship to the ordinary, and the ordinary is not certain, then we might not be who we think we are either, and the ground gives way. It could be argued that we cannot live with a constant state of fear that everything could disappear or radically transform from one moment to the next. Our minds simply could not maintain that degree of tension. It may be so, but tuning out latent paradoxes of the ordinary means we never have to question it or test it, which contributes to a willed forgetting or repression of the everyday.

Nicholas Royle, in his book-length study on the uncanny, characterizes it in useful terms—useful in that they allow for some crucial distinctions to be drawn. He writes: "The uncanny has to do with the sense of a secret encounter: it is perhaps inseparable from an apprehension, however fleeting, of something that should have remained secret and hidden but has come to light. But it is not 'out there,' in any simple sense: as a crisis of the proper and natural, it disturbs any straightforward sense of what is inside and what is outside. The uncanny has to do with a strangeness of framing and borders, an experience of liminality. It may be that the uncanny is a feeling that happens only to oneself, within oneself, but it is never one's 'own': its meaning or significance may have to do, most of all, with what is not oneself, with others, with the world 'itself.'"[32] In Royle's description, the uncanny is an interior feeling of instability about one's relationship to other people and to the world. While Freud locates that feeling in psychological states, Cavell suggests that the potential for disrupting foundational relationships between

self and others and between self and the world is philosophical as well. As part of the way we conceptualize, that potential for disruption exists as part of our understanding of ordinary experiences as well as in the very language of the everyday. The secret encounter Royle describes suggests that we are strangers not only to the world but to ourselves as well. The repression or denial of that strangeness is what makes certain aspects of the self secret, primarily, if not completely, to ourselves. Repudiating the feeling that something is indeed wrong itself becomes a form of repression. What is also denied is that the ordinary is not ever wholly recognizable. The uncanniness of the ordinary is just the sort of remove—known and intimate, yet strange and alien—that Wright seems to be describing. The uncanny ordinary brings together these conditions of repression in philosophy, psychology, and language that are always under threat of breaking down and revealing what has been denied, dismissed, or missed.

Ted Cohen, one of the most compelling philosophers of humor, has asked why it is that in the face of jokes that employ implausibility, absurdity, or contradiction, one is given to laughter. "An absurdity," he theorizes, "can be an example, a symbol, or even, say, an emblem of *incomprehensibility*. To laugh at an incomprehensibility can be an acceptance of incomprehensibility. An incomprehensible thing is unsettling. It can be terrifying, but it need not be—not if one can accept it, acknowledge it, live with it."[33] The type of joke Cohen describes locates the incomprehensible (that which demands interpretation and is not exhausted by it) lurking in the everyday, and evokes laughter as a form of acknowledging and accepting incomprehensibility. This idea of acknowledging the incomprehensible also echoes Cavell's thinking about the repression of the ordinary while also recalling Freud's characterizing humor as a means of protecting the ego against an intractable, otherwise inassimilable reality. The laughter disarms the threat of the incomprehensible. This space of incomprehensibility is where Wright's comedy brings his audience. The lines are resonant with the kind of acknowledgment of the incomprehensible that Cohen so eloquently describes in regard to experiencing the absurd. Wright shows that this ordinary uncanniness can be unsettling, and the fact that no amount of analysis and critical interrogation can finally explain what makes Wright's work funny indicates that his routine about the uncanny maintains its ability to resist attempts to make the incomprehensible rational. Like Cavell's remarriage comedies, Wright's routines show that this can be unsettling in every sense of the word,

but only through that unsettling can we lay claim to our responses and become aware of them. Jonathan Miller, himself a former comedian (as well as a theater director and neurologist), holds the idea that "in all procedures of life there are rules of thumb which enable us to go on to 'automatic pilot,'" but humor "rejuvenates our sense of what these everyday categories are," and this "restores us to the more versatile versions of ourselves."[34] The everyday is not dismantled, but its mechanisms are brought back to our active consciousness. We become pilots again, not autopilots.

In the previous chapter, we explored Wollheim's idea that the leading of a life entails attempting to understand life as a set of interactions we forge out of a dynamic, rather than static, sense of subjectivity. Such understanding takes effort and is arrived at through careful attention to our responses to our own experiences. Among these experiences are the most everyday happenings, yet even these are shot through with a wealth of meanings. Every word, were we to put pressure on each one, could chagrin us or others, but that pressure of constant interpretation would be to acknowledge that ordinary language and everyday living are as full of meaning and intensity and response as any work of art. In dislodging our expectations and inverting context, comedy can enable a person to see his or her own reactions with fresh eyes and to wonder why certain aesthetic responses are called forth. This wondering is no small thing, for those things that call us to active, engaged, and self-conscious attention provide the means of broadening our sense of experience. Actively engaging even the things we take as the most ordinary increases our capacity for an openness and versatility that undercuts the repression and skepticism that Cavell and Freud describe as being so ever present. Wright's comedy, as he notes, is about paying attention to how the mind notices everyday things, ordinary words. Whatever we are exposed to becomes a part of us, and an attention to everyday language and ordinary experiences analogous to how we read texts and art expands that receptivity. Indeed, the next step is looking at such things in the way that artists, writers, and comedians do. This is what it means to be a creative reader.

Art, film, comedy, literature, and philosophy are themselves acts of attention turned onto the world. These occasions can happen anywhere or anytime that we use language or try to understand an experience, but in art or philosophy we are given permission (or take responsibility) for interpreting as a way of determining the conditions for meaningfulness. These forms of

engagement also represent, but they "represent" in the sense that they present the makers' experiences of experience to themselves and to others. The interpretations spurred on by things, people, and language itself are guided by ideas and feelings, and interpretations require us to pay attention not only to subjects of regard but to the relationships based on an understanding of how the self stands in evolving relationships to others. The everyday domain does not change, but our attention does. To come to know the ordinary is to change our relationship to it, and then begins a new state of self-consciousness. The paradox of the ordinary is that our relationship to it changes the more we pay attention to it. It cannot show us ourselves as we are in everyday contexts. By paying attention to the values, beliefs, and understandings that are knit together and manifested in such works, the viewer or auditor experiences the quickening of his or her own attention and a deepening of perceptions because the viewer is tasked with interpreting interpretations of experience. Every experience begets another experience.

How optimistic this sounds, yet without such hope, hope born out of possibilities for responding and learning from our patterns of response, what are we left with? These acts of attention enact an open dialogue with the world that flows in and from our still deliberate and endlessly deliberated lives.

Chapter 3

HOW TO DWELL

John Ashbery and the Poetics of the Ordinary

As we have seen in the discussions of Fairfield Porter and painting, Stanley Cavell and the cinematic experience of remarriage comedies, and Steven Wright's one-liners, art, in its various forms, when it turns its attention to our everyday domain, can offer a fraught condition of skepticism and belief, frustration and revelation. This condition is analogous to a subjectivity that longs to discover itself in community, through exchange with materials and with people, but yet is threatened by the conformity that lurks within such a desire. A work of art brings forth a world that is new yet is also recognizable—able to be thought through once again—constructed as it is of all the ideas and ideals possible to anyone, a world that we have come to live within, yet often feel outside of. In its encounter with the everyday, art can forge, out of a process of understanding and imagination, a relationship to those materials that people work with in building concepts out of perceptions, so through that relationship we can trace how these materials work on us. Such work that art performs draws close all the elements that, gathered together, constitute the world. As we saw in Porter's discussion of Alex

Katz, "the manifestation of an integral spiritual whole" comes from the activity of attending to the various parts, and art attempts to hold these together. The problem, however, is that in its transfiguration art threatens to keep the meaningfulness of the ordinary at a distance, as if the only way that the everyday could have meaning is if it were not what it is. As Porter writes in a letter already cited, "Order seems to come from searching for disorder, and awkwardness from searching for harmony or likeness, or the following of a system. The truest order is what you already find there, or that will be given if you don't try for it. When you arrange, you fail." The paradox? That the hope that the world could be otherwise might actually be a denial of what it *is*, in its refulgent, its recondite specificity.

Because the ordinary does keep slipping out of grasp, it requires a multitude of approaches to bring it into the field of daily attention. The work of art becomes the shape of attention, which is what the poet John Ashbery said of Porter's own realist painting, describing it as a form of realism that is full of abstraction. In many ways, Ashbery, who spent decades as an art writer, is a collage artist himself, and as a poet he illuminates the various ways we use language to encounter the world that we experience.[1] His work does this in such a way that the poem becomes an experience for other readers as well. An Ashbery poem does not represent the ordinary as if the relationship to the everyday can be untroubled and immediate, but, like Steven Wright or like cinema itself, makes the pathos of that encounter a manifest part of the experience. The difference between the poem, the joke, and the film is that the poem foregrounds language as the very way that we conceptualize our experiences. The poem seeks to bring our attention to the most everyday thing of all: words. To return to Wollheim's sense that we need to understand our lives, we need to have some understanding of language's role in representing our experiences to ourselves and to others.

In an interview with the poet and editor A. Poulin Jr., Ashbery indicates that the difference between painting and poetry is that a poem presents "what's there" as well as "everything that isn't there," yet a painting offers only what is there. When pressed to say more about this, Ashbery explains, "Words suggest other words, the thoughts other thoughts, and when one starts to think about it the whole thing expands out of the frame in a way that a painting can't once it's pinned down and drawn and painted. I guess that is because the poem is not a visual thing, but something that's going on in one's head, coming in contact with all kinds of other things, remembered

experiences, words that one heard used in a different context than that in which they're occurring in the poem."[2] This sounds uncannily like what Wright said is the essence of his philosophical comedy, that his jokes come from "a heightened noticing part of [his] mind." It also seems to echo Wollheim's contention that "the core of this process [of leading a life] is to be found in three characteristic interactions: one, between the person's past and his present, and between his present and his future; two, between his mental dispositions and his mental states; and, three, between the conscious, preconscious, and unconscious, systems of his mind." The sympathetic resonances among these bring home my insistence throughout this book that living life as an artist does, that is, seeing everything as bearing meaningfulness and then trying to represent that meaningfulness, is a way to respond to the alienation of the ordinary that we might otherwise call skepticism.

Given that, at some level, lyric poetry is always dealing with the warp and woof of language, its register and measure, the poet, as a kind of exemplar for activating all the potential for meaning that Ashbery describes, impacts how we might think of language and the work it does in making a world available, or in making a self available to a world beyond the self. The ways that poetry, at its best, brings words self-reflexively into their multiplicitous range of possible meanings not only enact possibility but also open up language to readings that were otherwise closed off, thereby making apparent one's limitations in how one considers a word to mean.[3] By tropes and references, and with words vivified through surprise and the unexpected, poetry depends on the potential of language to say more than it is thought to say, to carry or enact meanings that reveal lost or unanticipated complexities in excess of what one intends is realized. In other words, and as Ashbery's comments suggest, a poem reimagines ordinary language and becomes like a moment of conversation with another who, insightfully, has discovered limitations that had been hidden in plain sight. As we will see, Ashbery sees that the fullness of meaning that happens in poetic language is just as likely to happen in ordinary language as well.

It is hard to think of a contemporary American poet who is more celebrated and honored than John Ashbery. Beyond the countless awards and the stream of critical responses, beginning with the publication in 1956 of his first book, *Some Trees*, Ashbery's work has directly influenced generations of poets. Harold Bloom, the contemporary expert on the question of poetic influence, has declared, "Since the death of Wallace Stevens in 1955,

we have been in the age of Ashbery."[4] Ashbery's primacy is a given. If this is "the age of Ashbery," then what does his work say to our everyday domain? What does Ashbery's work *do* in terms of representing its aesthetic moment and our general cultural present tense? What does it make possible? If art is one way that a culture shows itself to itself, what does Ashbery's art show us?

Everyday experience is a crucial part of Ashbery's poetics. In an interview with the poet and philosopher John Koethe, Ashbery explained why there is so often a comic dimension to his poems: "I include humor just as I include somberness and tragedy and sex and whatever else, just because it's something that crops up every day and you should try to make your poem as representative as possible."[5] Although I discuss not the humor but rather the loneliness and skepticism available in Ashbery's work, this comment by the poet establishes a crucial element of his poetics. A poem should be, according to Ashbery's statement, composed of all the elements and textures of daily life: the poem stands for the everyday. Yet, we could also see his meaning of "representative" in another sense as well. Elsewhere, Ashbery characterizes his poetics by way of a democratic inclusivity: "My idea is to democratize all forms of expression, an idea which comes to me from afar, perhaps from Whitman's *Democratic Vistas*—the idea that both the most demotic and the most elegant forms of expression deserve equally to be taken into account."[6] In such a way, the work ideally goes beyond the personal, and the language acts of the poem express a sense of a larger constituency. In his emphasis on the everyday, Ashbery reminds us that everyday language is available to all, and Ashbery has a sense that all words have the same potential poetic expressiveness. For this reason, the language of his poems—from the pop culture references of "Daffy Duck in Hollywood" to the high literary mode of "And *Ut Pictura Poesis* Is Her Name"—is drawn from all quarters of cultural experience. Roger Gilbert, in an essay investigating the interchange of play and profundity in Ashbery's recent work, remarks, "Eloquence may not be the first quality that comes to mind when we think of Ashbery, but for many readers his greatest gift has always been his ability to give voice to our most elusive apprehensions with a grace and precision unmatched in contemporary literature."[7] Thus, to think about Ashbery's poems is to ask how they represent the everyday as a shared experience, how they "give voice to our most elusive apprehensions," rather than to hold up the poet himself as an exceptional thinker.

Despite Ashbery's comments about his poetics being based on the idea that his experiences are representative rather than exceptional, people have noted the difficulty of Ashbery's poems. The poems' alleged opacity would seem to counter the idea that they can speak to and for a wide spectrum of people and their experiences.[8] It may be that such difficulty is part of what it takes to be representative, especially if that representation has a more complex sense of what representation entails. It would mean that being representative means going beyond mere mimesis and entails a combination of the real and the abstract, which is closer to the kind of "realism" that Porter describes in his reading of Alex Katz that I discussed in the introduction.[9] What I propose is to take seriously the oft-repeated proposition that Ashbery's work is difficult and ask what that difficulty amounts to in the largest possible terms. Language, as poetry shows, is not the way of narrowing complexity that is an intrinsic aspect of language use, but is part of the reason for that complexity. For insight into difficulty, we might first look to see how Ashbery explores the topic in regard to one of his forebears and sees that complexity *is* actually a form of realism that represents the world as a kaleidoscopic set of experiences and understandings.

In a review published in *Poetry* in 1957 titled "The Impossible," Ashbery describes the work of Gertrude Stein—specifically *Stanzas in Meditation*, a book-length poem that is one of her most daunting works—in a way that offers insight into his own work and the value of textual difficulty. He writes, "Like people, Miss Stein's lines are comforting or annoying or brilliant or tedious. Like people, they sometimes make no sense and sometimes make perfect sense or they stop short in the middle of a sentence and wander away, leaving us alone for a while in the physical world, that collection of thoughts, flowers, weather, and proper names. And, just as with people, there is no real escape from them: one feels that if one were to close the book one would shortly re-encounter the *Stanzas* in life, under another guise."[10] Ashbery's analogy offers an important way of thinking about Stein's text in terms of representation (or being representative) and complexity that he utilizes as a way to introduce her book to what turned out to be a resistant public. The insights he offers into reading Stein suggest ways we might read Ashbery's own work, for there are clear indications that Ashbery is sympathetic to the specific effects of difficulties that are so characteristic of Stein's texts.[11]

Stanzas in Meditation appeared posthumously from Yale University Press in the 1950s, but the typescript dates back to the 1930s. In the early 1990s,

Ulla Dydo, the preeminent Stein textual scholar, offered this context for Stein's text: "The stanzas must be read as word constructions, not as concealed pieces of autobiography. Their impulse is not to tell stories or to explain but to meditate upon what she perceived and, as she said, to achieve in their disembodied form an 'exactitude of abstract thought.'"[12] As Dydo indicates, echoing Ashbery's characterization of his own poetics, Stein's words draw on associations that already exist in the reader's mind or experience but are not dependent on some larger determining narrative supplied by the author's text. Narrative does sometimes appear in sections of *Stanzas in Meditation*, as in the following section Ashbery quotes in his essay.

> He came early in the morning.
> He thought they needed comfort
> Which they did
> And he gave them an assurance
> That it would be all as well
> As indeed were it
> Not to have it needed at any time[13]

Something clearly is happening, we just do not know—and cannot really know—the particular referents; the "he" and the "they" and the "it" and the "all" are plucked from some situation in which presumably someone knows who these pronouns attach to. As throughout the poem, there may be some order in place, but that order is not a given: one could call the poem an order of orders. We recognize the words; we just do not recognize their specific use within Stein's meditations. In this case, the absence of narrative and the frustration that follows, which many readers would call "difficulty," reveal the role expectations play in shaping how we make sense and create order.

What many readers take to be difficulty in Stein's work, Ashbery suggests, is the variability of words themselves. In some situations words, like people, are accommodating; at other moments they are intractable. Without an evident governing communicative purpose or overarching narrative, Stein's poem offers an openness that allows the reader to absorb the words into their own context. Ashbery clearly values the changing textures of Stein's poem in that they make possible the conditions for attention because a reader needs to continually revise one's relationship to the language and how it calls on acts of recognition and denial. "What is it when they wonder if they know / That it means that they are careful if they do what they show /

And needless and needless if they like / That they care to be meant," Stein writes in the poem's fifth section.[14] Ashbery speculates that "they" is the most frequently appearing word in the book, so others are on Stein's mind, whoever *they* may be. These lines can be read as comment on how readers might react to her poem and its complexities, "wondering" what they can know in light of her "word constructions" abstracted from specific experience. Yet, the lines can also suggest that what is being asked is what wonder itself is like: "What is it when they wonder." Or when "they" wonder what becomes of the object being wondered about? As if to say, "when they wonder" what becomes of that which is called "it"? But in any event, if Stein wishes to create situations in which wonder takes precedence over knowing—thereby doing what she is showing—then her language must give rise to the possibilities of wondering, speculating, and thinking. The text acts as provocation rather than authority for experience. The poem's title implies that thinking (in the form of meditation) is part of the program of how they work.

For Ashbery, Stein's difficulty comes not from the unfamiliarity of her words but from the way her words move off in so many directions. With that distinction in view, I want to linger over Ashbery's comparing Stein's lines to people since this revealing trope seems of a piece with what would be the democratizing impulse of his poetics. If the lines are "like people," then Ashbery's observations about her lines reveal his own sense of people, and this helps us move beyond thinking merely that Stein's texts are, in terms of their meaning, completed by the reader, a familiar enough way of thinking of modernist writing. The lines are, as the passages indicate, paratactic and agrammatical. What holds these constructions together is their constructedness, even if readers are pressed into service to deduce whether a line break is a unit or if it complicates more familiar syntactical units. Since we do not know for certain how to group the words, we have to take them one by one and forge some way of connecting them based largely on the ways that we hear the meaning coalescing. Still, the words are all short, common, everyday words that can be heard by a wide community even if that language is by turns familiar and frustrating, consoling and mystifying, vivifying and grating—the way words, just like people, often are. It is not always easy, but it is a human language. The ways that a reader might think to group lines and phrases and how he or she might explain these choices are not exactly a fiction, but also not incontrovertible. Our sense of people also depends on

context—what they mean to us, how we locate their stories and life narratives. We know what any person is as a human being, but their subjectivity—as revealed by their behaviors and actions—can be as resistant to our sense of the world as Stein's language. Stein created a text whose words are as variegated as human beings themselves, and the various ways that the words can be grouped, and therefore come to be meaningful, are as varied as people themselves.

Although often described as abstract, Stein, in her way, offers a complex kind of realism that does not try to represent a phenomenal image or a scene that adheres to some narrative integrity, but instead attempts to present and even enact the complexity of humans as being creatures (and creations) of language. In that, Stein's text tries to "do what it shows," which is akin to what Cavell believes is true, generally, of modernist art, as we saw in an earlier chapter. In Ashbery's reading, the difficulty of working out Stein's poems, in essence alongside the author herself, makes possible a powerful moment when the language becomes recognizable, for as he sees it, in "Stein's work the sudden inrush of clarity is likely to be an aesthetic experience, but . . . the description of that experience applies also to 'real-life' situations, the aesthetic problem being a microcosm of all human problems."[15] Art becomes the testing ground for discovering that problems of interpretation and meaning are not limited to texts and paintings and music, when we are confronted with these questions whenever we encounter other people. The pathos of limitations that signify human life flows backward and forward into aesthetics and ethics, between art and "real-life situations." For that reason, all language, all kinds of experiences, no matter how common or ordinary, can come into poetry.

Throughout his career, Ashbery's work has consistently made colloquial language part of its poetics. He employs commonplace references along with the commingling of high and low culture—from Popeye in "Farm Implements and Rutabagas in a Landscape" to Parmigianino and Vasari in "Self-Portrait in a Convex Mirror." This bears out his ideal of giving "the most demotic and the most elegant forms of expression" equal weight. Though no one would take his poems for actual speech drawn from an ordinary interaction, the poems bring attention to the potential meaningfulness of familiar language. Ashbery makes ordinary language seem so extraordinary by bringing the difficulties of language and the contingencies of experiencing that language into full view.

Ashbery's more recent work adds to these elements of negotiating types of language with a sense of mortality, of finiteness that has not always marked this poet's work. That awareness of mortality introduces a growing sensitivity to limitations, to distance, to the pathos of living. Consider one of his most recent poems, "Homeless Heart," which first appeared in 2012. Here it is in its entirety:

> When I think of finishing the work, when I think of the finished work, a great sadness overtakes me, a sadness paradoxically like joy. The circumstances of doing put away, the being of it takes possession, like a tenant in a rented house. Where are you now, homeless heart? Caught in a hinge, or secreted behind drywall, like your nameless predecessors now that they have been given names? Best not to dwell on our situation, but to dwell in it is deeply refreshing. Like a sideboard covered with decanters and fruit. As a box kite is to a kite. The inside of stumbling. The way to breath. The caricature on the blackboard.[16]

This prose poem does sound autobiographical, or at least personal, coming as it does from a poet in his eighties and wrestling with the pressing realities of one's mortality. The poem immediately becomes a metaphor that goes beyond just one specific person's feelings, however, and gains a broader purchase on a more universal sense of mortality. In part, Ashbery accomplishes this by shifting from an "I" relating its feelings and fashions the poem as an address to a "homeless heart." This "homeless heart" could be the speaker's own heart, but it could also be a poetic way of referring to another person, who feels restless, lost, alienated from the work that is being finished. Perhaps just the sort of person, as in Wright's lines about the planetarium, who is caught between galaxies and is spurned by someone he thought was a lover or, in the bit about the apartment, who feels all the furniture in his home has been replaced. There is in these lines a longing to belong. In that way, the poem is an address to the specific "homeless heart" as well as anyone who might recognize themselves in such a call. The work could be anyone's work and any kind of work.

The stuttering phrases that open the poem are telling: first the speaker thinks of finishing the work, which implies it is not done but is coming to its end, and then the thought slides into the work as (at some point) being finished. This is to imagine some moment after the end, when even the finishing itself has come to a close. Then the work is no longer a "doing" but is

"being." We might say that *work* moves from being a verb to being a noun. In this poem, a process cannot become a product and yet remain in process. Although "being" takes possession, it does not own the "doing": they do not share an identity. In the ratio that the poem offers (*being* is to *doing* as a *tenant* is to a *rented house*), the work becomes a house for being, which begins to sounds like a passage from Martin Heidegger's "Letter on Humanism": "Language is the house of Being. In its home man dwells. Those who think and those who create with words are the guardians of this home."[17] Poetry creates its own conditions for its meaningfulness rather than responding to or being dependent on structures of rationality and practical communication.

I want to pursue these sympathetic resonances a bit further since the invocation of Heideggerian terms provides associative links. Despite the profound interest in Hölderlin that Ashbery shares with Heidegger, it is unlikely that Ashbery is consciously drawing on Heidegger's terminology.[18] Nevertheless, Ashbery and Heidegger do share a wish to keep experience opening up and moving forward as well as the belief that the work of art is part of a process that is not limited to just the production of objects but is tied to subjectivity itself. In an argument that Ashbery makes for ambiguity— in the vein of Fairfield Porter's description of usable paradox—he offers this perspective: "Things are in a continual state of motion and evolution, and if we come to a point where we say, with certitude, right here, this is the end of the universe, then of course we must deal with everything that goes on after that, whereas ambiguity seems to take further developments into account."[19] For both figures, we can see that in the process of presenting the work of art, the artist or poet provides a legible text of how he or she imagines a relationship to the world to look and feel and that text is filled with ambiguities that are part of that relationship.

In thinking of Heidegger in regard to "Homeless Heart," one of the terms that bumps against Ashbery's poem is, of course, "being" ("dwelling" is another). In Heidegger's vast corpus there is hardly a more complex concept, though we can say that for Heidegger "Being" (so capitalized) is a totality of everything that is. There is also "being," which refers to existing within that totality. Given how encompassing that frame is for "Being," no one can access that totality *as* a totality, since humans are always limited by their own subjectivity and mortality. Therefore, we can never know the meaning of Being. This frustration is also the source of possibility in Ash-

bery's poetics. We see that in "Homeless Heart" the word "being" stands for the completion of work, of doing, of becoming. Futurity and possibility no longer stretch in front of the action of doing. The state of "being" to which this poem alludes occurs when something achieves its identity and becomes a form of certitude such as Ashbery is skeptical of.

Ashbery's poem makes it clear that the being and work someday part ways. This text is not simply a representation, a mirroring, but an enactment of relationships that flow outward and inward. The work creates and dramatizes the possibilities for coming into relationships with others and for responding to means of presenting a worldview. According to Heidegger, just as "the artist is the origin of the work. The work is the origin of the artist. Neither is without the other."[20] This mutual dependency for existence between the artwork and the artist starts to explain why Ashbery's poem states there would be a sadness that seems like joy as an aftermath of the work. With the doing finished, there is a new world that the artist or poet has created, which would lead to a kind of joy. Yet the sadness comes from the transience of that world and the artist's own mortality. The work having been completed, a work that manifests a worldview, the artist cannot then partake of that world, can never be at home there, because *as an artist* he or she will no longer exist.

This excursus into Heidegger's thinking is generated by words that Ashbery uses in his poem, but they do not reduce the poem to being an illustrative example for Heideggerian philosophy even though Heidegger's work offers a useful frame for thinking through what the poem is doing and demonstrates the potential for complexity within the poem.[21] At the same time, it is hard not to think of this poem in terms of a poet's relationship to his or her body of work, the body now being a charged trope in light of the reference to a "homeless heart," if we think of the heart or the soul as located in the body. As life's possibilities begin to close, a fact that the poem also seems to touch on, as the insurmountability of mortality becomes more and more real as one ages, the frustrations of existence as always being marked by limitations become impossible to overlook. The poem avoids becoming maudlin or morose in part because it invokes "a sadness paradoxically like joy," a feeling state not easily paraphrased. On the contrary, the poem maintains a sense of pathos by enacting the struggle of the affirmative and the tragic, the tension between avoidance and acknowledgment that language and one's responses can reveal. This shuttling back and forth comes in the next line of

"Homeless Heart," which states, "Best not to dwell on our situation, but to dwell in it is deeply refreshing." Clearly, we are meant to consider the differences between "dwelling in" and "dwelling on" because discovering the difference offers some insight into how one lives one's life. Putting pressure on a word to find out the two different ways that it can mean, Ashbery's poem also brings out the problem of words themselves. Essentially, readers are asked to dwell on what the word "dwell" means in one sense ("dwell on") and then the other ("dwell in") so as to make decisions that affect one's way of being in the world.

The poem does indicate that one can make a choice. "Dwelling in," according to the poem, is "deeply refreshing" and offers the counterforce to the exhaustion described at the beginning of the poem. The advice against "dwelling on the situation" sounds like a form of avoidance, if not outright denial, against thinking about the finishing of work, about becoming like a tenant in a house because, after all, that brings a sadness. Also, "dwelling" implies being trapped in some psychic loop, unable to move, weighing every option and possibility. Yet instead of an outright blindness or indecision, the speaker suggests there is an alternative way of addressing the situation: "dwelling in the situation." So we might say that "dwelling on" means that a person is caught between readings and decisions but believes there is one to be made. "Dwelling in" means accepting the paradoxical situation of multiple coexisting worlds. Such acceptance forecloses the need for choosing.

In this section of the poem, however, "dwell" is not the only word that needs attention. The introduction of the pronoun "our" complicates matters as well. Is it the speaker of the poem referring to himself and his homeless heart? Or is this "our" more inclusive and reaches out to the reader as if to say "our situation" is a human condition? The slipperiness of that "our" suggests that the pronoun can refer to both and that in this case the specific example of the speaker and his homeless heart is the particularity that represents a larger, more general existential condition.

Ashbery offers a way of understanding how "deeply refreshing" it is to "dwell in" by comparing it to "a sideboard covered with decanters and fruit." This experience of refreshment seems common enough and refers us back to the idea of the home. The sideboard provides sustenance, but the fruit and liqueurs offer the creature comforts that allow one to feel at home, even if that home is merely "rented." Yet Ashbery takes the poem a step further and offers another simile, this time comparing the deep refreshment of dwelling

in a much more complex manner: "As a box kite is to a kite." Here the analogy is much harder to parse since a box kite is a kind of kite. And it does not make sense to say that a box kite "dwells" in a kite. It *is* a kite. We could say that not all kites are box kites, so at least we could say a box kite is a subset of the larger grouping of things that are called kites. And a box kite that is not flying can be mistaken for a box. The language of comparison breaks down altogether and offers, "The inside of stumbling. The way to breath." Are these two fragments still in the process of analogizing what it means to dwell in and attempting to communicate how "deeply refreshing" it is? The two sentence fragments do not offer a clear idea of the contained being separate from what it contains, the very tropes established in the poem's first half. The analogies also erase the distinction between an action and a thing. For instance, stumbling is an action that has neither inside nor outside, though one might think of "the inside" of stumbling as what one feels in the process of stumbling. But as soon as one stops stumbling, the stumble vanishes: the "inside" of stumble is not a place or location but a moment in time. There is no "way" to breath; there is only breathing and not breathing. When one takes a breath, one is breathing. When one is not breathing, there is no breath. Is the "way to breath" the moment between the thought of a breath and the breath itself?

The poem offers as analogies these examples in which the activity exists only as an action, and once it stops its identity vanishes. For instance, a box kite that is not acting as a kite is just a box. Ashbery leads the reader to this realization through the chain of comparisons that move from clear similes to comparisons that are more direct (not mediated through "like" or "as") but are arrived at by way of juxtaposition. In other words, the reader needs to do the work to figure out the connections, and these are not easily paraphrased as feeling states. Indeed, the linguistic devices used to create clarity do not obscure the relationship between "the inside of stumbling" and "dwelling in a situation," but they help it to resist the intellect almost successfully, as Wallace Stevens might say. This difficulty—or to use Ashbery's word, this "ambiguity"—allows the poem's work to stay unresolved in the sense of the relationships it describes being left open. If the poem's work does not conclude because it is taken up in the reader, then the "finishing [of] the work" never arrives, and both the work and the heart can keep going, even as there is a sense that sometime that close will come. The poem travels back and forth between its hope of remaining open and ongoing, and its despair

that the work will one day be done, and that very pathos places it within Cavell's vision of moral perfectionism. We could see this as an experience of mortality. Paradoxically, Ashbery's poem both "dwells on" and "dwells in" such limitations, and so the poem constitutes an experience of the paradox of limitations and mortality and as such offers a reader an opportunity to grow accustomed to paradox as a way to learn to "dwell within it."

I want to step back to an earlier moment in the poem. Before we get to the poem's aphoristic instruction that asks us to consider distinguishing ways of "dwelling" and before the consequent chain of analogies that follows that choice, the speaker asks the heart where it is located. After "being" takes possession of "the circumstances of doing," is the heart "caught in a hinge, or secreted behind drywall, like your nameless predecessors now that they have been given names?" The heart *must* be hidden away if the speaker has to ask where it is. Indeed, that the speaker does not know where the heart is describes the alienation I have already mentioned, that division of the self from within the self, since he is separated from what many would take to be the very core of a person's sense of being.

In these particular lines, naming takes on a curious dimension since the predecessors seem to have been "secreted behind drywall" *because* they now are no longer nameless. The lines may be read as suggesting that the names themselves, by being so specific, cover up the former namelessness of the predecessors. The names make the nameless predecessors fixed or stuck by their now-specified identities, and as we have seen, Ashbery is much more an advocate for that which is fluid and changing. Ironically, the very things that particularize those predecessors—names—are what makes them recede or become stuck or hidden away. In fact, having been named, they are no longer "nameless predecessors." Being given an identity through names, their old identities vanish. This problem of a name both illuminating and displacing what it names is another of the paradoxes set to work in Ashbery's poem.

And what are predecessors that are nameless? The awareness of predecessors signals an acknowledgment that there was a past, but one that is unknown to the current occupant, just as one knows that other people inhabited a home one is renting, even if there is no trace of those predecessors in the present. Invoking the predecessors also indicates a succession of occupants. Just as they gave way to the new tenant, so too will the current

occupant become a nameless predecessor. Since the "homeless heart" is what is associated with the predecessors, the suggestion is that either the speaker has had other "hearts" before, and therefore has been other selves, or more likely what this heart is going through is a very ordinary condition that speaks to the human limitation of mortality and time.

Within Ashbery's body of work, this paradox of naming occurs not only in "Homeless Heart" but also in another collection of Ashbery's poems that specifically takes on the problem of working through names, naming, and lyric address so as to explore the relationship between particulars and the general by way of poetry's ability to create conditions for openness. *Your Name Here*, the poet's twentieth collection of poems, is part of what might be considered Ashbery's later (that is, more recent) work.[22] In the rendezvous of questions arising in the context of reading this volume, the poems foreground how we might acknowledge the pathos that is so much a part of living among and with others in a variety of ways, but arises particularly at the level of language and its representations. This pathos reveals itself in language beginning with the question of what names are and what they do— how names, if not words more generally, both serve to particularize and to displace what they refer to, as we saw in "Homeless Heart." As Ashbery's work demonstrates, poetry becomes an arena for staging "usable paradoxes" of meaning latent in all words, even those as familiar as "home" or "heart," so as to reveal the role that language has in experience itself.

As we will see, even the very title *Your Name Here* poses interpretive challenges built on paradoxes, especially those that cluster around questions of address and naming, and these resound throughout the collection. Yet Ashbery's paradoxes rarely hover at the theoretical level; they often bring out emotional complexities as well and show how a person can hold multiple and even contradictory feelings, all at the same time. In *Your Name Here* there is also an elegiac element to the poems, as Ashbery dedicates the book to a loved one who had died just two years before the book appeared. The elegiac context frames the way that the poems figure not only absence and loss but also the impossibility of full, incontrovertible communication between people. Whatever else the poems might do, collectively, *Your Name Here* offers an occasion for thinking through the conditions and strategies by which we *both* approach and avert our attention from the problems of engaging with others and wrangling the world into shared and ordinary language.[23]

Your Name Here seems ironic and witty enough as a title for a collection of poems, and that humor can signal an emotional distance in ways similar to Freud's understanding of the protective, repressive properties of humor as held against an excess of reality that I discussed in regard to Wright. What's in a name? A great deal, evidently. Characteristic of Ashbery's wit, one could simply enjoy just that pleasure and move on, and yet pausing over that moment indicates there are additional depths to be experienced by a more careful reader. Ashbery's work does not defamiliarize or estrange language, thereby replicating a process of alienation. Instead, and perhaps more powerfully, the work refamiliarizes us with the language we use to communicate with others, with ourselves, and *to* ourselves in the ways that it slows down how a reader receives the text. When asked by Peter Stitt in an interview for the *Paris Review* if a poem is an object in and of itself rather than some allegory of abstract meaning, Ashbery responded: "I would like [the poem] to be what Stevens calls a completely new set of objects. My intention is to present the reader with a pleasant surprise, not an unpleasant one, not a nonsurprise. I think this is the way pleasure happens when you are reading poetry."[24]

On its face, the title *Your Name Here* is a decidedly banal phrase that most of us encounter with some frequency on the dullest of dotted lines—a person might be tempted not to listen carefully to that language. Reading too quickly circumvents the possibility of the words—any words—surprising us, making claims on us. Yet the everydayness of much of Ashbery's language is what becomes so intriguing about it, particularly in the context of a poem, for by so many Romantic and modernist conventions the language of a poem calls for attention, whereas ordinary language is that which is overlooked.

The title invites the reader to provide the missing title, to *complete* the book as it were. While this might be a characteristic aesthetic principle of modernist and postmodernist work, in this case there is an additional level of literalness. The reader is asked to supply the element that brings the whole collection together as a unit in the ways that a title does. We might think, then, that "name" substitutes "title," as if to say *Your Name Here* means "call it what you will." If we take "your name" to mean literally the *reader*'s name, however, the book is not simply completed by the reader but becomes metonymic—in other words, the name of the collection becomes *Deming* when *I* read it. The poems compose this "book of Deming" (or whoever is

reading the book), and the poems flow through what that name identifies to me and *as* me. The book represents not an *ideal* reader but in fact *each* reader, since the "you" changes depending on who is reading the book. So, for each reader the "you" has an altogether different referent. The poems are written by Ashbery, but in reading them these acts of language pass through the reader's consciousness—in that way, the poet's words, the words of his poems, are in effect not merely his own. Any reader who takes up the volume is inscribed onto the poems, which is why it might be appropriate to have a title so open that it can accommodate each reader collectively as well as individually.

The reader may not complete Ashbery's book, however, at least not in the ways that Noël Carroll argued that an audience completes a joke. While I still hold that Carroll underestimates the interpretive potential for some (but not all) jokes, a poem is indeed likely to have far more possible readings, so instead we might say that a reader provides a field for the poems' cohesion. This cohesion is guided of course by the poems themselves and the words that are there. Meaning is not wholly subjective, but the reader provides a field of possibilities, and his or her engagement of language shapes what meaning can be derived from a text. We might say that the text "reads the reader." Whereas I mean that the text's rhetoricity guides the reader's warp and weave of attention, equally true is that the interpretation is shaped by the reader's subjective understanding of the words and conventions. The reader works within the language games according to his or her sense of them. Meaning is not static but is arrived at through negotiations, even interior negotiations. The references are not merely the reader's but are also no longer solely Ashbery's.

This all assumes that the title's pronoun "*your*" refers to the reader, but it might not be—need not be—so, which further complicates the confusion of names and pronouns.[25] Instead, the "you" (implied in *Your Name*) may be self-referential, if we see poems as not simply the author's own authentic voice but as the negotiation of cultural and epistemological elements. It is harder to see immediately but still possible that the pronoun's referent is the poet, especially if Ashbery is pushing against the grain of the built-in authority of *the Author*, something functionally other than the flesh and blood person, John Ashbery. Frustrating the tendency to see his work by other means, Ashbery's poems create a situation where one needs to attend to the words themselves to discover their claim on the author as well as on individual

readers. In *Other Traditions*, Ashbery insists that he sees his poems as being their own explanation: they provide experiences instead of commenting on them or describing them.[26] In that sense, Ashbery's ideal is that poems express more than an author knows he or she knows. Beyond intent, the poem expresses the very processes of understanding as a negotiation rather than stipulating the content of one's understanding.

The idea that language offers a struggle of meanings is thematized more directly in a dialogic poem in Ashbery's collection. "That was the day we first realized we didn't fully / know our names, yours or mine, and we left quietly / amid the gray snow falling. Twilight had already set in," the poet writes at the conclusion of "Crossroads in the Past," a poem at the center of *Your Name Here*.[27] The poem is essentially an argument between a "you" and an "I" that begins, "That night the wind stirred in the forsythia bushes / but it was a wrong one, blowing in the wrong direction." Immediately another speaker interjects:

> "That's silly. How can there be a wrong direction?
> 'It bloweth where it listeth,' as you know, just as we do
> when we make love or do something else there are no rules for."

Note that these lines open and close with quotation marks, a common enough convention that separates this voice from the voice of the two opening lines. Yet, as the poem continues, the quotation marks disappear altogether and only the use of "you" and "I" maintains the clear distinction between voices, which also begins to break down. That the voice in this passage quotes the Bible (specifically John 3:8) folds another "voice" into the text. The biblical verse actually continues on to describe a state of being in-between, not knowing origins and destinations: "thou hearest the sound thereof, but canst not tell whence it cometh, and whither it goeth: so is every one that is born of the Spirit."

In that first exchange, the interrupting voice calls into question the poetic authority of the poem itself in this self-conscious disruption that questions what "wrong" means in terms of "a wind." That question cuts against the poem's ability to authorize such claims and offers a kind of editorial comment on the lyricism of the poem in its use of the colloquial "that's silly," a phrase that is another form of judgment in the way that "wrong" is taken to be a judgment. And it does seem that the second voice is wondering what it

means to call something "wrong" in regard to things or actions that are out-side systems of order. The voice indicates right or wrong can be determined not by some fixed, a priori moral order but only on a given thing's own terms and according to its own context. "In what way do things get to be wrong?" the voice asks, more pointedly and with a legitimately philosophical impli-cation. A few lines later, that speaker says that the two people (the "you" and the "I") need to "talk our relationship back to its beginnings." Then, one of the voices (and as the poem continues it gets harder to know which voice is speaking) offers that the source for "wrong" comes from beginnings: "that's probably what's wrong—the beginnings concept, I mean. / I aver there are no beginnings, though there were perhaps some / sometime." Once again, a claim is made and yet then undercut, and the poem offers a paradoxical con-tradiction that there are no beginnings, though at one time there may have been.

With the lines I cited earlier, "Crossroads in the Past" concludes with a compelling paradox about the uncertainty of names, suggesting a connec-tion between names and beginnings that offer wrong directions. What does it mean to not "fully know" one's name, as the voices in "Crossroads in the Past" say about themselves? If our names are not our own in the sense that we do not "fully know" them, what hold do they have on us? Do they end up serving as a kind of drywall that covers us up, as Ashbery suggests in "Homeless Heart"? The title "Crossroads in the Past" does suggest that it is reflecting on points of choice that were already determined in the past. Yet, without fully knowing the names, in the poem "we" walk into a colorless, liminal time that is neither night nor day. Without the distinctions that names offer, everything blurs together and becomes undifferentiated, yet there is no sense in saying "wrong." And in this poem, the two voices do not have proper names; they have only pronouns as names. What does it mean to say "I" or "you" since these pronouns are names of a sort that distinguish the self from the other in the ways that proper names specify distinct individu-als? We can say that our very grammar is dependent on there being others to address: for there to be an "I," there must be a "thou." Those grammatical structures are so internalized they appear even in private, interior mono-logues. Language and grammar are predicated on others, whatever the onto-logical status of those others. Ashbery's title does presume there will be a "you." Even if the other is not really there, we cannot help but speak to them as if they are, if we are to speak at all. The question at the end of Ashbery's

poem doubts the efficacy of speaking, even as it tries to speak. This reminds us of his belief that it should be noticed that frustration and desire dog every speech act.

Ashbery's lines in "Crossroads in the Past" about the uncertainty of names unsettle the Adamic duties of a poet and suggest a certain, recurring in-betweenness in which possessive pronouns (not to mention proper names) are contingent rather than conclusive, are means of location rather than def-inition. What does such drift of the names mean, and what does our partial knowledge of them reveal? The difficulty here lies in the reminder that the world could indeed be otherwise and that names and words start to fore-close possibilities. The collection's title both invites and forecloses the invitation—as crossroads themselves do. *Your Name Here* does give a title—it is a blank that is already filled in by the phrase that notes its being blank or open. The title is a double dream of inscription and blanks that do not re-main blank. The question of how and why we fill them leads to the possi-bilities of taking—or coming upon—a responsibility for our responses.

Some of the feeling of being caught between names and the world is tied to larger affective and cognitive structures, Ashbery believes. In his interview with Poulin, a conversation that predates *Your Name Here* by almost two de-cades, Ashbery is asked about the critic Stephen Koch's claims that Ashbery's poetry is marked by "[his] love and hatred for words and [his] love and ha-tred of the experience of communication."[28] Ashbery responds by asking if that is not true of everyone. He adds, "We want to communicate and we hate the idea of being forced to. I think it's something that should be no-ticed." Ashbery's poetics are shaped not only by this desire to connect with others, to communicate experience since that validates one's own subjectiv-ity, but also by the frustration that one needs to work through the inconstan-cies of language to make this communication happen at all. This conflict is not personal to him, Ashbery indicates, but is common to everyone.

The comments to Poulin also express a moral imperative—somewhat uncharacteristic for this poet—that this dilemma all of us face *should be* no-ticed. Ashbery's poems and their difficulties strive to bring out the interpre-tive knots of everyday communication—the problems of speaking and of being heard, of getting across to others all that one thinks to mean—for the same reasons he suggested Stein's work does this in the essay he titled, tell-ingly, "The Impossible." Again, the problems of art express the paradoxes of life, and the way that Ashbery describes people in his essay on Stein reflects

his basic sense of how we interact with one another. As he says, people "sometimes make no sense and sometimes make perfect sense or they stop short in the middle of a sentence and wander away, leaving us alone for a while in the physical world, that collection of thoughts, flowers, weather, and proper names." Or as Emerson puts it in "Self-Reliance," in regard to the struggle between an individual and the conformism that creates society, "Every word they say chagrins us."[29] What chagrins is the dissonance between people's most basic understanding of values in much the way that we see being dramatized in "Crossroads in the Past." What Ashbery says about people applies to words themselves. Ashbery concludes that Stein's lines, just like people, cannot be escaped. People are everywhere and yet they can suddenly abandon us to the things of the world, he tells us. Or so Stein's texts, Ashbery argues, illustrate.

"Lucinda, will you always love me?" Steven Wright asks his girlfriend. "I doubt it. I don't even love you now," she responds. Anyone who has experienced great emotions of love, grief, or horror knows the feeling of being abandoned by language. These poetics express an ongoing negotiation of a self's alienation from others and, at times, language itself as well as a persistent, even optimistic, desire to connect with others.[30] This conflict speaks to Ashbery's democratizing sense of poetry: since all language can enter into a conversation, that diversity of discourses represents the textures and variegations of daily life, and in this way interactions will be as much success as failure, as much frustration as intimate recognition. Democracy entails (ideally) limitless possibilities based on the diverse perspectives it makes possible, but it also entails endless consternations of having to reckon with so many people who do not share one's full set of values exactly. Ashbery's poetics do not argue for a specific politics; they arise out of the experience of what it feels like to be a democratic subject.

Although "people" cannot be escaped (which suggests there is some small threat that other people offer) or avoided altogether, Ashbery's *Your Name Here* begins with absence. The volume, as I mentioned before, is dedicated to the late French poet and novelist Pierre Martory, a friend of Ashbery's for more than forty years and with whom Ashbery lived in Paris in the 1950s for almost a decade. The dedication page not only acknowledges Martory as the dedicatee but also provides the dates of his life and death (1920–1998). This dedication offers a specific sense of the "you" that resonates throughout the book, beginning with the first poem, and at every turn the reader

remembers that there is a "you" who is already absent because of death, and that reference resonates through the poems. The name Martory, however, does not limit to the autobiographical mode how the poems might be read, in part because Ashbery keeps troubling how we make sense of the relationship of pronouns to people. To begin with, the issues of the pronominal reference of the title appear before the dedication page. Wrestling with the absence of a title is then thematized in more complex ways when a dedicatee, a deceased friend, is invoked. One absence gives way to another. In that manner, the emotional and even physical absence of Martory marked by the dedication also joins with a general experience of absence that begins with the book's title. Martory's distance becomes the reader's as well.

Ashbery strives to write *representative* poems that are not descriptions of specific personal events of the sort a confessional poet might depict, but are the enactments of responses to more widespread human experiences and concerns. As Shoptaw describes it, "By making his poetry the stream of everybody's or anybody's consciousness, [Ashbery] creates an all-purpose subjectivity which is neither egotistical nor solipsistic."[31] In this case, that "stream of everybody's consciousness" is found in tropes of love and loss and the unreliability of language to communicate across the divide between the self and the other, and perhaps between personal and collective experience.[32]

The death of Martory could shape a reading of the first poem in *Your Name Here*, a poem that shows how absence can seem paradoxical. "This Room" opens with the line, "The room I entered was a dream of this room" and, later in the same poem, "Why do I tell you these things? / You are not even here."[33] While we might see those latter lines as an accusation with the sound of "even" containing some resentment, if we read the "why" as being pointedly directed at the "I" (the internal rhyme underscoring a marked connection between those two words), the couplet also suggests an uncertainty about the speaker's own actions, their reality, their actuality. What it means for the addressee to be an absent audience to another's dream will be one worth returning to because it signals a certain wariness about audiences, about people's ability to hear and to be present to one speaking. At the very least, the issue brings us back to questions raised in the earlier chapter about that distance that surrounds presumed intimates. Is the "you" not in the dream, or is the "you" not present as audience? To ask this another way, where is "here"? If the addressee is not present, how would it be that the

speaker can *tell* him or her "these things"? What is it to tell something to someone who is not present? This latter question raises the specter of skepticism not in its questioning of the addressee's ability to hear the words because he or she is not present, but in a wondering about the value of telling at all.

"This Room" also opens with a move that suggests a skepticism at play in *Your Name Here*: "The room I entered was a dream of this room." Throughout *Your Name Here*, we see similar instances of things being both themselves and things other than themselves, simultaneously—including the final eponymous poem, which begins, "But how can I be in this bar and also be a recluse?"[34] A poem appearing earlier in the collection goes a step further with its suggestion of the real being unreal offered in its title, "Life Is a Dream." It is a funny sort of paradox and Ashbery's wit is usefully self-conscious in the ways that it undermines an overdetermined or practiced profundity that lyric poetry can affect in either its Romantic or modernist modes. The humor also provides a way that Ashbery can cite pathos while not having his work subsumed by it. A skepticism is built into these moments since they both offer a moment or an experience and then immediately question its ontology. One hears that sort of question ("how can I be in this bar and also be a recluse?") in one's daily life, and it has an immediacy that does not hide its poignancy; one still feels a pull of disparate discontinuities manifesting themselves in places so ordinary they seem surprising.

It is thus the room and not the room; it is a place that can be entered but that is also an imagined representation of "this room," with "this" specifying a room unknown to the reader that puts into question the certainty of the room. Is it real or just a dream? The entering is not presented as the dream, just the location is. And if it is a dream state being described, the poem seems to take as axiomatic the belief that everything in a dream is some part or aspect of the dreamer: "Surely all those feet on the sofa were mine," reads the second line. This line suggests a fractured multiplicity of the self, and the multiplicity is further expressed in two puns in this line as well. A pun, by its very nature, expresses the way one utterance can have different meanings. To begin with, a "room" is mentioned in the first stanza, and *stanza* itself is derived from the Italian for "room." The speaker enters a room, just as the poet enters the stanza, just as the reader enters both the stanza (at the level of structure) and the room (at the level of the diegetic

space). We might also then read "feet" as suggesting poetic measure. All the words of the poem, and therefore each poetic foot, are guided by the poet's choices in terms of fashioning meaning built on an understanding of how language works and what the conventions of poetry are. The poem is expressive of all the cultural, psychological, and aesthetic values that compose the poet's subjectivity, consciously and unconsciously, just as all aspects of the dream are the dreamer's. The poem then offers a moment of dream logic when "the oval portrait / of a dog was me at an early age." I say "dream logic" because the poem offers a situation in which a portrait can be both of a dog and of a person at the same time, the "both/and" status of the painting echoes the first line, in which the room is both itself and a "dream of itself." "This Room" offers these somewhat easy paradoxes almost as a way of showing in the most conventional and familiar manner what poems can do in staving off resolution and definitiveness because they are not beholden to strict mimesis. The poem describes a paradoxical situation but with a familiarity that is indicative of what it means to "dwell in" this liminal state between subjective imagination and objective empiricism, between belief and doubt: a room and a dream of the room. Here, the familiarity and ease of the poetic strategies enact the feeling state of being familiar. The poem creates a sense of the ordinary out of the extraordinary.

At the end of Ashbery's poem exasperation can be heard reverberating in its question, "Why do I tell you these things?" There is room for doubting in this exasperation: doubting that what the speaker says matters, or doubting that the "you" cares enough to listen. Or if we read the "you" as Martory, we could discern a frustration directed inward that "these things" are being told to someone who has passed away and this action is an impossibility. In other words, the frustration may be that the speaker should know better than to speak to the dead or the absent. Although one can speak to the dead, one cannot tell them anything because they cannot hear what is being told. "Telling" implies reception as well as expression. There may also be the exasperation that "these things" are so well understood that they should not need to be told. The "you" may also be the poem's reader, who is not in actuality there with the poet when the poem is written. In such an address, the "you" is directed to a future presence, but who is not with the poet and that is the reason for the frustration and even melancholy in the last line.

In any event, the final lines are left unanswered, and it is as if the "you" is not given space to answer. The speaker expects that rhetorical question to

never be closed, and that it is not answered only proves his point about the absence. The lack of response is the expected response. Bringing together these various readings, overlaying them one on top of the other, indicates that any absence—whether through death or disinterest—is an absence in terms of the success or failure of expressing oneself to another. The doubts hovering around that question reveal that some part of the attempt to express oneself always courts failure or frustration.

Ashbery's conception of this distance between a speaker and the addressee takes on a specific tenor in that for his poems, particularly those of *Your Name Here*, a skepticism occurs in the form of the exasperation intrinsic to our relationship with the language that we use every day. Yet, those moments of clarity or transparency, when actual communication has occurred between a self and the other, feel that much more powerful *because* of the difficulty inherent to language and being with others.

More distinctly, however, this isolation encountered in or as revealed by Ashbery's poems is not a crisis, in that it is not a situation that takes one by surprise or reaches a climatic rupture that has immediate effects. Instead, for Ashbery, this is a given condition; it is how things are. In this case such alienation is perhaps not necessarily a negative condition in that it delivers us to ourselves, because of being thrown back on ourselves, to a consciousness of the self. The more apt term is "loneliness," an emotional state no less poignant or deeply felt for its being so ordinary. It may be that by exchanging loneliness for alienation in discussing Ashbery's work, we can put the poems in a context for discussing the negotiations of emotional distance and uncertainty.

In an interview from 1989, Ashbery responds to a question about a sense of isolation he felt as a child. He explains, "My earliest childhood I spent with my grandparents living in a city and there were plenty of children to play with, you could walk from one street to the other and visit people. Then I was transplanted out to the middle of the country and there were no children close by. I went to school in a village, and after school I would be taken home so I never had much of a social life as a child. I kept regretting the earlier time when I had been part of a little society. So, perhaps that is a trigger of loneliness, a feeling of loneliness in my writing, plus the fact that my brother died when we were children."[35] That feeling permeates his body of work.[36]

Much the way that Ashbery's *Your Name Here* as a whole arises out of the death of a loved one, Pierre Martory, the poem "The History of My Life"

delineates a personal history, a life, that begins with loss: "Once upon a time there were two brothers. / Then there was only one: myself."[37] The poem refers to the specific autobiographical fact that the poet lost his brother to leukemia when they were both children (Ashbery was twelve and his brother Richard nine). According to this poem, "the history" of his life is predicated on loss, but the poem reveals ways of thinking about the death of a loved as being not just an experience in the past but an opening of ongoing questions at the linguistic level about how people identify themselves through language and grammar. In the poem, we see that "myself" appears only after the death of the brother: before that the poem identifies a set of two brothers and "brother" is always a word that by definition specifies a relationship. With that set of "two brothers" no longer existing, the survivor becomes an individual. Yet, when one boy dies, is the survivor still a brother? In light of this loss, one way of looking at this word and what it means would be to say that the identity of *brother* vanishes when the sibling dies. Yet, psychologically we can presume that the survivor will always feel like a brother, indicating that a relationship continues even after death; however, now the word "brother" points perpetually to an absence. At every moment the sense of being a brother is marked by the fact that the sibling has gone. The poem suggests that the individuated self begins out of that cleaving of the two brothers and is connected to the isolation and loneliness that Ashbery describes in the interview I cited.

"The History of My Life" ends with the poet saying that he became more charitable to himself as he "aged / increasingly" and "then a great devouring cloud / came and loitered on the horizon, drinking / it up, for what seemed like months or years." The cloud could be many things—depression, fear of death, perhaps even survivor's guilt—but the dark cloud displaces the "charitable" feelings the speaker had toward himself. In that way the impending loss of others and the loneliness in the face of their mortality (what the cloud's "devouring" seems to point to) reveal the limitations of our sense of the world—it changes when the others become absent and is continually changing. The realization that the world is not stable and that everything disappears points toward the loss of ourselves. This private sense of loss is one we all experience and so is characteristically and perhaps even definitively human. To understand Ashbery's poem, then, we need to think about what loneliness is as a condition and an experience.

Thomas Dumm, a deft thinker about the ordinary and its role in political theory, offers a definition that is germane in this context. "Loneliness," he writes, "is the experience of the pathos of disappearance." This understanding of the condition of the ordinary that I have been mapping out over the course of the earlier chapters participates in that pathos of disappearance—in being distanced from the ordinary, in confronting its transformation and mysteriousness there is a feeling of this loneliness. That "experience of the pathos of disappearance" would seem to describe the estrangement that Steven Wright evokes in his comedy. Dumm expands his definition of loneliness by indicating in a useful commentary the circumstances that flow toward and away from a sense of being isolated: "We are marked by loneliness when we register the death of others to us, when we cease to be connected to the things that surround us, and when we notice that we somehow have become something that we no longer recognize as ourselves. Loneliness is akin to the experience of skepticism."[38] Dumm emphasizes that loneliness is most pronounced regarding the death of a loved one because it dislodges us from our dailiness in the way that the absence always intercedes and creates feelings of separation and isolation. He does not refer to it as alienation as such, but we can see how that term might fit. The disappearance of another—the transformation from presence to absence—reveals not only human mortality but the fact that the things and people on which we base our understanding are not fixed and enduring.

Dumm's comments about loneliness and death have direct bearing on *Your Name Here* and its meditations on emotional distance. We can hear this incipient pathos that is loneliness in the concern about the disappearance of the "you" in Ashbery's poems "This Room" and "The History of My Life." This isolation is brought on by the complexities of life and dealing with others, as his earlier comments about Stein reveal, but clearly also through the absences death creates.

The very title of Dumm's book alludes to Pierre Hadot's *Philosophy as a Way of Life*, underscoring Dumm's arguments that loneliness has an intrinsic connection to the life of the mind and therefore, however painful it is, loneliness has the potential to be a "usable" condition. That loneliness, despite its isolating effect, is a shared condition that everyone feels at certain times suggests that it in some way shapes ideas of subjectivity. As part of his reading, Dumm suggests not only that the modern era is shot through with

loneliness, but that feelings of loneliness and estrangement are part of the very nature of modernity. Dumm makes a case for seeing loneliness as "a side effect of Cartesian doubt," which is why he links skepticism and loneliness. Although Dumm does not elaborate the connection, examples may be drawn from Descartes and that well-known scene of the philosopher's solitary meditations in order to see how tropes of isolation affect Descartes and give rise to the modern era of philosophical thinking and subjectivity. This isolation asserts itself in Descartes's thinking in moments such as this: "If I look out of the window and see men crossing the square, as I just happen to have done, I normally say that I see the men themselves. . . . Yet do I see any more than hats and coats which could conceal automatons? I *judge* that they are men."[39] In this passage, distance makes Descartes's perspective possible because it places everything at a remove. As familiar as this passage may be, it is nonetheless metonymic of Descartes's larger method of separating what cannot be doubted from what can be—he extricates himself from others. A certain distance between the *cogito* and all else arises out of the Cartesian method of doubting everything that is possible to be doubted even as those efforts are marshaled to discover "just one thing, however slight, that is certain and unshakeable."[40] Descartes is left with himself.

Descartes's first move is to transfigure the ordinary sight of people crossing the square into uncanny terms by seeing those figures as automatons. This uncanny scene is Descartes's rendering of the ordinary as familiar yet alien forms. The familiarity cum strangeness calls into question everything Descartes sees, for, like Steven Wright's belongings, everything has been replaced with an exact replica. The philosopher asks, of course, what it is that we *know* for certain about what we see. If all that any one of us knows is that "I am thinking; therefore I exist," then the expression of "I" is an articulation of that existence in a grammatical way. The fixing of an "I" to a person represents the self entering into language as language enters the self. Just as Descartes wonders whether the people he sees out his window are not, rather, automatons, then certainty in no way extends to them, and so the other, or "you," is always far less certain. The isolation that arises from this idea of knowledge that is imminently self-conscious and self-reflexive is central to an experience of all things outside the self. This distance between self and other that Dumm describes as being shaped by our Cartesian inheritance is echoed in Ashbery's recurring skepticism toward language and

the frustrations he notes as being part of any attempt to cross the gap between selves. Yet to acknowledge that gap is necessary to have as full a purchase on the everyday as possible, as well as grasp what it means to be a self.

This move into Descartes has been necessary in fleshing out some of the philosophical implications of loneliness and feelings of isolation, because these are elements of Ashbery's poetics and seem to be part of the context of contemporary life. As we have seen, Ashbery sees a connection between aesthetic questions and real-life problems. The loneliness in the poems has some specific biographical origins, but is not explained fully by the death of Ashbery's brother or the death of his beloved friend.[41] I have indicated that Ashbery believes that such feelings are part of daily life for existential reasons and because of the side effects of liberal democracy, which facilitates difference in the emphasis it puts on individuals. This is not to say loneliness is the *only* dimension to Ashbery's poetry—far from it. Yet given all the evidence, it is a significant one that is all too often overlooked in considering the ways that Ashbery's poetry becomes an occasion that reveals both distance and proximity of subjectivities. This distance appears in degrees of recognition and difference in the understanding of words arising between people. Such elements are always facets of that process of interpretation and negotiation occurring whenever language is used. The troubled moments of interaction thereby activate the various possibilities of both sense and self as people are forced to think through their understanding of a word and why they believe it does or does not fit a situation. In this way, reading and even speaking enact active analyses of situations, context, and intent.

This process of negotiating the unfamiliar familiar, the uncanny ordinary, is both enacted and dramatized in the second poem included as part of *Your Name Here*, "If You Said You Would Come with Me."[42] In this prose poem, we encounter a speaker walking with Anna, a name unknown to the reader, yet expressed with an immediate familiarity. Once again the pronouns create problems, for there is no clarity regarding to whom the "you" in the poem's title refers: is it the speaker, Anna, or the reader? Perhaps Martory? Only later do we come to know that the speaker's name is Hans; that is how Anna introduces him to a hostess at a rooftop party. The openness of the poem's title allows the reader to project identity onto the pronouns, while the specificity of the names and the ensuing situation prevent the reader from simply taking the poem as meaning just anything. It cannot become private

and personal; the reader must confront the unfamiliarity of the poem's elements and negotiate them rather than translate the poem wholesale into personal anecdote.

Throughout the poem, which is largely narrative, the speaker seems to presume more familiarity than a reader would have, and without being given an introduction or exposition, the reader is kept separate from the poem's context and events. The poem creates this position of not knowing in various ways, developing an example of an alien intimacy, one that signals a gap between the presumption of the reader's connection to the people and events described in the poem (the speaker assumes that familiarity and does not introduce the people in the poem) and the fact that we do not know Anna or, for that matter, the speaker beyond what we experience in the poem. That estrangement born out of presumed intimacy becomes itself a context or existential condition confronted by the poem.

Even the setting of the poem is unclear. The first sentences state, "In town it was very urban but in the country cows were covering the hills. The clouds were near and very moist." This suggests they are in the countryside, but then the speaker indicates that he is walking on the pavement. Soon the pair turn into a courtyard and enter a building where a rooftop party they will join is occurring, all of which sounds like they are in town. And yet at the party, the guests, who pay no attention to Hans and Anna, look out across the fields and vineyards. Set neither in the country nor in town (or set in both), the poem occurs "out of place." Furthermore, Hans, the reader's main point of contact with the events of the narrative, is himself feeling out of place and uncomfortable at a party where the hostess does not even remember his name. Hans wonders if the house is a "harvest home," a phrase he "had often heard but never understood." In these ways, the poem creates and perpetuates feelings of estrangement and isolation with Hans being outside the events, an interloper, and the reader not even having as much information and context as Hans does. The reader is outside the outsider. What the poem does provide are opportunities for observing how and why we make choices when confronted with gaps and ambiguities, for we do not leave the poem's indeterminacies unanswered. The gaps are filled in order that the poem can be read.

In "If You Said You Would Come with Me," the speaker, Hans, and Anna are out walking and "enjoying the scattered scenery" somewhere between a town and the countryside, a vagueness that makes them seem some-

what unlocatable and furthers the feeling of the unreal in the ordinary be-
gun in "This Room" and then continued throughout the collection. The
"unlocatable" perspective of the poem may be amplified by the fact that the
text is a prose poem, which is always caught somewhere between prose and
poetry, dependent on a sense of the writing's mood rather than any concrete
formal signals for it to count as a "prose poem" and not, rather, simply prose.
Even at the formal level, the poem works against expectations.

After the scene is established, however ambiguously, suddenly the two
walkers hear "a sound like a deep bell." Anna identifies the sound: " 'It's the
words you spoke in the past, coming back to haunt you,' Anna explained.
'They always do, you know.' " The speaker agrees and says: "Many times this
deep bell-like tone had intruded itself on my thoughts, scrambling them at
first, then rearranging them in apple-pie order. 'Two crows,' the voice seemed
to say, 'were sitting on a sundial in the God-given sunlight. Then one flew
away.' " Clearly the words that come back are not always straightforward.
The brief tale of the two crows is cryptic and has the veneer of mythology or
a folktale. It may be that the speaker is drawing from the myth of the Norse
god Odin and his twin ravens, Huggin and Munnin, who stood for thought
and memory, respectively. Odin's concern, so the legends ran, was that one
day, having been sent out by the god to gather information, the ravens would
not return. Odin worries about them both, but his larger concern is that
Munnin, or memory, would not come back. Given the way memory and its
return is a trope in the poem, this allusion to the Norse myth is a possible
way of reading the story that Hans thinks the "voice"—a voice that is a
sound that sounds like a bell—is telling him. However, Hans does not know
for sure what the voice is saying. And is that story about the crows some-
thing he has said before exactly, or are the "words from the past" returned
in some new way that demands interpretation? Or do we take the reference
to be some clouded element that Ashbery, the poet, interjects into the piece
because it is half-remembered, and thus does not have a specific allusiveness
that can be gleaned? Or, going a step further, is that reference open enough
that one reader, such as myself, would see it as a reference to Odin's crows,
but another reader with another set of references would read it some other
way? Thus, attaching an allusive meaning to that trope measures the way
any reader projects meanings and references onto language, and so we can
see that the crows become a screen bearing whatever words from the past
the reader can fix to them.[43]

The speaker in this poem seems to have forgotten what Anna insists he already knows: that the words spoken in the past are not passed by, they travel with us. Harold Bloom, in his seminal chapter on Ashbery in *Figures of Capable Imagination*, writes, "Poets want to believe, with Nietzsche, that 'forgetfulness is a property of all action,' and action for them is writing a poem. Alas, no one can write a poem without remembering another poem, even as no one loves without remembering, though dimly or subconsciously, a former beloved, however much that came under a taboo."[44] For Bloom, this desire for forgetfulness springs from an anxiety poets have about strains of influence, and according to this model the poet thinks he or she needs to forget in order to move forward and so as not to be overburdened by indebtedness. The passage from Nietzsche that Bloom cites is found in *Untimely Meditations*, "On the Advantages and Disadvantages of History for Life," and there Nietzsche insists that human beings must forget to a large degree the events of their own lives or they would be drowning in their own history. The more free of the past that a person is, the more likely his or her actions will be spontaneous and original (and therefore authentic) rather than being simply a reaction to someone or something else's will or force. Also, the happier the person will be. This desire for forgetfulness can be taken as a willed repression of memories since Nietzsche indicates that forgetting can protect a person from painful experiences, insults, guilt feelings, and resentments. In *The Genealogy of Morals* he makes this explicit: "Forgetting is no mere *vis inertiae* [inertia] as the superficial imagine; it is rather an active and in the strictest sense positive faculty of repression."[45] And as Freud argues, the repression of memories *can* serve as a necessary, though problematic, defense mechanism for the ego. Yet as the poem's Anna indicates (and she may well be a poetic allusion to Anna Freud), words that were spoken in the past haunt us. The repressed returns.[46]

As Bloom insists, Ashbery's poems enact that complex exchange of forgetting and remembering oneself and that acts of imagination, being composed of a lifetime's worth of learning words and all their references, always call (or, that is, *recall*) us back to language in order to create sense and context for new experiences. This trying to forget but being unable to because that knowledge is necessary for processing and understanding new experiences is part of the nature of how the mind works. It works to determine the meaning and significance of what it encounters by way of what it has known in the past. In the poem, the pair hears a sound and imagines it as a bell that

is also a voice, a voice that is our own, Anna indicates, while also being alien, unrecognized. In some ways, this describes the process of looking at art— one looks at the work or reads and sees its specifics while also looking at it as a vehicle for some other meaning. As we recall from that interview with Poulin, Ashbery maintains that a poem is "something that's going on in one's head, coming in contact with all kinds of other things, remembered experiences, words that one heard used in a different context than that in which they're occurring in the poem."[47] In that way, a poem is both of its moment, a present engagement, and caught up in memory as the words of a poem are set to work in the reader's mind. Ashbery suggests that the reader weighs both the known and the unknown against memory and experience, whether that be that words themselves serve as triggers or, like in "If You Said You Would Come with Me," bells heralding the return of memories or experiences that make new scenes understandable because of what those memories bring. "Many times this deep bell-like tone had intruded itself on my thoughts," Hans says, "scrambling them at first, then rearranging them in apple-pie order." The memories first disorient and then offer a way of making sense of a situation because they can create a narrative for understanding. The description of what the voice does actually echoes what Ashbery says poems do. "Yes . . . *and then?*" Hans wants to ask of the voice's story about the crows, and yet he remains silent. Readers are apt to ask this very same question of the story of the crows, if not the poem as a whole.

The frustration Hans feels at first—apparent in the interjection, "Yes . . . *and then?*"—seems to be in response to the fact that one needs to make choices even if what and how we choose is how anyone comes to know (and be) a self. So, too, do we do this in everyday life. Psychoanalysis is predicated on the belief that we must listen for the meanings revealed but not spoken (and even not consciously thought) in all that is said or done, and more and more Ashbery's poem sounds as if it is drawing on tropes of psychoanalysis. Elements of psychoanalysis become more prevalent as the poem continues, in that memory, social anxiety, and the reading of minds all intertwine.

Near the end of "If You Said You Would Come with Me," Hans hurries Anna out of the party because he is unsettled by the hostess, a woman who, he says, can read his mind. Anna insists that she herself is a mind reader. *Well, maybe she is and maybe she isn't,* we say, since we cannot know for sure what Hans thinks ourselves. It is not clear that the hostess did read his mind. Anna retorts, "And I can tell you what you're thinking is false. Listen to

what the big bell says: 'We are all strangers on our own turf, in our own time.' You should have paid attention. Now adjustments will have to be made." This ending and especially Anna's resigned consternation reflects a Kafka parable in more than just its strangeness and its concision. Its specificity is disorienting, and Hans, as in a Kafka parable, is at fault for something ("You should have paid attention") but does not know how or why, even though consequences follow because of this judgment. Even the accusation "adjustments will have to be made" sounds like a Kafkaesque bureaucratic euphemism.

What the bell is telling Anna and what the speaker is not hearing is a lesson about a general human condition, evident in the aphoristic form of the pronouncement. Hans feels awkward and out of place at the party because he does not know anyone and no one cares to know him, and because the hostess cannot remember his name, yet she can read his mind. This anxiety can be read as loneliness. However, the reader cannot verify whether the hostess is or is not a mind reader; we are not really given a sense of what thoughts she read. As we have seen, the entire economy of the poem creates this feeling of being unsettled, uncertain, and out of place. So, readers cannot necessarily just accept what the figures in the text say because Hans's and Anna's feelings so obviously impact their reactions to things. Hans simply may be given to feeling out of sorts and awkward, or he may just be easily bored. Questions rise up around Anna, too. She *calls* herself a mind reader, but nothing proves this. She says that what Hans is thinking is false, though again there is no way of telling what he is thinking, so there is no way of determining if she is right in her assessment, nor can we be sure that the thoughts he is having can be called false. If he feels like he does not want to be at the party because everyone there is a snob, then it would not make sense to say his thought is false. The poem deals with a basic uncertainty of interpretations and particularly those that occur in the absence of facts.

Since the bell's ringing is Hans's words returning from the past, according to Anna, Anna accuses the speaker of not hearing himself and now a price is to be paid. What she says that the bell said does not correlate with what Hans had indicated it said; there is a wide gap in interpretation, and it is hard to know which interpretation to believe. And is the "you" that Anna had used earlier in regard to what the bell signifies meant to refer specifically to the speaker, or is it meant to imply more generally "one," as if to say that whoever hears the voice hears not Hans's voice but his or her own words

coming back? In the latter case, what Anna hears are her own words, not Hans's, and so she has no grounds for accusing him of not paying attention, unless she assumes that everyone hears the same message. Within the context of the poem, we have no way of knowing for certain and the interpretation will be decided in terms of whatever seems most apt to the reader. Either paying attention (as Anna does) or not paying attention (as Anna says of Hans) comes with a result, an "adjustment" of either whatever needs to be done or one's understanding of the past. And no matter what, the reader, in the same position as Hans—that is, unsure of the bell's voice and what it says—can recognize the words being said yet be unsure what they ultimately mean, even though there is a sense that one is expected to know and judgments will be passed if the meaning is misinterpreted. This is where the feeling of isolation and estrangement arises. That this series of questions for Hans (and the reader) comes from a feeling of discomfort brought on by being at a party illustrates the ways that art can reveal the fact that in ordinary and even banal situations there exist deeper philosophical and psychological implications for how one responds to what is happening. Anna's reading of the situation, for instance, draws an ethics from a very ordinary anxiety about feeling out of place: "'We are all strangers on our own turf, in our own time'" and because of that being true of everyone, rudeness to another is unjustified. The poem enacts that very feeling of living in a gap between the ordinary and the unfamiliar, with everything having the possibility of both revealing a lesson of how a person lives and expressing what that is like.

The loneliness expressed in the idea that even in our own place and time we are strangers echoes Steven Wright's description of his apartment filled with replicas. For another poet, it might be an overwhelming crisis and the vision would be decidedly bleak. Yet, just like Steven Wright's bit, this feeling of distance and estrangement in Ashbery's poems is ameliorated by wit and charm. The ease of the voice in so many of Ashbery's texts is due in part to the fact that he believes that being a stranger to one's own "turf" and one's own words is not an unusual crisis but is commonly felt everywhere. The feeling is not a "crisis" if it is simply how things are. To say it is not a crisis is not to say there is no grief, as if that schism between words and the world, between people, and within people and their own experiences did not matter or did not come with costs and decisions. On the contrary, grief begins after denial becomes untenable. Ashbery's poetry acts as decidedly nondidactic, nongoverning model or "representative" in the way that it reveals paradoxes

of meaning and feeling in language and relationships. Throughout *Your Name Here*, not to mention Ashbery's oeuvre as a whole, the poems acknowledge frustration, the very disorientation of being "strangers on our own turf," sometimes earnestly and other times with great humor, but neither meekly nor with a resigned acceptance. Rather, the poems give an occasion for engaging that feeling of separate familiarity.

The poems I have been discussing here offer us some opportunity for undertaking the work of mourning, at least in terms of exploring a prevalent melancholic relationship to a past that cannot be regained. And Ashbery's dedication to Martory announces from its very opening that *Your Name Here* specifically is caught up in the act of mourning and dealing with what Dumm describes as "the pathos of disappearance." As the examples I provided in the introductory chapter or in other moments in this chapter illustrate, such tendencies are present throughout Ashbery's books. These melancholic aspects of Ashbery's poetry and poetics resonate with something more than elegy, however. As we have seen, Ashbery's poems are shaped by a skepticism toward the ability of language to represent the world directly, immediately, and consistently. There is also a doubt that experiences can be expressed across the gap between people's subjectivities and this manifests itself as feelings of loneliness and isolation, even though people share these feelings as part of being human. We also saw that Dumm describes loneliness as being akin to the experience of skepticism.

There is a counter to that grief in the desire to overcome boundaries of sense and experience. These attempts to exercise agency mark what counts as human, even as human beings again and again attempt to overcome the very real limitations of language and despite the fact that people are apt to meet those limitations each time. Only by challenging those boundaries do we determine what they are and, thus, what the horizons of experience might be. Ashbery challenges these boundaries through the opening of ordinary language, familiar words and experiences, to paradoxes of meaning so that limitations are not experienced as limitations but as possibilities existing within boundaries. Rather than repressing a sense of limitations, emotional distance, and doubt in the face of the bond between words and the world and between one's words and other people, Ashbery's poems test these gaps in order to acknowledge them. Even if language is always limited, it can still reveal previously unapprehended dimensions of how words may communicate experience *as well as* the boundaries of experience.

To place the connection of grief and skepticism that Ashbery's poems explore in terms of wider stakes, we can look to the opening paragraph of "On Transience," an essay of Freud's touching on grief that Stanley Cavell has mentioned on many occasions.[48] In the essay, Freud describes a walk he takes with two friends during a beautiful summer day a year before the war begins: one a "taciturn" companion, the other a young but well-known poet. Although Freud never gives their names in this essay written amid the years of the First World War, the poet, it turns out, was Rainer Maria Rilke and the reticent third party was Lou Andreas-Salomé—an auspicious trio, to be sure.[49] Rilke takes no pleasure in the beauty he sees, Freud reports, as all he can note is how everything is given to death and decay and so only experiences the inexorable mortality of all things. "He was disturbed by the thought that all this beauty was fated to extinction, that it would vanish when winter came, like all human beauty and all the beauty and splendor that men have created or may create. All that he would otherwise have loved and admired seemed to him to be shorn of its worth by the transience which was its doom."[50] Freud argues with the poet, unsuccessfully, that the mortality of things, their very transience, increases their value rather than negating it. In his reading of the poet's concern (a concern shared by Andreas-Salomé), Freud concludes that present in the young Rilke's mind is what the psychologist refers to as a "revolt . . . against mourning" and the realizations of value that would go with it.[51]

Freud describes two impulses that can appear as responses to the transience of all things. One is the despair that Rilke feels. The other is a refusal of mourning, the denial of the fact that things end. This response is an altogether avoidance of pain. Freud characterizes the impulse this way: "Somehow or other this loveliness must be able to persist and to escape all powers of destruction."[52] The denial indicates that what is beautiful will last, and since such things are the screen onto which love, desire, and value are projected, there is commensurate belief that we ourselves will continue as long as the beauty does. Mourning is a holding tight to the *absence* of things we love and know (not the things themselves). This necessary process comes to a conclusion when that hold can no longer be maintained and those feelings of grief transform themselves as they withdraw into the ego.[53] Freud writes, "Mourning, as we know, however painful it may be, comes to a spontaneous end. When it has renounced everything that has been lost, then it has consumed itself, and our libido [that is, our capacity for love] is once more

free."[54] We can see Freud as being fully in his therapeutic mode in that he suggests Rilke's worldview can be addressed and resolved not with repression or despair but with an acknowledgment, the adult acceptance of the finitude of all things including, therefore, one's self.

With this idea in place, we might even see Anna in "If You Said You Would Come with Me" as a kind of psychoanalyst since she says she is a "mind reader," which is a trope applicable to an analyst. She is able to discern, as a good analyst would, that what is following Hans, what he is not confronting, and what he is repressing are his own words from the past. If that is the case, then that final line is, more or less, what Anna interprets the speaker to be thinking and she speaks for him, speaks his words for him *to* him, and serves as representative for an interior life that is hidden from Hans. In doing this, Anna models often what we would like poems to do for us—speak the words and feelings and experiences that we have and cannot bring (or have not yet adequately brought) into language. Yet, how do we know that Anna is right? The poem ends without either confirming or repudiating her claim; it does not verify her analysis. Do readers believe her, or do we feel her to be presumptuous and sanctimonious? We must ask such questions since we have no way of knowing for sure whether she can read minds. At the end of the poem, the *reader's* feeling about this dilemma is more important than the speaker's assessment of what Anna says because it gives a means for looking at one's own responses. The meaning is not transparent, and there is no reading that can be wholly objective and conclusive, just as is the case with psychoanalysis. Poems, in their complexities of meaning and interpretation, return people to their lives rather than help them escape.

So, how we measure the import of what Anna says depends on how seriously we take the threat of her statement that "adjustments will have to be made." The reality she describes is threatening in that consequences come to those who are insufficiently attentive to their own words. The ways that the line might be resolved (that is, the way a given reader might make sense of it) give an occasion for a person to ask himself or herself about his or her own belief systems. First, however, one needs to be conscious of the fact that the ambiguity of the authority of that last line asks a question, no matter how open, that we are each of us apt to answer in our own fashion. The answer reflects one's understanding of that instance and the world in general, and does so in such a manner as to make it clear that any reading is contingent

rather than final and built from memory and understanding, misreading and subjective perspectives. Anna, if we see Anna as a voice of the poem, as well as a voice of poetry, is the creation of a friend and interlocutor, a representative Other who helps bring us to an awareness of all the elements of belief, value, and understanding that inform our every action. Whether we trust her or distrust her, she is what we *make* of her articulations, and we can read not only what she says but also the very processes we undertake in order to forge meaning from her lines, given what is projected onto them from a reader's thoughts and his or her own forms of transference.

"Most of my poems are about the experience of experience," Ashbery says in his interview with Poulin, and then adds, "the particular occasion is of lesser interest to me than the way a happening or experience filters through to me."[55] This "experience of experience" casts Ashbery's poems in terms of phenomenological, rather than simply personal, discoveries. In the intensity of poetry's thoughts we discover and recover our experiences of experience. In short, Ashbery's poetry attempts to offer its readers the opportunity to experience through someone else's representations the readers' own senses of being. This experience is never quantifiable or definable and often creates more responses in need of their own negotiations of how they came to be. Often enough, these responses can take the form of art. It is in that way that Ashbery's text reads *us* even as we read *it*. As we have seen, the title *Your Name Here* refers to whatever name a reader puts on his or her experience of occasions for interpretation. Naming that experience, making choices as one always does in interpreting, entails discovery of meaning and reference as well as the loss of *boundless* possibility.[56]

Ashbery's poems, however much they draw on some degree of loneliness and isolation, also enact the attempt to counter those forces. Often that countermeasure includes showing how other people and other voices play a role in any attempt to work through paradox and complexity. Listening *for* others as well as *to* others constitutes that dimension of hope that is so often a part of art's expressiveness. The hope is that experience *can* be shared despite the gaps in understanding the meaning of our experiences. *Your Name Here* offers an important poem for seeing this process of listening across gaps in understanding in "They Don't Just Go Away, Either." The poem invokes the pathos and tension of the complex situation of why and how answers are offered in the face of a need to address undecidability—the opposite, one might suppose, of Keats's ideal of a negative capability. In the face of paradoxes,

are the answers we arrive at merely instrumental or do they express something more complex? Writes Ashbery:

> Father, I can go no farther, the lamp blinds me
> and the man behind me keeps whispering things in my ear
> I'd prefer not to be able to understand . . .
> Yet you must, my child, for the sake of the cousins
> and the rabbit who await us in the dooryard.[57]

So much depends on being willing to be able to understand. Is the whispering man and the lamp an allusion to Tiresias, and therefore the speaker's wish "not to be able to understand" a resistance to what truths he might impart? Whatever the man says also asks of the speaker a response to the claims it makes on him. There are consequences. Such truth may be blinding and painful, an excess of things one must acknowledge. Freud, in "On Transience," observes, "What is painful may none the less be true."[58] But the reader does not know what the man says, only that he is whispering, and whispering entails working to hear what is being said.

This literary occasion in which philosophy, psychoanalysis, and literature come together illuminates how language explores the dismaying disorder of the ordinary. Such a moment reveals via language and style the way we communicate through as well as against our separateness. This persistence of language against the division gainsaying any mutual intelligibility provides what Cavell calls the condition of "living our skepticism." By this he means,

> the circumstances that it is I, some I or other, who counts, who is able to do the thing of counting, of conceiving of a world, that is I who, taking others into account, establish criteria for what is worth saying, hence for the intelligible. But this is only on the condition that I count, that I matter, that it matters that I count in my agreement or attunement with those with whom I maintain my language, from whom this inheritance—language as the condition of counting—comes, so that it matters not only what some I or other says but that it is some particular I who desires in some specific place to say it. If my counting fails to matter, I am mad. It is being uncounted—being left out, as if my story were untellable—that makes what I say (seem) perverse, that makes me odd. The surmise that we have become unable to count one another, to count for one another, is philosophically a surmise that we have lost the capacity to think, that we are stupefied.[59]

This sounds like a program for the work of listening, no matter how hard, and for listening most of all to how we sound out the world for ourselves and to risk the threat of intimacy.

Often, Ashbery's poems feature people and figures that are—as in the passage I just cited—heroically unheroic and are thus recognizable in terms of one's daily life and within an everyday domain even when the context is unclear or occluded. Nevertheless, there are stakes, Ashbery's poems remind us, for choosing to either listen or not listen. There is no way of simply standing still, no way of not coming to know what we will know. In "They Don't Just Go Away, Either," the initial speaker says it is a man who keeps whispering that moves him into a situation of knowingness and it is the father who urges him forward. In this poem, as in "If You Said You Would Come with Me," undecidability is met not with disorientation but creates a reason to reach out to others—with the figure of the friend, the beloved, however we might call it, whatever one's name for the figure would be. And this other—the "you" to one's "I"—helps us through the act of mourning or confusion or isolation. Think of Freud, who first attempts to help his companions in his efforts to persuade them that "limitation in the possibility of an enjoyment raises the value of the enjoyment."[60] In writing his essay, Freud attempts to help others, to help himself. The world he wishes to make possible is one in which others feel the work of mourning as being not only powerfully moving but also revelatory of spiritual and emotional value as well. Conversation, like art, brings forth the complexities of acknowledgment. This is no easy consolation—as Ashbery's poems indicate every interaction offers its own frustrations in gaps, mistakes, and silences—but it *is* the consolation of poetry. The poems present in multiple ways the words of ordinary life we know but hear only intermittently, showing them to be rife with paradox in their gaps of meaningfulness. The gesture of *Your Name Here* is thus a bequeathal, the poems giving us back to ourselves, as if for the first time. Readers are lead into paradoxes that deepen and expand ordinary senses of meaning tied to all the elements that make up understanding—imagination, experience, and perhaps even luck.

The value of Ashbery's work lies in the generous, open patience of his poems, poems that are the tuition, the learning offered by his intuition, that the ordinary is formed with complexities that we become inured to, and a loneliness and skepticism toward the world, words, and the other that can overdetermine all possibilities of change and motion. There is a patient hope

in art; it must be patient, for it is perpetually beleaguered on all sides and above all by a worldly increasing temptation of distraction and disinterest, and perhaps even despair that it can overcome the distances between people. What poetry asks is attention: slow, steady listening to the language where we find ourselves, by which we find ourselves through the names we give to things. Ashbery's poetry enacts a hope that lies in a willingness to try to listen to the voice whispering in our ears. This willingness is born of the hope that it is not isolation, but the drive to acknowledge and then overcome isolation and loneliness that is a measure of human possibility.

Chapter 4

ARTFUL THINGS

Looking at Warhol, Looking at the Everyday

I'm sorry—in staring too long out over this elaborate view one begins
to forget that one is looking inside, taking in the familiar interior which has
always been there, reciting the only alphabet one knows.

—JOHN ASHBERY

In Freud's description of the uncanny and Cavell's conception of skepti-
cism, we have seen a similar dynamic of alienation, that of a seemingly un-
avoidable sense that the known, the familiar, is what is least known, most
mysterious. Yet as we saw in the first chapter, according to Wollheim, lead-
ing a life is an attempt to reconcile the forward motion of living a life and
the necessary backward glance of trying to understand one's life. The para-
doxical contrast that Wollheim maps—trying to understand one's life nec-
essarily abstracts one from living that life—reflects this same estrangement
from the ordinary that we saw in Cavell's and Freud's models of perceiving
experience. What I have tried to show are various ways that certain figures
and texts manifest this estrangement from the ordinary. Sometimes, as is the
case with Wright or Ashbery, the work tries to evoke those feelings of es-
trangement and alienation as a way of negotiating them. With Ashbery, we
saw how his poems find the conditions of intimacy arising from the risk of
exposing the internal contradictions of language as it seeks to name or fix
experience. With Wright, we saw the comic using humor and comedy as a

means of confronting the uncanny effect that arises when the ordinary becomes the focus of attention. With Cavell's reading of cinema, we see film as offering a specific theater for people to experience in nonthreatening ways that feeling of alienation that skepticism produces, and then as part of that pathos remarriage comedies offer figures (such as the Bonners of *Adam's Rib*) that try to find the basis of ethical action and self-knowledge within that theatrical and rhetorical space. This can be a lesson that viewers then apply to the events of their daily lives.

Fairfield Porter argued that embedded within "realism" and mimesis is a degree of abstraction that makes even the most faithful mimesis available to interpretation, when held up as a mirror for mental dispositions, beliefs, experiences, and values—in short an understanding of the world. Not despite but because of its desired fidelity to "reality," realism is, or can be, just as conducive to interpretation and mental activity and moves viewers beyond mere recognition. Porter's argument can then be expanded to fit other forms of art and thought that attempt to deal with the everyday. The figures and texts that have thus far been discussed draw encounters with the everyday and the ordinary into the open so as to acknowledge them and recontextualize them as matters to be collectively interpreted in the form of art, philosophy, poetry, and comedy. Arguably this has the result of making the isolation and estrangement a shared condition of the sort that is the case for the audience at Wright's concerts. This means that the "usable paradoxes" these texts and figures offer are not the depiction of merely personal fantasies and neuroses but might reveal some larger, intrinsic psychological and metaphysical context. What they contribute is not a text for self-examination but a manifestation, outside of one's own flow of life, of phenomena by which one can read one's own reading of another mind. These artists present life as being meaningful and offer ways that one can learn how to make one's own life into a text.

To put things somewhat reductively, there are two ways that art can encounter reality. One way is through what we might call *vision*. *Vision* indicates a transformative imagination that discerns some potential or possibility for things. The other approach is to see what is there, set before the eyes, to be seen. *Seeing* a thing is perhaps another way of referring to what Cavell thinks of as acknowledgment. This acknowledging as fully as possible, not in terms of what it could be but in terms of what it is, avoids celebrating the everyday or making it a moment of transcendence. With

Wright's "galaxy sandwich," that feeling of transcendence is itself a form of alienation, one that triggers and is countered by self-consciousness and even anxiety. Seeing or acknowledging is an experience grounded in the everyday that strives to maintain those grounds. There may be no better case than Andy Warhol for discussing seeing as an approach and what it can reveal because he presented himself as medium for the ordinary. "I just happen to like ordinary things," Warhol once said. "When I paint them, I don't try to make them extraordinary. I just try to paint them ordinary-ordinary."[1] Warhol does not facilitate moments of Romantic transcendence so much as he fixes attention on how we might respond to the world as it is.

Not only is Warhol arguably the most significant artist of the latter half of the twentieth century—at least in terms of influence—but he is also an artist whose work, Arthur Danto has long argued, constitutes a form of doing philosophy. According to Danto, Warhol "changed the concept of art itself, so that his work induced a transformation in art's philosophy so deep that it was no longer possible to think of art in the same way that it had been thought of even a few years before him. He induced, one might say, a deep discontinuity into the history of art by removing from the way art was conceived most of what everyone thought belonged to its essence."[2]

In what follows, I discuss Warhol's work within its context as visual art as well as in terms of how it has been recontextualized by philosophy. This will entail a discussion of Warhol's art and to some extent Danto's thinking as well. In considering both Warhol and Danto's engagement with Warhol's work, we see an example of how one layer of interpretation and response (Warhol's art) gives rise to another (Danto's philosophical readings). Most importantly, Warhol creates his art out of familiar and ordinary images, and Danto's idea that Warhol is a kind of philosopher indicates what I have been suggesting all along—that the ordinary, when brought to the level of consciousness, is revealed to be a site of philosophical complexity that we overlook all too often *because* of its being so familiar. In considering Danto's arguments, we can determine his philosophical implications for seeing Warhol's art as embodying certain philosophical issues regarding ontology. Indeed, Warhol, at his best, achieves philosophical perspectives by creating work that is at the space where boundaries of definitions and categories bring together as well as separate objects and the ideas called on in order to make understanding possible. With this context in place, additional philosophical complexities and conditions can be seen as flowing from engagements

with Warhol's work. In this way, we can consider how Warhol's art, and perhaps art in general, can teach us about the discernible shape of the everyday as well as uncover the persistence of its meaningfulness. Arguably, since he looks at the ordinary-ordinary rather than the extraordinary, Warhol does not change the everyday; he transforms how people experience it, making room for Ashbery's "experience of experience." As Danto writes, "Warhol, in giving us our world transfigured into art, transfigured us and himself in the process."[3] To extend Danto's claim, we might note the self-reflexivity in this philosopher's recontextualizing the art of everyday. An artist translates the everyday into art, and then philosophy translates art once more, thereby indicating the ordinary is always shifting its position between various contexts, and in this case might be a rejoinder to the alienation and estrangement of the skepticism that haunts encountering the ordinary. Yet, I will also seek to add to Danto's readings by showing the pedagogical element in Warhol's work, which also distinguishes Warhol from other figures that I have discussed thus far.

In *Philosophizing Art*, Danto makes it clear why, for him, Warhol is a crucial figure for thinking about the interface of art and the world in philosophical terms.[4] The philosopher's earliest experience with Warhol's work occurred in 1964, when the artist first exhibited at the Stable Gallery in New York City his 17" × 17" × 4" plywood boxes silk-screened with the red, white, and blue color labels announcing *Brillo Soap Pads* on every side. Danto has continued to sound the resonances of the artist's thinking ever since, arguing not only that Warhol's *Brillo Boxes*, which replicate the mundane, commonplace cartons of Brillo pads found in any grocery store, were a definitive stepping-stone in Warhol's development, but also that with such work the enigmatic artist changed the parameters of art forever. Somewhat curiously, it has been *Brillo Boxes* that has most seized Danto's imagination, as well as the public's, and this work is among Warhol's most famous; however, for the same exhibition at the Stable Gallery, Warhol also created objects that look just like boxes of Heinz ketchup, Campbell's tomato soup, and Del Monte's peach halves. *Brillo Boxes* is much more aesthetically appealing, since the other boxes are less vibrant and look much more like cardboard with its flat brown tones. Why are these other pieces so rarely discussed while *Brillo Boxes* has become so iconic in Warhol's repertoire?[5] The most likely answer may be the most obvious. The Brillo packaging is much more eye catching, with its bright white label and garish lettering, and therefore that work lin-

gers more in people's minds than Warhol's *Heinz Boxes* or *Del Monte Boxes.*
This suggests that at least some aspect of conventional aesthetics is not wholly
dispensed with, even in Danto's own responses.

Nevertheless, with Warhol's boxes (whether they be *Heinz Boxes* or *Brillo
Boxes*) a clear set of boundaries was made evident just at the moment those
lines were made porous. Given Warhol's boxes and their commonplace veri-
similitude, daily reality permeated aesthetic experience and vice versa, each
conceptual template refocusing the eyes so as to allow a person to see both
the art world and the everyday domain in cross-dependent ways.[6] Within
Warhol's body of work there are particular reasons why *Brillo Boxes* is such
a touchstone. While by 1964 Warhol had already created his Campbell's soup
paintings and his Coke bottle silk screens, these were always clearly repre-
sentations that could not be confused with what they represented, being
more or less homagistic responses to advertising images. But even though
these other paintings and silk screens are not objects in the way *Brillo Boxes*
is, it becomes impossible to tell whether Warhol's soup cans or bottles of
Coca-Cola are meant to be representations of the products themselves (that
is, actual cans of soup or bottles of soda) or if the silk screens are representa-
tions of the images found in ads. In other words, looking at the soup cans, is
a viewer meant to compare Warhol's image to an object or to another im-
age? The difference gets at the viewer's perception of a relationship to a thing
versus another representation, and might be read as suggesting that the
difference between objects and representations of objects is winnowed away.
However, in looking at Warhol's *Brillo Boxes*, the questions regarding per-
ception are perhaps more readily evident because of the objects being three-
dimensional. In comparing Warhol's *Brillo Boxes* with the cartons within
which the actual scouring pads are packaged and observing no real percep-
tual differences, a person is forced to ask, what makes one art and the other
a "mere real thing"?[7] Such a concern starts to work at the divisions between
art and "reality."

Pop art in the early 1960s—the names Jim Dine, Claes Oldenburg, Roy
Lichtenstein, and James Rosenquist being the standard referents of that
label—made it necessary to address art philosophically because the tradi-
tional breach between art and life was being overcome as these artists looked
to contemporary consumerist culture for their inspiration rather than to the
most sublime heights of nature or humanistic values.[8] In traditional terms,
art was the apotheosis of experience and so remained separate and elevated

from the everyday. The abstract expressionists of the generations preceding pop art (Willem de Kooning, Jackson Pollock, Mark Rothko, Barnett Newman, and so on) had assailed distinctions between art and life as well, but they had done so in terms of how each action on a canvas was meant to point back to the singular presence of the artist who had performed that action. The pop artists, however, moved from the interior to the exterior. The images that one sees everywhere in the urban landscape, on television, at the movies, in magazines—everywhere that visual culture reaches out into our consciousness—began appearing on the walls of galleries and museums, walls that had once been the dominion of "great" art signifying emotional or spiritual intensity, originality, genius, beauty, and, above all else, aesthetic pleasure. One of pop art's earliest advocates, Lawrence Alloway, a critic who helped define the term, explains that since its beginnings the label of "Pop" has been applied to work coming out of "an expansionist aesthetics, a way of relating art to the environment. In place of an hierarchic aesthetics keyed to define greatness and to separate high from low art, a continuum was assumed which could accommodate all forms of art, permanent and expendable, personal and collective, autographic and anonymous."[9] This radical break with tradition that the pop artists achieve, especially in terms of the most evident aspects of the culturally hierarchical values surrounding art, means that certain expectations and conventions changed with art's opening itself to materials, styles, and subjects that previously had no place in art. Instead of a vertical understanding of art in which the original and the rarefied were exulted and images and signs that were mundane were seen as somehow either base or not worthy of attention, pop art offered a more horizontal set of values. Warhol once said that what he loved about Coca-Cola was that it was always the same—the Coke that Elizabeth Taylor drinks tastes exactly the same as the one that the homeless person drinks.[10] Such a view of things democratizes as well as makes the domain of art inclusive rather than exclusive in terms of both subject matter and audience.

This process of expanding art's boundaries and increasing its inclusivity had begun earlier than Warhol, of course. For instance, Marcel Duchamp with his readymades showed that such things as snow shovels (*In Advance of a Broken Arm*) and urinals (*Fountain*) can be brought into the context of art. Yet, the difference between Duchamp's readymades and Warhol's is a question of direction. As I noted, Alloway described pop as "a way of relating art to the environment." Duchamp, in a sense, reverses the flow by relating the

environment of an everyday domain to art by inserting ordinary objects into art contexts. Yet Duchamp did not actually claim that the object *itself* was the work of art; instead, he showed how these objects could be transformed by context and concept into art. In that way, it is not the object but rather Duchamp's intervention into artistic discourse that constitutes the work of his art. More specifically, the names that he gives to his respective ready-mades transform them from, for instance, an empty pharmacist's ampoule into *50cc of Paris Air*. Through the act of naming the object, Duchamp creates out of thin air (so to speak) a specificity that brings with it a host of associations and references to Paris and all that it might invoke, but it also plays on one's desire to be able to transport and even save the essence of a place. Duchamp understood that this process happens in the mind and not through the object qua object. On the other hand, Warhol, with his *Brillo Boxes*, uses the practices of art to make an object that *appears* to be a "mere real thing" into an art object and then even titles the work after that thing, rather than using the title to create some additional set of references.

To take the next step and to think of Warhol as an exemplar of philosophical thinking has less to do with thinking of Warhol's work as transgressive or radical in terms of what it does to discourse, and more to do with making a case for showing that his paintings, silk screens, and sculptures offer new ways of perceiving both art and the world because of ontological and existential questions they raise, questions that extend beyond the artist and can be taken up by others as well. To begin with, Danto believes Warhol's work indicates a possession of a full self-consciousness that could not have been possible as art at any other time.[11] This aspect of Warhol's work I will turn to shortly, but I first want to place Warhol (and Danto's thinking about Warhol) in a context that broadens the work's reach.

In describing an ideal version of an artist's contributions to the general commonwealth of knowledge, Danto argues that "the originality of the artist comes from inventing modes of embodying meanings she or he may share with communities of very large circumference."[12] It should go without saying that Danto believes in the originality of Warhol's work. Nevertheless, originality does not necessarily mean singularity. While Warhol's practice of making art that so closely resembles objects in the marketplace is original, such efforts draw on very recognizable commercial elements. In fact, the familiarity is essential to the work. This is true not only of *Brillo Boxes* but of Warhol's silk-screened representations of Elvis and other celebrities as

well. Indeed, some work, most especially that which in the fullness of time comes to be thought of as important, invents modes that embody or enact meanings shared by as wide a community as possible, though not as wide a community as is *imaginable*. We might do well to add that such a community needs to have a certain durability or continuity that distinguishes the community as significant and cohesive rather than transitory. The shared meanings sketch out the shape and limits of the community, and the community represents shared or cohesive meanings. As Danto's observations point out, for there to be communication, the meanings must be shared, or at least recognizable to the constituents of a community, even as the modes for embodying them are invented or discovered anew. If the meanings exist prior to the artwork, then the modes the artist employs are what reanimate or recast those meanings and values. The importance or greatness of an author or artist lies in that person's abilities to both innovate forms and represent meanings, even if those values are transgressed or critiqued. The ground for thinking of artists and writers in terms of their significance is the belief that art and literature can have bearing on even daily lives. The larger issue is how and why art touches the ordinary.

The images Warhol's work draws from are images immediately recognizable to everyone, and in that way signify a kind of inclusive *Lebensform* developing out of and circulated by the media and the marketplace—from soda to supermodels. The Wittgensteinian concept of *Lebensform*, or "form of life," refers to historical groups of individuals who are bound together into a community by a shared set of complex language-involving practices.[13] The community is formed not by agreement of opinions or values but by a pattern of activity and mores. The *Lebensform* Wittgenstein describes is the frame of reference we learn to work within when initiated into the language of our community. Learning that language is thus learning the outlook, assumptions, and practices with which that language is inseparably bound and by which its expressions come to their meaning. Warhol, by employing not nature but images and icons that were so immediately recognizable, suggested the language of images that mark a community and its *Lebensform*. Warhol effectively turned to pop images as the bank of signs that Americans could all recognize and be familiar with—or even comfortable with—because the images are so familiar.

Warhol saw how the media have increasingly disseminated pop culture, creating a network of images and meanings that have bound together groups

of people. Of course, Warhol, a lifelong practicing Catholic, would have been attuned to how both pop culture and iconography employ images to mark culture and belief, serving not simply to reinforce ideology but to create a sense of cohesion within groups of people who identify themselves and others by way of their relationship to the meanings carried by those representations (by superstars and saints, respectively). Warhol's talent was his ability to shift contexts—moving from one culture or language game to another. He moved from Catholic iconography to pop culture spectacle and from Madison Avenue's advertising to the high art of the Museum of Modern Art. In drawing his work from a shared set of secular images, Warhol shows how that spectrum of images and practices drawn from supermarkets, television, and newspapers has a potential for metaphoricity that is often lost because of familiarity and ordinariness. By metaphoricity, I mean to indicate that the images, in their new context, are not to be taken simply as literal signs of specific information, though they do have that capacity. Their metaphoricity entails their ability to signify meaning beyond the literal. It is not simply enough to say such images are estranged from their usual context. By placing them within art, Warhol draws on the fact that art is the context within which every thing is approached as if it is meant to be an experience given over to interpretation.

For Warhol, that anyone could comfortably recognize the images he pulled into the art world meant also that anyone could feel as if he or she had some stake in a vocabulary that everyone could draw from, not just those who had some daemonically inspired, heightened aesthetic sensibility. In 1962, Warhol created a series of paintings titled *Do-It-Yourself*, which are half-painted scenes of landscapes and flowers created in the vein of "paint-by-numbers" kits, with numbers marked on the canvas in parts of the images outlined but unpainted to indicate which colors should be applied. These paintings could be taken as ironic rejoinders to the avant-garde tenet that viewers complete the meaning of any painting or image. Yet, beneath that reading is the fact that a general viewer would recognize just such a kit and because of that familiarity would be able to decode what the somewhat arbitrary numbers are meant to represent. Someone who had no prior experience with such a kit would not be able to create any connection between those numbers and anything else. The familiarity of the practice is what invites the reader's participation, not that he or she has to fashion meaning in the absence of a clear narrative or symbolic content. The painting, then, is

not "about" the landscape outlined and partially painted in on the canvas. Instead, the painting foreground activates viewers' awareness of patterns of reception that are already established, and Warhol's work deals with relationships between viewer and artwork—and artist and viewer—rather than some paraphrasable, representative content. In other words, anyone who recognizes the idiom Warhol is drawing from in his homage to the "paint-by-numbers" kits is part of a larger group and the shared familiarity marks the boundaries of that group. With those kits the idea is to allow people who cannot draw or paint because they lack training or talent to still participate in making art that is recognizable as art. Warhol's *Do-It-Yourself* series does at least three things: it uses wit to level the difference between the rarefied position of a professional artist and an initiated viewer (both desiring to be part of the art world), it draws on an idiom that demystifies the artist, and it signals Warhol's own awareness of what viewers will be able to identify with. Of course, different viewers will have different responses—an elite art world aesthete will see Warhol as commenting ironically on the mystique of artistic genius or on the commodification of works of art. A more general viewer will see Warhol making use of a familiar and homely art kit in a way that lets the viewer in on the joke, and is therefore inclusive. As with any "do-it-yourself" kit, even as the outline of meaning is offered by Warhol's painting, the viewer must provide the color and tone.

The proliferation of media images throughout the contemporary cultural environment ensures any viewer's consciousness is shaped by images found in advertising, movies, or comic strips before reencountering them in pop. One's image literacy is honed and formed by the media, and even illustrated children's books begin training people's eyes prior to any exposure to what is generally called *art*. In the early 1960s, pop's assimilation of those images usually attached to commodities and celebrity (two categories not altogether distinct from one another in terms of consumption) resulted in the problem of how to determine the continuity of art conceptually—what we might call its historical narrative. The problem took the form of the now familiar question, "but is it art?" due in part to the fact that what artists such as Warhol, Rosenquist, and Oldenburg were drawing on were images that had first appeared in advertising and in magazines or on supermarket shelves and were not either taking their subjects from nature (as the impressionists had done) or producing the drips and swipes expressive of the painter's interior life (as the immediately preceding and then dominant generation of action

painters were doing). If the hierarchy of values had been so completely re-structured that objects and images from the marketplace could be repre-sented or even utilized by artists in the same ways that portraits and still lifes once had been, as well as art being made to look like mere objects (rather than transformed objects), there had to be a new thinking about what art's relationship to the world might be. Philosophically speaking, the continuity between Warhol and what preceded his generation comes from the work's both demanding and providing an opportunity for interpreta-tion. The interpretation occurs not only in regard to where a work of art stands in terms of its historical moment and its response to the aesthetic sensibility of prior eras, but in regard to *all* objects and images.

In the introduction to *Philosophizing Art*, Danto reflects on what he saw as the central issue facing him in his attempts to write about the aesthetic implications of Warhol's work from the very beginning: "Instead of attempt-ing to define art as such, the problem, far more tractable, was to distinguish philosophically between reality and art when they resembled one other per-ceptually."[14] Considering contemporary art, beginning with or at least being amplified by the cultural inclusiveness of pop art, there came a difficulty in simply using one's eyes to see the difference between art and "mere real things." Because some aesthetic aura could not immediately be en-sured as "arising" like some magic essence from one box rather than the other, Danto finds Warhol's work establishes a site for a crucial act of on-tological questioning, and therein lies the grounds for thinking of Warhol as a philosopher.

The skepticism that inflects this question comes across quite clearly: the senses can give no clear certainty in regard to ontological status in this in-stance of regarding the work by Warhol and the actual product's packaging. The senses, as Descartes warns, are the locus for doubt. Elsewhere Danto insists, "The form of a philosophical question is given—I would venture to say always, but lack an immediate proof—when indiscriminable pairs with nevertheless distinct ontological locations may be found or imagined found, and we then must make plain in what the difference consists or could con-sist."[15] The way Danto phrases the issue, with its Cartesian inflections, makes evident why Danto maintains his belief that Warhol's art, in its complex at-tention to repetition, reproduction, iconicity, and surfaces, has much to teach us not just about art but also about our relationships to things as well. In asking questions and attempting again and again to establish what constitutes

art and what constitutes "real things" in elaborating how distinction between art and reality might be established, viewers encountering Warhol's work are brought to investigate the most basic and fundamental issues of philosophy and how we chart and value the set of relationships between a self and the world it inhabits.

I would add another element as well and say that the skepticism intrinsic to the problem of Warhol's work goes both ways: one can look at a Brillo box and not be sure that it is not a mere real thing—at least the senses will not offer definite proof—but now, after Warhol, one cannot look at a Brillo box package and be sure that it is not a work of art. In other words, all the processing one engages in when looking at Warhol's soda bottles or soup cans or boxes does not then just stop at the museum door. The new way of seeing art enters into how one perceives the world. One then has to ask, "what makes this 'just' an object?" And if the artwork is a vehicle for meaning and association, the very fact that these are activated in the art space means such things are latent in the everyday world—latent but still present potentially. In that way, Warhol's work has a pedagogical effect as well as an aesthetic effect.

Since philosophy invests itself in charting out the ways that language and the world touch, in mapping the gap between the world and what human beings use to make sense out of their experiences, art that illustrates how objects are surrounded by language on all sides and interrogates context participates in its own philosophicality. Emerson and Nietzsche envision art as having the function of creating new artists by transforming viewers and readers into people who see the world aesthetically. If we place this view alongside Danto's argument that contemporary art has come into its own self-consciousness and taken on its own philosophicality, then we can say that with Warhol each viewer (or reader) ideally learns from art how to use the everyday and the commonplace to question the most fundamental concerns given to human consciousness—death, finitude, existence, and our indeterminate but self-defining relationships to the world. That art can so ably foreground the ordinary illuminates how the ordinary itself is a potential site for philosophy. This requires a certain self-consciousness in the art that activates a self-consciousness in the viewer as well. We may recall in the introductory chapter that Ashbery, in discussing Fairfield Porter's work in "Respect for Things as They Are," describes Porter as "intellectual in the classic American tradition." Ashbery characterizes this tradition by saying

Emerson, Thoreau, Porter, Moore, and others "have no ideas in [their work], that is, no ideas that can be separated from the rest. They *are* idea, or consciousness, or light, or whatever." We can take this to mean that these thinkers produce texts and art that enact their thinking and embody meaning at the level of style and form rather than simply commenting on philosophical problems. These figures create self-conscious works of art that question and trouble their own terms. For that reason, we can see Warhol as being part of this tradition, a tradition whose primary figures are all also committed to setting their philosophical stakes in the ground of the ordinary.

With this idea of self-consciousness in place, Danto substitutes for the dreary question "But is it art?" a more challenging inquiry: What is art that it can accommodate Warhol's *Brillo Boxes* as well as, say, Caravaggio's *The Calling of Saint Matthew*? Given such a wide spectrum of possibilities, what are we saying when we call something art? In looking over the last one hundred years of art history, Danto observes that throughout the twentieth century and especially with the advent of pop, which enacted a kind of apotheosis of art's consciousness of itself, art has reached a moment of culmination in which there is no longer a somewhat narrow way that art is *supposed* to look. Whatever the criteria for art might be, how it physically appeared is no longer a factor. If there need not be any visible difference between art and other material objects—and with conceptual art the work need not even be material—it was not the senses but thinking that would be the arbiter of whether something was or was not art. Moreover, various modes of art have come to exist simultaneously rather than each new style or school necessarily displacing or making irrelevant what came before. Thus, not only does Tom Friedman's *Untitled (Eraser Shavings)*, a pile of red eraser shavings arranged on the floor in a circle, coexist in the same aesthetic period with David Hockney's vividly colorful paintings of California swimming pools, but both have equal claim to being called art as well. Danto explains that this new inclusivity means that "as far as appearances were concerned, anything could be a work of art, and it meant that if you were going to find out what art was, you had to turn from sense experience to thought. You had, in brief, to turn to philosophy."[16] Furthermore, Danto insists, there needs to exist a theory of art expansive enough that it could accommodate everything from Warhol's *Brillo Boxes* to Robert Rauschenberg's *Bed* to Willem de Kooning's *Woman I* to Raphael's *The Transfiguration*. The work, whatever it might be or whatever form it might take, would

be situated within the context of art inasmuch as it stands in conversation with its own moment and with art's prior eras.

This dizzying inclusivity, Danto believes, signals that we have reached "the end of art." Too often this statement is misconstrued as a suggestion that art is over, that painting or any other medium is materially and conceptually dead, exhausted. His point is far from this. Danto has stated repeatedly that in describing the present state of affairs as "the end of art" he is offering a model for the narrative of art's development based on G. W. F. Hegel's ideas of a teleological history.[17] In Hegel's view, history constitutes a narrative in which the potential of universal rational freedom is actualized through a progression of events whose internal mechanisms of conflict broaden the possibilities available to the *Geist*, which can be translated as either Mind or Spirit. When *Geist*, or a collective rational subjectivity, achieves absolute consciousness, History will come to an end. "The History of the world," Hegel writes, "is none other than the progress of the consciousness of Freedom; a progress whose development according to the necessity of its nature, it is our business to investigate."[18] Essentially, art has *achieved* that condition of maximal freedom in terms of what it might and can be and its self-consciousness testifies to this achievement.[19]

With art having come to the end of its narrative means, Danto believes, any new developments will not displace or make irrelevant what came before, but will be folded into the active definition of art and its now expanded possibilities. Its dialectical imperative has come to rest. In that Danto's earliest work deals with the philosophy of history and narrative, his tendency to read the story of art in such a Hegelian inflected manner is not at all surprising. Narrative entails not just things happening over time but a linked series of events progressing toward some end or conclusion. In terms of possibilities, we have arrived at a moment of absolute freedom regarding what counts as art. The inclusiveness that Alloway describes as being characteristic of pop moves outward to redetermine all of what we call art, and in that way the narrative by which the history of art is expressed shifts from verticality to horizontality.

The inclusive model for art Danto has developed necessitates that such a theory be at once pluralistic and self-conscious, with each work of art necessarily commenting on and enacting the possibilities for meaning that it expresses. Warhol's boxes, for example, raise an ontological question not separate from but part of the work; with that, art not only intertwines with

but also becomes a form of philosophy. Asking about its own existence, the work of art comes into a form of self-consciousness. Again, this view of art coming to consciousness of itself is predicted by Hegel, who writes in his lectures on aesthetics, "The universal need for art, that is to say, is man's rational need to lift the inner and outer world into his spiritual consciousness as an object in which he recognizes again his own self. The need for this spiritual freedom he satisfies, on the one hand, within by making what is within him explicit to himself, but correspondingly by giving outward reality to this his explicit self, and thus in this duplication of himself by bringing what is in him into sight and knowledge for himself and others."[20] We might then pair this passage with a statement Warhol made in an interview conducted by the journalist Gretchen Berg: "[Pop is] just taking the outside and putting it on the inside or taking the inside and putting it on the outside."[21] Warhol's vision may be far less explicitly Romantic than what Hegel describes, but still the artist's work indicates how art manifests certain internal, though not private, aspects of subjectivity. If culture and its signifiers, no matter how banal, go all the way inside, then even the most private images are built from images everyone could conceivably recognize. Warhol *sees* rather than *envisions* the connection between the interior and the exterior. Through Warhol's eyes, the everyday becomes the very thing by which people might recognize themselves and their subjectivity.

Within Danto's model for a philosophy of art that could encompass art's full spectrum of possible media and method, poetics and potentiality, a given work of art must have an "aboutness" and it must then enact that aboutness. The concern is that any distinction between art and "mere real things" could fall away, hence this emphasis on interpretation as the essence that separates the two orders of objects—the difference is not material or perceptual. In this way, Danto offers an expressivist notion of art; what is expressed, however, is not necessarily some private experience, but rather the whole network of ideas and beliefs, the context writ large, within which the work exists.[22] Artworks are what Danto refers to as "embodied meanings."[23] Thus, we might see a canny wit working in Warhol's choices to make boxes and paintings of cans, boxes, and bottles—these are all forms that emphasize their contents, whether that be soup, soda, or soap pads. The work points to the act of containing something, as if to suggest that the art exists in order to contain meanings.

A work of art would not reduce to a specific idea; instead, art calls forth the struggle of and for interpretation, since what the work expresses goes

beyond intentionality, though to be art it must be born out of intention, and expresses the wealth of conceptual, historical, and cultural context that co-alesce not just in the work of art but also in the mind and life of each person who sees the work.[24] This multiplicity of readings and interpretations can stand as a testimony of pluralism just as well as it can be a testament to the partiality of any single person's perspective—mired in time, luminous in a complex subjectivity. By the same token, since there is ever an object (or con-cept) that any viewer struggles with in the act of interpreting, meanings will be tethered to the specific work of art and the audience will struggle to un-earth the work's conscious thought—a beginning place, to be sure—as well as that which was unsaid or even unthought but that lies as a latent aspect of the art under consideration.

Take any or all of these famous works by Warhol: the film *Empire*, the Brillo boxes, the soup cans, *Tunafish Disaster*, Marilyns or Jackies of any color, even various prints of electric chairs. Is it possible to have a wholly disinterested response to these images, all of which carry with them their rhetoric, their intention of significant (signifying) persuasion? An electric chair not only serves a specific function of delivering punishment but also be-comes a symbol (or so some say) in a way that is supposed to serve as a deter-rent to others; the Empire State Building stands as a monument to human endeavor, achievement, and conquest, as the name makes sure to impress upon us. Brillo boxes and soup cans sport labels that catch the eye and sell the product, marking the brand in the mind's eye, as if to say we see through branded eyes; Marilyn Monroe and Jacqueline Kennedy Onassis, their respec-tive biographies colored with tragedy and lived in negotiation with mascu-line power and desire, are celebrity icons of beauty, fashion, and influence who have become so familiar that their full names need not be mentioned. Warhol latches onto all of these images and signs, eliciting from their ubiq-uity a familiarity that reveals how iconographies, in being shared vehicles and engines of meaning, reveal the cohesion of individuals within a culture.

Let me linger over one of the pieces included in what has become known as Warhol's *Death and Disaster* series: the 1963 silk screen ink on silver poly-mer paint on canvas known as *Tunafish Disaster*, of which there are two versions. In 1962, Warhol had already painted a series of "headline" paint-ings. These were paintings produced by hand that replicated pages from contemporary tabloids featuring articles about Elizabeth Taylor and Eddie Fisher or a page of the *Daily Post* with "A Boy for Meg" emblazoned across

the front, announcing the birth of a son to Princess Margaret. Warhol did not include these tabloid pages as material parts of still life paintings, as Picasso had done in his celebrated collages of 1912–17 (such as *Glass and Bottle of Suze* and *Bottle, Cup, and Newspaper*). Nor did he use newspapers as a surface on which to paint as Rauschenberg did in many of his combines. Warhol instead made the black-and-white texts and images of the very pages of the tabloids the "objects" he was representing. The text and images are in that way a form of abstraction insofar as he was not representing nature or the world, but representation itself. Warhol's tabloid paintings are images of images, of the intangible rather than the material, versions of how human interactions are presented back to viewers and readers. Warhol would continue to return to working with headlines or press photos throughout the rest of his career.

The two paintings that compose *Tunafish Disaster* differ from his earlier tabloid paintings in that there is a darker aspect to what is being reported and that Warhol did not paint them but used the silk screen process. Warhol had begun his *Death and Disaster* series with a work drawn from a headline: *129 Die in Jet!* was taken from the front page of the New York *Daily Mirror*, but Warhol's is a painting, not a document, and the switch to a different process brings with it new aspects to read when we attempt to draw meaning from the image. In regard to their dimensions, the paintings that make up *Tunafish Disaster* are sizable but not monumental. One is larger than the other (316 × 211 cm, the other 284.5 × 208.3 cm) but both are composed of headlines, press photos of the faces of two middle-aged women, and the photo of a can of a store brand tuna fish with numbers handwritten on its sides. All of these elements are silk-screened multiple times onto the canvases. The smaller version includes newspaper text that explains that the two women, Mrs. McCarthy and Mrs. Brown, were housewives from a midwestern suburb who died, slowly, hideously, from having eaten tainted canned tuna. The headlines of *Tunafish Disaster* ("Seized shipment: Did a leak kill Mrs. McCarthy and Mrs. Brown?") are so tabloid-commonplace that it is impossible not to read them as we do any other case of such miserably saddening news: with some sense of pity and empathy, yet with an emotional distance arising from the condition of being inundated daily with just this sort of news. Their greatest tragedy is that the story has no tragic, transcendental element. This constraint might very well also fall within the scope of what Danto called "the tragedy of the commonplace." In and of itself, such

a news story, when encountered in the daily papers, is informative but would be taken to have significance beyond the reminder that death can come from the most familiar sources, such as a can of tuna.

Revising the news story by making it part of his artwork, Warhol accomplishes two things. He borrows on the comfortable, nostalgic domesticity laden in his Campbell's soup paintings and yet shows that nothing can be taken for granted. In fact, one could, after seeing the *Tunafish Disaster* canvases, look at the soup cans, created just a year before, and wonder if botulism might be lurking within any of those cans as well. This is not to say that the soup cans or even the Brillo boxes seem insidious after *Tunafish Disaster*, and yet Warhol complicates the familiar (the homeliness of a can of tuna) with the fact that one does not necessarily know all there is to know in the most ordinary of things. Just as this realization that even a can of tuna may hold some degree of the unknown (not just something deadly) pushes against how one sees the work, it also shows what happens when an ordinary news story is brought into art.

Rather than just being informed about the specific deaths of these two women, a viewer engaging *Tunafish Disaster* now has an added dimension in regard to how he or she receives this information. As part of a work of art, the story moves from just a specific instance, a singular case, to something more generalizable. By this I mean it becomes something more than a feeling that what happened to these two women could conceivably happen to anyone, for that would be merely a matter of information. The headlines and news, now included within the artwork, become part of a process of negotiation because a viewer places such information within a framework that has historically determined that art demands an ongoing process of interrogation because its meaning is not fixed. A reader or a viewer keeps asking questions, but not about causality or blame or aspect from wholly empirical observations. Instead, the questions are of the order of discourse, affect, ethics, and existential meaning because there is a presumption that some insight might be extracted from the work. In the context of art, actions are shown to be mental actions and the context self-reflexively presents phenomena that are otherwise overlooked in everyday life so that they might be interpreted as carriers of meaning.

Ezra Pound once described literature as "news that stays news," and Warhol's *Tunafish Disaster* could be seen as commenting on that claim. I take Pound to be suggesting that what enters into art keeps opening new inter-

pretative possibilities. Art itself holds a certain faith that it does not make an argument so much as enact relationships and worldviews that are never transparent. Thus, art is not communicative, which would mean that the news comes to a conclusion once it has been received, but expressive, and expression in any form is as complex in terms of its emotional and existential components as is possible, formed as it is out of both an individual's understanding and psyche as well as a culture's conventions and mores.

One way that Warhol changes the context of the news is through the repetition of images. That Warhol uses a silk screen process means that the headlines and images can be endlessly repeated. Unlike with a painting, which is each time a singular event, with a silk screen the possibilities of reiteration and return are part of the work itself. Paradoxically, the very fact that the images and headlines are repeated on the two canvases enters into the series of experiences that for a reader join together and keep the events poignant. The repetition is part of what is to be interpreted because it signals the difference between art and communication. The repetition asks for attention. In actual news, repetition can dull the significance of any story or photograph. In art, one must deal with that repetition and factor it into his or her understanding. With this, Warhol indicates how art incorporates a self-consciousness that the news media never confronts.

With any and all of these cases of Warhol's representing the most ordinary and familiar of objects, a viewer cannot be fully divested—the images are familiar, reminding us of our daily lives and the ways and means that we are always being spoken to at every turn by objects and images, texts and words. Yet there are differences in the images. As surprising as it is to see Campbell's soup cans in all their variations and iterations on canvas after canvas, *Tunafish Disaster* creates a shock and perhaps even an uncanny effect of seeing the photos and text from the daily news (especially such a saddening story) as part of a work of art, since news is *supposed* to be objective and art is *supposed* to be subjective. The surprise of seeing in a work of art not just the particular headlines of *Tunafish Disaster* but also the grisly details of how the women died after acute seizures offers the opportunity for thinking about what the conditions are that establish our expectations so as to present an event this sad and this prosaic from being something we might anticipate as appearing in art. In Warhol's work, the death of these women enters into the artwork and rather than disappearing into the daily deluge of news coming to us from the papers and television, it continues to

work on the viewer who engages the question of what it means to differentiate between art and news.

Warhol's inclusivity, in other words, provokes questions about perceptions and how values attach to those perceptions. If both art and news are forms of representation, what are the differences between them? What follows entails asking complementary questions. What does art do? What do news stories do? When we read or look at such things in their expected milieu, what are our expectations and why do we have them? In short, by asking about our relationships to these things, we are asking, who are we when we look at a work of art as opposed to a newspaper article? What happens to these things and to us when those contexts are made porous? Warhol's *Tunafish Disaster*, in distorting the newspaper's reporting through his artistic praxis (its repetition and its use of a painted canvas), draws attention to how the events are represented. The work makes evident that the news does not merely communicate, but rather it shapes our perception through the combination of words and images. Beyond that, Warhol makes it clear that context determines not only a thing's meaning but also how we attune ourselves to a thing, an image, a story. By transforming contexts, Warhol's *Tunafish Disaster*, in no lesser or greater degree than the soup cans or boxes, reveals what and who we become in the course of negotiating and reconceiving the cognitive and interpretive patterns we establish to understand things. These interpretive identities are contingent at best. Call this a form of adaptability. Our modes of understanding, Warhol makes clear, could be otherwise.

In thinking about the philosophicality of Warhol's art, it is important to see what he does in getting viewers to consider objects by crossing contexts and expectations. These efforts of Warhol's suggest he initiates new ways of looking at work that makes context a crucial part of how we see it. Encountering the work of art after the end of art—including especially work that engages the ordinariness of the ordinary—one becomes aware not only of the experience of beauty but of the lack of such an experience. Not only can *any* thing potentially be art at this point in time, but also any experience can be part of that art—not just beauty, pleasure, or the sublime. Engaging with meaning as a primary characteristic of art, one must become aware of the elements of understanding that contribute to experience itself. Such an experience cannot announce itself since it is less likely to have a determined form established a priori. Perhaps this is best described by what Ashbery called "the experience of experience," when one is self-conscious of how one

is taking in stimuli and forming a response to it. Because the experiences that art makes available are so variegated and various, the question of quality becomes somewhat beside the point because there is no one condition—for example, excellence of mimetic representation in pursuit of beauty—that art as a whole is trying to achieve. Each piece sets out to achieve something different, and can only be weighed against what its internal demands are determined to be. With no set criteria, there is no way to gauge in any definitive manner such judgments of work being either "good" or "bad." Other judgments come into play—for example, if a piece is consistent or inconsistent in regard to its inner logic. There is simply more that the viewer needs to do, which pushes not only aesthetics and criticism beyond where they have traditionally stopped, but also the sheer act of looking at art.

Works prior to the twentieth century stood in need of interpretation, but the court of meaning was far more limited and determined. Since painting or sculpture was once predicated on mimesis, what was being interpreted were scenic elements (was the figure on a horse, seated, at a desk, set in a drawing room, holding a bible, and so forth) or dramatic aspects (the range of facial features, the action the subject was depicted as engaging in) with iconicity being a system of social signification.[25] These features do not call for the very ontology of the work itself to be considered and brought to the level of consciousness. It is necessary to take these developments into consideration in order to understand that after the "end of art," art actually needs to be looked at differently. This complexity leads to an openness in forms of reception. If there is no way a work of art is supposed to be, then there is no one way its meaning is supposed to be determined. The result is that viewers have to work much harder at understanding the work because the questions to be asked of it are not a given.

If art once traditionally provided icons that circulated and reaffirmed attitudes toward religious and historical figures and disseminated ideological beliefs and morality, visual culture still maintains a pedagogical impact in shaping how we understand and familiarize ourselves with emotions in social and even ethical situations. Movie stars teach us what beauty is; films and television programs represent emotions writ as large as possible so that viewers can recognize in the broadest way their own range of affect. Warhol had a remarkable grasp of the role media play in disseminating ideals and even teaching and reaffirming cultural and moral values, such as they are, and married this to the traditional function of high art to represent humanity's

highest sense of beauty and achievement. He saw that art *complicates* the iconicity when it troubles its traditional function as the reserve of the beautiful and of aesthetic pleasure. If the form of art breaks from such conventions and can be anything, then a specific variable set of forms alone is not a criterion for art. After Warhol and the end of art, what makes art art is not form alone but meaningfulness as revealed by form. One cannot say that a specific meaning makes something art, for art itself works against a specificity of meaning. Instead, it takes the problems of meaning making and the reception of meaning as its subjects. This is the nature of art's self-consciousness.[26]

By extension, such an argument suggests that artworks do have an essential degree of intrinsic metaphoricity, and it is that which makes them art, insofar as a metaphor is grammatically imbued with "aboutness" and enacts its aboutness. Danto connects metaphors and artworks by arguing that the two share certain structures; in both cases "they do not merely represent subjects, but properties of the mode of representation itself must be a constituent in understanding them."[27] Not only are the artworks vehicles of meaning but also they bring to the fore through self-consciousness of their processes the means of attending to how one thing can stand for aspects of another. Joseph Margolis, critiquing Danto's theory of art, offers useful clarification of what Danto means by *metaphor*. "Danto views art as the *rhetorical* effect of an artist's treating some 'real thing' metaphorically. . . . The 'structure of art' is, then, in the mind of the artist (or 'percipient'), *not* in any public artwork: it is an imaginative 'context' *we* bring to certain 'mere real things.'"[28] Margolis then asserts that what Danto risks is "not ontology at all but a reminder of the sense in which understanding art is tantamount to understanding ourselves," which would mean that there is no actual ontological difference between art and a "mere real thing." The dilemma Margolis illuminates speaks to the ways that skepticism is not wholly evaded in Danto's—or Warhol's by way of Danto—thinking about art. This strikes me as, to invoke Porter's phrase, a "usable paradox" in regard to how we conceive of our relationship to the everyday. That is, the question would arise, is there an ontology as such or are these distinctions "merely" within the mind?

To call on the language or discourse of art in the process of looking at an object is to decide to call such a thing *art* and then to work that object into the discourse.[29] This premise, however, does not necessarily move us toward metaphor. Danto's use of *metaphor* is perhaps itself metaphoric, or at least

rhetorical, as Margolis argues. There is a degree of incompleteness to the structure of metaphor as Danto applied to art. This is because he sees the metaphor as necessarily being completed by the receiver. Certain conditions must be in place. For instance, one must know, within a given context, that a thing is standing for something else, or perhaps signifying an other un-paraphrasable experience. The metaphoricity that works of art embody and enact creates opportunities for acts of interpretation focused through the art—or words, in the case of verbal metaphors—thereby gathering language around itself. The language one uses serves to express a series of decisions that one makes to contend with a situation or condition. That is to say, the art feels that it offers something beyond the literal.

I have mentioned that Danto's drawing on metaphor makes use, strategi-cally, of its being an incomplete structure. Danto draws on the enthymeme, a specific rhetorical figure, to outline what he sees as the metaphor an artwork can offer:

> An enthymeme is a truncated syllogism, with a missing premise or a missing conclusion, and it yields a valid syllogism when, in addition to meeting the usual conditions of syllogistic validity, the missing line is an obvious truth: something anybody can be expected to accept without special further effort: a banality. But the enthymeme then does more than demonstrate its conclu-sion given the truth, and in the pertinent case the obvious truth, of its prem-ises. It involves a complex interrelation between the framer and the reader of the enthymeme. The latter must himself fill the gap deliberately left open by the former: he must supply what is missing and draw his own conclusions ("his own conclusions" are those "anyone" would draw). He is not, as a pas-sive auditor, told what to put there; he must find that out and put it there himself, participating in the common procedure of reason, which operates the way responsive prayer is supposed to do, where a congregation is not prayed at, or in front of, but with. In a small way, the audience for the en-thymeme acts as all readers ideally should, participating in a process rather than just being encoded with information as a tabula rasa.[30]

For Danto, the fact that we recognize the figurative nature of an artwork establishes that foundational context and the act of interpretation is the way the viewer takes part in the process so as to provide the missing element.[31]

The creation of the work of art itself also reveals the artist's decisions of composition and the values used to create an object that he or she calls art.

From one person's situation, the decision of another's must be contended with—recognized, identified, disputed. This negotiation is what it means to be a human living with other humans. Art arises as an exemplary occasion for human engagement, an engagement with the other's engagement with his or her understanding of the world. The more blurred the distinctions between artworks and everyday objects become, the more we are required to consider what constitutes those differences, thereby reshaping our shared imagination for what art asks of us as human beings. In contrast to the grandeur that defined the focus of art from prior eras, regarding Warhol's work, the engagement is with the ordinariness as ordinary, with the things most familiar to human beings and which they wish to overcome, as against the heroic and sublime, that which they most idealize and wish to become.

It is necessary to have this changing paradigm for art and what constitutes contemporary aesthetic experiences in view in regard to Warhol largely because his work activates the very fundamental questions of the contexts on which interpretations depend. Warhol's work examines how people form relationships to objects and images and how these relationships determine the ways a person engages other things and even other people. Warhol finds these complications are not exceptions but are present in the most everyday examples.

Warhol's series *Dance Diagrams* offers an allegory of sorts for this process of engagement that I am describing, one that creates relationships out of the formation of context. I call it an allegory because the relationship between the symbol and what is symbolized is relatively secure and offers, though obliquely, a moral lesson. In these black-and-white paintings, Warhol recreated diagrams for such dances as the tango and the foxtrot; numbers and arrows provide guidelines for how the steps in these dances go, and the viewer is meant to identify with the shoes used to represent the potential dancer. Warhol's paintings invite the reader to take part in the ritual being depicted, and in fact they show him or her just how to engage in the specific steps that constitute these dances. Benjamin Buchloh has suggested that the paintings offer a form of "bodily synecdoche" in the way that the *Dance Diagrams* activate a reader's desire for participation in the work, with the diagrams standing for potential movements of the viewer's body and letting the audience complete the work of art in characteristic avant-garde fashion.[32] Buchloh also notes that the advertising industry had already adopted such tactics to get viewers to actively identify with ads. One could say, however,

that the viewer who takes part in the dance is limited to the steps as represented in the paintings. This pas de deux argues against a wholly free play of interpretation, and so it is not so clear that Warhol's work is participatory in just the way that Buchloh suggests. For instance, the steps are a constraint or a set of rules to which someone must adhere. One might be dancing if one goes outside those steps, but he or she is not doing *that* dance. With any work of art, the viewer or the reader needs to engage what is there before the eyes, and to go too far afield is to no longer be dealing with the art itself but rather with some set of associations that are merely personal to the viewer. Just as with any dance: if someone does not do the proper steps, that person is doing *something*; they just are not performing a tango, a fox-trot, or a waltz. With *Dance Diagrams* Warhol presents a work of art that raises questions about the boundaries of categories: is a work that offers a clearly instructional diagram and makes use of readymade images of a pair of shoeprints still within the range of what one would call art? Not if we encountered these on the floor of a dance studio; but at a gallery we would be inclined to examine those differences since Warhol violates what traditionally had been clear tenets of fine art—to be original, to instill values and baldly not instruct, to create work that could not be made by most people, to emulate nature.

With *Dance Diagrams*, Warhol again takes into account the fact that the viewer takes part in the painting's meaning by asking such questions about context largely because the work is not simply the material object of a painted object but also necessitates the viewer's working with what is there and where it is. The viewer and the artist in a sense meet at the work of art. There is a loaded irony here in that Warhol notoriously had an aversion to being touched. With *Dance Diagrams*, he creates a *metaphoric* space where viewer and artist come together. That Warhol offers the dance steps indicates that the work teaches the viewer something—it teaches the viewer the basic steps to participate. Dance of course *is* an art form, so clearly Warhol has on his mind some relationship between the way a person takes part in one art form and the way that person participates in another; in both cases the person must be active. The pedagogic nature of the dance steps becomes generalizable even when transfigured into art. Although the diagram illustrates the necessary movements, how a person finesses those steps, makes them his or her own, is up to each individual: in this version of art, decisions happen within constraints. There is room for interpretation and variation

as long as these remain connected to the art itself—whether that be the specific dance steps or the painting—and not given over entirely to personal associations or private digressions.

In the case of *Dance Diagrams*, the viewer needs to find the connection between dance and painting; Warhol provides no explicit argument tying the two. Indeed, Warhol's diagrams offer only one side of the dance. Is this to suggest that the other dancer's steps are so understood that they do not need to be represented? What is the role of the other in these dances, since only one side is represented? Or can a realization be extracted that any dance, finally, is done separately, with each partner having only his or her own side to take care of? By crossing discursive situations, Warhol creates an occasion by which the most important questions of ethics and aesthetics can be revealed, but rather than providing answers, by bringing the ordinary into the space of art, Warhol's work offers questions just where the viewer tries to discover intention and effect.

In just the same way that a dancer must ultimately memorize the steps in order to learn to move his or her feet and body gracefully and elegantly, without continually consulting a diagram, we could say that the painting offers a model for seeing that a viewer must internalize if he or she is to bring the art into the world themselves. The receiver's intention counts as well. One could, it is possible to imagine, just happen to move his or her feet in the same pattern as a fox-trot, but unless that person was intending to do so, we could not say he or she was actually performing the dance. So, too, is the case with art. A viewer needs to look at the painting as art for it to become art. And interestingly, the *Dance Diagrams* make an even more compelling case for the issue of ontology than *Brillo Boxes*. Warhol's boxes only look just like the "mere real thing." Warhol's *Dance Diagrams* really *are* diagrams that show someone how to dance. The difference occurs in that Warhol's "diagrams" are actually painted by hand rather than mass-produced, and, much more tellingly, they appear in designated art spaces. Although the figures on the canvas do not change, a person adjusts his or her seeing to match the context where the diagrams are found.[33]

As I have been saying, one way to approach Warhol's work is to think of him as continually challenging the boundaries of what counts as art and substituting the ordinary for the idealized. Or, putting it another way, Warhol questions what we mean or what we are meant to do when we call something art. The challenge is put, therefore, not quite to the thing itself but to

the arbitrariness of the definition and the language we use in regard to such an object. This challenge often gets read as Warhol's ironic detachment and the work being seen as parodic. While there are grounds for such a reading, I want to address that irony to show that it might be more complicated than it is often taken to be before addressing how Warhol enables an aesthetic experience of the ordinary itself. If Warhol is a master of context and the works are "embodied meanings," it is crucial to understand the textures of the irony to get at how it also participates in the meaning of Warhol's art.

While the inclusion of *Brillo Boxes* or similar pieces in a space defined by a commitment to memorialize "high art"—whether that be the Stable Gallery or, now, such stately institutions as the Museum of Modern Art, the National Gallery, or DIA Beacon—still comes across as a bit ironic (albeit only quaintly so), one wonders how long the disruptive possibilities of such irony can endure and remain relevant. If we take it to signify some subversion of expectations, is that the only meaning that the work embodies? Does the work become merely a monument to some inaugural irony as it looked in 1964, an irony for its own, disruptive sake? In that case, the work has nothing to offer any longer, now that it has become so accepted as art. If it is primarily institutional irony, does the fact that Warhol has entered the canon dismantle its value? Or have the boxes burned through their most obvious ironies, coming to offer us something more profoundly substantive in terms of their implication for what we talk about when we talk about art? To think of ways that Warhol's work puts pressure on the definitions and discourse surrounding art is an attempt to put aside the dizzying attention on market forces and social gossip that otherwise so often dominate discussion of Warhol's work in order to get at its lasting importance. This would be to consider what keeps contemporary art contemporary.

The irony of the work is something to be reckoned with because so often Warhol himself is portrayed as the archetypal postmodern ironist—emotionally detached, turning pretension into obvious affectation, celebrating artifice, and mocking emotion as mere mawkishness. But what is the nature of that irony, we might well ask. Indeed, once the conditions of irony are established, meanings can begin to proliferate—the irony itself can be polyvalent. Perhaps the irony of Warhol's work is closer to a Socratic variety. In other words, the irony of bringing soup cans or silk screens of Marilyn Monroe into the domain of art is not necessarily (or merely) some aesthetic joke. There is no way of denying the play that informs so much of Warhol's

work: the cow wallpaper (pink cows on yellow background silk-screened onto wallpaper) of 1966, for example, is witty and campy. Yet, the playfulness also serves to soften some of the more powerful effects of what the artist did in bringing together the images of the everyday domain into the more rarefied field of high culture. It is this somewhat specious or facetious element of Warhol's silk screens and paintings that plays down how the work actually reconstitutes definitions by transgressing traditional boundaries between what constitutes art and what is the ordinary. The playfulness is a form of confrontation that we might call an aesthetic civil disobedience since it does not explicitly call for revolution, even as the work makes strategic substitutions that enable one to think about the conventions of art and representation as habits of thought rather than as necessary conditions. And irony, as a trope, indicates that there is a meaning to what is being presented other than what is most evident. With irony, the representation itself comments on its own mechanisms. This would be to say that Warhol means the meaning in his work—he even means the irony. Gary Indiana argues that what he calls the effect of Warhol's soup cans (and by extension, his body of work in the 1960s) was "not to rescue American banalities from banality, but to give banality itself value."[34]

Any threat pop art presents comes not from the meaning of the work, though for a time a vexed wariness toward Warhol and his peers seemed to be an unavoidable symptom of the changes they were making to definitions of art. Instead of confrontation, rather, *Dance Diagrams*, and works like it, enacts a questioning of what happens to familiar images that are brought into that new discourse of art, thereby taking on a symbolic force, even if what becomes symbolized by the objects are not specific, stable ideas. A work of art that can resist having its potential for meaningfulness being narrowly determined by traditional aesthetics calls for a new measure of how it is to be judged. Warhol's work argues that the work of art lies in that transformational effect of art as being its real force. In that sense, Warhol's work establishes a revaluation of values, to paraphrase a Nietzschean ideal.

Warhol's real irony, therefore, consists not in the fact that he was trying to pull one over on the art community, although that still seems to be the most obvious way of characterizing what Warhol did. By transgressing expectations of taste or convention as if he did not know any better, he sought to discover the boundaries of art. What happens if one simply does not accept the traditional parameters of art? Warhol asked through art what art

must be, with *Brillo Boxes* acting as the unspoken but probing elenchus that makes a tacit argument against critics such as Harold Rosenberg or Clement Greenberg, the most decisive critical voices of the then dominant abstract expressionism. Rosenberg's depiction of the abstract painter as existential hero caught in an inauthentic world, with each brushstroke serving as the articulation that bodies forth the pure action of self—and Greenberg's Kantian formalism, with its emphasis on the flatness and self-reflexivity of the medium—depended on a distance between the art world as some idealized realm and the flatness of the everyday domain.[35] Rosenberg's specific dismissal of Warhol is telling: "The innovation of Andy Warhol consists not in his paintings but in his version of the comedy of the artist as a public figure. 'Andy' . . . has carried the ongoing de-definition of art to the point at which nothing is left of art but the fiction of the artist."[36] Rosenberg makes clear the contrast he sees between the painters he spent his career championing and Warhol: "The Action painters repudiated picture-making in favor of acts of discovery and self-transformation. Warhol interprets literally the overshadowing of the artwork by the artist; that is, he sees it strictly in terms of the art market."[37] It is not surprising that Rosenberg, who was otherwise a powerful and thoughtful critic, would be so suspicious of Warhol's work, but it is unfortunate that he would put his critique so cynically and ultimately in such a conservative key. Too, one might be puzzled that Rosenberg put so much emphasis on the abstract expressionists' ability to represent their own subjectivity with a galvanizing "authenticity" and yet worry that Warhol sets up conditions wherein the artists overwhelm the art itself. Warhol is no heroic figure, but that stance itself is part of his aesthetic: for Warhol, it is not some defiant act of will but a reciprocal act of attention that creates art, and therefore anyone can potentially do it. No wonder Warhol was so open to input from other people. He continually asked people what he should make next.

This stance of Warhol's was in absolute defiance of the abstract expressionists, who saw the ordinary as banal, overdetermined, and stultifying. Poet and curator Frank O'Hara, in his monograph on Jackson Pollock (the second ever written about the painter), made clear the stakes for that generation of artists: "[Action Painting] does have qualities of passion and lyrical desperation, unmasked and uninhibited, not found in other recorded eras; it is not surprising that faced with universal destruction, as we are told, our art should at last speak with unimpeded force and unveiled honesty to a future which may well be non-existent, in a last effort of recognition which

is the justification of being."[38] The desire shared among the generations of New York artists of the 1940s and 1950s (and into the 1960s) was to create an art that directly expressed the interior world through spontaneity, through brushstrokes that signified intensity by means of the shape, the depth, the velocity of the stroke as recorded on the canvas by the movement of the hand. Because such things as Coke bottles and buildings and pictures of celebrities are so commonplace, their familiarity begets inattention. Even though these are the images and objects that surround all of us all of the time, de Kooning, Pollock, Rothko, Newman and other figures of their generation sought ways of transcending common objects. Robert Rauschenberg, just slightly ahead of Warhol in terms of a generational timeline of New York artists, famously said, "Painting relates to both art and life. Neither can be made. (I try to act in that gap between the two.)"[39] While Rauschenberg brought objects such as tires, used cardboard, and stuffed goats—real-life detritus—into his work, he still perceived a separation between art and life, and directed his efforts as an artist to overcome that gap. The work produced by Warhol and the other pop artists did not deny the value of insisting on individual, subjective presence, but there is a clear antipathy to a Romantic desire for transcendence. In looking at pop art, we might paraphrase Cavell's concerns about philosophy and apply them to art, asking, "What is art that it cannot—and for some people *must not*—represent the everyday world?" In other words, if art is conceived of as a higher order in a hierarchy of experience, where does that leave daily life and human beings? Warhol's work provides a response.

In part to discover *why* there was a perceived gap between art and life and to get at what might be the essence of art, Warhol drew his materials from the most commonplace of places—grocery stores, comic books, ads, and magazines. In terms of the consumerism that produced these images, all of the sources sought to create specific design elements that would rhetorically manipulate the public, as all rhetoric attempts to do. Warhol did not secretly know the "truth" behind the distinctions between commercial art and high art, between religious and celebrity icons, between art and life that he interrogated. The "not knowing any better" is no pose but rather a position that enabled him to create art by demonstrating how the definition and the ideals that policed them were not grounded on some immutable foundation. He showed the ways that the ordinary and the art world mirrored one another. His work, even and especially a piece such as the cow wallpaper, material-

ized the means of interrogating definitions and theories of art by providing counterexamples that were as crafted and obviously artificial as anything found in art.

We might put the questions raised by (and as) Warhol's work this way: Is art, its essence, intrinsic to certain objects and if so, do these objects provide the cause of what we call art to be an attitude within us? Or is art within us and projected onto those objects that we then call art? Warhol found the means in his *Brillo Boxes*, his silk screens, his paintings, and, as we will see, his movies to make this problem of definition an integral part of art itself.[40] With these arguments about the stakes of the ontological concerns brought forward by Warhol's art, we might go past those initial concerns to consider the role art can play in deepening one's ability to see and acknowledge the everyday in a way that brings the ordinary itself more directly into consciousness, so as to experience, in Heraclitean fashion, both the ordinary and its mysteriousness. Many of Warhol's films, the work that dominated his productivity in the mid and late 1960s, bring us to those very questions.

The fact that very often Warhol's most confounding work dealt with the ordinary—as in the movie *Sleep* (1963), which is a roughly five-hour film of the poet John Giorno sleeping—indicates just how the everyday somehow had been a particular barrier for art, as if dailiness had no truth or value to offer. There can be no more everyday activity than sleeping, except maybe eating, and Warhol made a movie of that too: *Eat* (1963), featuring the artist Robert Indiana eating a large mushroom for forty-five minutes. As these films demonstrate, the images Warhol pulled from the everyday are *not* aestheticized—he never romanticized them or aggrandized them in the way we might say a still life by a nineteenth-century painter offers a glimpse of the ordinary made beautiful through representation.[41] To represent the everyday as beautiful is to transform the ordinary, to make it other than ordinary. This changes a relationship to the everyday, but it does not transform art. It becomes an act of translation rather than transfiguration. If the images of celebrities that Warhol drew from are somewhat glamorous, their repetitions diminished that luster because the glamour was shown to be something that could be repeated and manipulated and therefore not unique. They were ordinary or commonplace images of glamorousness. Yet, Warhol's films were anything but glamorous.

The ordinariness of the images Warhol made remains internal to their meaning, indicating that beauty was not the primary criterion for a work of

art to be art. Both *Sleep* and *Eat* are useful examples in that there is nothing beautiful about either of these activities and Warhol presents them in black and white, flatly and inexpertly. The clumsiness, the primitiveness of War- hol's filmic style and method foregrounds the artifice and prevents an ab- sorption into the work. The experience of watching someone doing these things—eating or sleeping—is in fact quite tedious. There is room for thinking about boredom in Warhol's work, and I will turn to that aspect later, but now it is enough to point out that in watching *Eat* or *Sleep* the viewer is placed in a position of intimacy without there being a sense of power or politics that enters into the interpersonal dynamics between two living, present people. If I were to watch my beloved sleep, for instance— and there are not too many situations in which I could watch any other per- son sleep for several hours—I would at first be feeling some sentimental or romantic tenderness. I might be worried about waking her up. If she woke up and saw me watching her, she would become self-conscious. How would my experience of my beloved change when her expressiveness is not present (since she is asleep)? How would *I* become self-conscious ("this is creepy *and* boring," I would start to say to myself, after ten minutes, let alone five hours)? *Sleep* allows the viewer to engage in an activity (watching) and a proximity that we almost never have with the other, certainly not for such a protracted amount of time.[42] The same is true for *Eat*. But again, these were not ren- dered as beautiful activities and that proximity creates a kind of distance as well, since the people on-screen are not fully developed "characters." We look at them, but we do not know them. They are simply engaged in activity— they are actors in the sense that they are performing actions, but not in the sense that they are portraying something other than what they are.

Of these films, Warhol has said, "I can catch people being themselves in- stead of setting up a scene and shooting it and letting people act out parts that were written because it's better to act out naturally than act like some- one else because you really get a better picture of people being themselves instead of trying to act like they're themselves."[43] In essence, Warhol changes what it means to act in a movie. Rather than performing, the actors in these films are people who are undertaking everyday actions, and thus they could be any of us.[44] That is in contrast to most Hollywood films, in which actors largely act in extraordinary ways or in which the cuts, angles, and other cinematic techniques do not represent standard means of perception. In that

way, Warhol puts pressure on *acting*, one of the central terms in the cinematic lexicon.

These films are not merely documents of daily life, however, since there are no explanatory elements surrounding the films and the camera's presence is never made invisible. Also, Warhol would project the films at a slower than average speed. Usually, a film is projected at twenty-four frames per second. Warhol's are sixteen frames per second, a rate that changes things perceptibly, but only slightly so. The result is an artistic intervention into the visual perception of the ordinary events of sleeping, eating, kissing, or the like. And since the subjects on film are the actions themselves and these actions are being acted by artists—a painter and a poet—the work becomes a comment Warhol is making about "action art," indicating that there are all sorts of actions that can be art, not just the grandiose strokes of the action painting of the New York School.

For Warhol, then, the ordinary was not somehow beneath the possibility of studied attention and acknowledgment that coalesces around objects circulating within the art world. What Warhol's work does is not elevate but isolate events and objects to permit the possibility of acknowledgment image by image, object by object. He manages to slow down one's perception of the ordinary so that one can "experience the experience" of it, to borrow Ashbery's phrase about his own poetics.[45] In this case, more specifically what is experienced is the activity of paying attention. The experience of watching the films reveals the ordinariness of attention because there is no spectacle or narrative that enables an escape from our bodies. The passivity of the actors on-screen is mirrored by the viewers' passivity—but in the case of watching Warhol's films, that passivity becomes something that is experienced rather than repressed. Typically, a moviegoer is passive, but the spectacle absorbs the viewer so that what he or she experiences is the spectacle; in Warhol's films, the viewer cannot be so absorbed. The passivity in its protracted state begins to have real consequences in the way it makes the passing of time something we directly and consciously experience, which in turn becomes a self-consciousness. This self-consciousness can take the form of irritation or agitation, perhaps because one cannot escape one's own embodiment, and yet is a form of self-consciousness quite different from the experience of cinema Cavell described, in which the self feels estrangement from what he or she sees. The two states are not mutually exclusive, however, and

in fact might bridge the body and mind in generative, revealing ways that ground a viewer in the present in a manner that narrative film does not.

Consider Warhol's best-known "anti-epic" film, *Empire*, which is simply a camera's lens fixed on a famous building for several hours. Danto has called *Empire* a "philosophical masterpiece."[46] In the more than eight hours for which it is on-screen, *Empire* is just that amount of time spent looking at the Empire State Building, with the changing cast of light, as daytime gives way to evening, the only thing that appreciably occurs during that time. For Danto, one of the primary questions raised by the film is, again, what comprises the definition of art that it could include something like *Empire*, which is not beautiful in any familiar sense of the term, which is not a work of genius in regard to craftsmanship or inspired vision, and which displays none of the aspects or criteria that in earlier eras would enable something to be considered art. Yet following from that question, which is located within an aesthetic context, and in order to approach the possibilities of the film's "aboutness," or what its thought is, one might need to ask what the differences and what the similarities between *Empire* and the Empire State Building might entail. Most obviously, one is on-screen and is an image, while the other one exists in multiple dimensions, has mass, has density: one is in the material world as material reality and the other is part of the art world.[47] More specifically, how does the *experience* of one compare with the experience of the other? In other words, if we were to sit watching *Empire* and compare that with looking at the Empire State Building, what would be different?

Watching the building and watching the film of the building share at least one crucial condition: both make the viewer acutely conscious of durée. With so little visibly happening, a viewer watching *Empire* cannot forget that he or she is a being embodied and caught in time.[48] The object of consciousness becomes time itself as the boredom begins to set in and take hold. Since so little happens on-screen, one effect is that the film's image cannot maintain its central position in the viewer's mind. The environment—the chairs, the other people in the audience, the sounds of the projector, the gurgling of our own stomachs, the flecks of dust floating in the projector's light—comes forward, as these things that we normally overlook, repress, or try to escape from engulf us. Other thoughts, memories, daydreams all begin to intervene, but eventually these are also overwhelmed. Consciousness seemingly needs to feed; not only does it need an object, but it must be refreshed with objects or perspectives, which explains why the ordinary is overlooked. Par-

adoxically, the perception of time becomes more and more acute even as more time passes during which nothing perceptible to the senses happens. A being that is caught in time is returned to the moment each moment, and to the fact that one is a body that physically inhabits a single point in space, unable to repress the passage of time or the experience of being part of that flow, unable to transcend it.

Yet, what is gained in watching *Empire* as opposed to simply sitting on some roof in Manhattan and watching the famous building over the same amount of time? The film's intrinsic limitations are more immediately apparent. Certainly the view in *Empire* is more restricted as it is a single point perspective; if we were there in person we could adjust our eyes and the shifted field of vision would take in more accordingly—more sky, more distance. With the view offered on-screen, we can see only what is to be seen through the lens. The individual frames of *Empire* link together one repeated image, as if Warhol found a new way to create seriality.[49] Its single shot protracts the moment so that there are not the usual ways of marking the passage of time except the change of light, which moves so incrementally, one is apt to notice—that is, actually *see*—that time *has passed* rather than observe it *as passing*.

In any event, that experience of time in terms of what we would call boredom is consistent with both activities. What, however, makes one art and the other merely the activity of looking and consequently being bored? One crucial difference is that in feeling this boredom, we are apt to say Warhol's *Empire* is boring. As a work of art, it is about the conditions of feeling boredom, even in the face of a landmark so iconic and symbolic. If we are looking at the Empire State Building, we are likely to say that the activity becomes boring, but we would not say that the building itself—unlike Warhol's film—is boring. An eight-hour shot of any building would be boring, no matter how dull or how compellingly innovative the building's architecture and design might be. In that Warhol is an artist, his creation—the film—changes that experience of boredom by making it part of the experience of art and locating that feeling in the object itself. What has changed to make this attribution possible? How is it that the building is not the source or cause of boredom, but the film of it seems to be? And if *Empire* is art, what constitutes its redemption of the ordinary, since obviously what it represents is the everyday? Warhol frustrates the Nietzschean ideal of art by offering neither rehabilitation nor condemnation of the ordinary, though the change he

facilitates shapes one's interiority. Let us say that Warhol is an artist of contextual sensitivity rather than creative vision. Instead of inventing some new perspective, he brings to the fore how context provides a ground for experience and meaning in both art and life.

One way to think about *Empire* is not only that it creates the conditions for boredom but also that it serves as a metaphor for the feeling of boredom, as if answering the question, what is boredom like? It is like looking at a building for eight hours. Love and hate are not the only feelings that can make use of metaphors. If beauty, according to traditional aesthetics, is a quality that has needed articulation to bring out its subtleties, then why would not affective states closer to hand need it as well? One cannot ever know if others feel emotions in the same way, and metaphors offer the possibilities of shared analogies that locate the freight of one's interiority onto shared, objective particulars.

In his efforts to allow us to draw near the ordinary and the close at hand, Warhol focuses the possibilities of our attention on that which is always around us. In the case of *Empire*, he isolates one of the factors that hide the ordinary from us: boredom, a feeling that most try to escape whenever possible. At a certain level, work such as the soup cans and *Brillo Boxes* or *Empire, Eat*, or *Sleep* is about the experience of boredom in the everyday. Rather than simply making a critique, Warhol's work investigates and reveals what boredom can open in the viewer. In *POPism*, Warhol insists, in what amounts to a beautiful description of what we might call a disinterested interest

> I've been quoted a lot as saying, "I like boring things." Well, I said it and I meant it. But that doesn't mean I'm not bored by them. Of course, what I think is boring must not be the same as what other people think is, since I could never stand to watch all the most popular action shows on TV, because they're essentially the same plots and the same shots and the same cuts over and over again. Apparently, most people love watching the same basic thing, as long as the details are different. But I'm just the opposite: if I'm going to sit and watch the same thing I saw the night before, I don't want it to be essentially the same—I want it to be *exactly* the same. Because the more you look at the same exact thing, the more the meaning goes away, and the better and emptier you feel.[50]

The boredom caused by Warhol's films is therefore intentional—it is what the films are about, and in that way there is a kind of honesty to the bore-

dom, as opposed to what appears on television. There is no attempt to repress the dullness or banality of repetition as there is in the television programs Warhol refers to in this passage. Warhol's comment develops an immediately surprising position in that most people, most of the time, try to avoid or extricate themselves from boredom. The spectacle of the action programs, which is supposed to offer respite from our daily routines, distracts viewers from noticing the static, generically determined structures of such shows. More contemporarily, we have reality shows whose dramatic structures are thoroughly produced, shaped, and composed to maximum artifice. These falsely locate spectacle within daily lives—or rather, daily lives are made over in the form of spectacle. The spectacle is usually sufficient to enable the illusion that there is no repetition in their plots, tropes, and images. These programs are ways of passing the time, which obstructs but does not transform a deep boredom. Warhol reverses the skeptical method: instead of (merely) critiquing contemporary culture for being banal, he embraces it in order to discover what it can teach us. This is Warhol's form of acknowledging that which we would otherwise deny. Boredom, like skepticism, has something to teach us.[51]

Warhol has in mind the possibility that his films can produce through boredom the conditions for an emptying of the self that we might see as a form of meditation. This emptying does not necessarily lead to a sense of enlightenment, though Danto himself offers a useful frame for thinking about what it does enable: "I think Warhol had an almost mystical attitude toward the world: everything in it had equal weight, it was all equally interesting."[52] We could say that his work aims at a *self-conscious* emptying of the self, which is what prevents any kind of mystical transcendence.[53] Paradoxically, one arrives at this equal weight in various ways—like, for example, showing that the Empire State Building, one of the most recognizable and historic symbols of America, can become as boring as watching someone sleep. Everything is equally interesting; everything is equally uninteresting.

That attitude of inclusivity and equality is, to Warhol's mind, part of the power of pop art. During a cross-country drive to Hollywood from New York that Warhol made with Taylor Mead, Gerard Malanga, and Wynn Chamberlain, he offers what starts to sound like a conversion narrative: "The farther west we drove, the more Pop everything looked on the highways. Suddenly we all felt like insiders because even though Pop was everywhere— that was the thing about it, most people still took it for granted, whereas we

were dazzled by it—to us it was the new Art. Once you 'got' Pop, you could never see a sign the same way again. And once you thought Pop, you could never see America the same way again."[54] A few sentences later, he adds, "We were seeing the future and we knew it for sure. We saw people walking around in it without knowing it, because they were still thinking in the past, in the references of the past. But all you had to do was *know* you were in the future, and that's what put you there."[55] His statement sounds very much like Warhol believing that those who have eyes can see the change in perspective that makes the future look the same as the past but mean something entirely different. For Warhol and his colleagues, their *Lebensform* had shifted such that the things they saw, the same things anyone else sees, thereafter meant something entirely different because they attached to them a forward-looking set of references. The past and the future *appear* the same, but a distinction is arrived at by way of a discourse that determines one's perspective. We are once again at Danto's central philosophical issue—"when indiscriminable pairs with nevertheless distinct ontological locations may be found or imagined found, . . . we then must make plain in what the difference consists or could consist"—only this time the pairs are the past and the future, the everyday domain and the art world.[56] The world Warhol, Malanga, and the others were living in converged with the domain of the art world. This newness they experienced revealed how each thing they saw had potential meaningfulness because every object they saw was part of the "new art" of the everyday. "The mystery was gone," Warhol concludes, "but the amazement was just starting."[57]

Again, it is the very familiarity and banality of 1960s America that opened up for Warhol this anti-Romantic vision of the ordinary, a way of seeing that is present in and as Warhol's art.[58] He then creates an art from within these signs, possibly to create this conversion experience for others as well. In looking at Warhol's work, the viewer's own subjectivity flattens out since it is not actively being provoked, called forth, by the art. At the same time, there is nothing in Warhol's works of art to absorb the viewer. Caught somewhere between the art and one's own subjectivity, unable to be completely one or the other, the viewer's and his or her relationship—subject to object—keeps redetermining itself. The self does not vanish, according to Warhol, it empties out—the self is still a self but an emptied one. As the boredom increases, it displaces the self, becomes dominant. Rather than changing how the world looks, Warhol's work transforms how we look at

it; *we* change, or need to. Things remain as they are, however. This makes Warhol an artist of *seeing* rather than vision.

Because Warhol can be seen as doing philosophy, we are free to put him in conversation with other philosophers, and indeed Warhol's thoughts about the emptying effects of boredom resonate with comments Heidegger makes about what boredom can reveal. "Profound boredom," the philosopher writes, "drifting here and there in the abysses of our existence like a muffling fog, removes all things and human beings and oneself along with them into a remarkable indifference. This boredom reveals beings as a whole."[59] Boredom, argues Heidegger, serves as the principal means of attunement to Being largely because of how it brings forth an attention to time itself. Beyond that, profound boredom, once it takes hold, is a generalized experience, not specific to one particular catalyst and nothing has any greater claim on consciousness in that state of boredom than any other thing. Warhol's work seems determined in its protraction of time and attention to create just such conditions for boredom to occur.[60] The feeling is in this way inclusive—once boredom sets in all things are equal—and achieves the horizontality that both Alloway and Danto, in their own ways, refer to in regard to pop art, and to art after Andy.

What Warhol did by transferring the experience of looking at the Empire State Building into the domain of art, to make it part of the art world, was to make the experience itself—be it the experience of looking, the experience of deep boredom—an interpretable text, one luminous with meaning because of its context within art. Part of that experience refers us back to the condition of boredom itself. Why does the film bore us rather than have no effect at all on us, and what is this connection of boredom to an emptying of self? Heidegger argues, "Things [that bore us] leave us in peace, do not disturb us. Yet they do not help us either, they do not take our comportment upon themselves. They *abandon us to ourselves*. It is because they have nothing to offer that they leave us empty. To leave empty means to be something at hand that *offers nothing*. Being left empty means to be offered nothing by what is at hand."[61] Rather than not offering *anything*, the things that bore us keep offering *nothing*. By this I mean to say the boredom is a relationship between the thing and us, though it is a relationship wherein expectations are activated but never fulfilled. The expectations and the reasons for them are begun enough that we enter into the relationship. Still, in refusing us, refusing what is expected of it, the thing that bores us holds us in a kind of

limbo—we cannot complete our role in the relationship if the force upon us is refusing to complete its role. Think of "Marco Polo," the game that children play in a swimming pool; one child is "it" and keeps his or her eyes closed while other children keep their distance. The "it" child calls out "Marco" and others respond "Polo" and this is how the one who is "it" tries to determine his or her friends' location. Now imagine being "it" and calling out "Marco" and then waiting indefinitely for the others to respond. Until the child quits the game, he or she is part of the game and so cannot move until the others respond, no matter how long that takes. That is what boredom is like and reveals, perhaps, its uncanny dimensions.

With film, we expect a flow of a sequence of images and at least visual change, if not some form of narrative. Watching *Empire* or *Sleep* or *Eat*, we are in the cinema, the projected frames flicker on-screen, but nothing comes of that, at least none of the things we anticipate. The films do not need us. Robert Indiana eats whether someone watches or not, Giorno sleeps, and the Empire State Building stands, which is why, in part, audiences come and go during screenings of so many of Warhol's films. Narrative, like meaning itself, exists only if there is a viewer who receives and assembles the constituent parts. There is no meaning without someone watching. In watching, nonetheless, our expectations are not frustrated so much as their consummation is delayed indefinitely. The ordinary, I have been saying, intervenes, and now I suggest that what that means is that the ordinary offers nothing that we do not already have, and this situation keeps asserting itself; the ordinary becomes a form of boredom that can be repressed more successfully because of its familiarity. As we have seen, though, this repression is never total. And if we are emptied, as Warhol tells us boredom does to us, each person becomes a thing among and amid other things. Our individuality does not seep away so much as the Will attains a kind of balance in that it cannot dominate what offers no resistance.

Danto describes the way that *Empire* is similar to *Brillo Boxes* in its ontological questions by noting that the film seeks to establish the essential properties of a movie—what makes a movie a movie—through identifying and then challenging common assumptions. "Warhol subtracted everything from the moving picture that might be mistaken for an essential property of film. So what was left was pure film. What we learn is that in a moving picture it is the film itself that moves, not necessarily its object, which may remain still. Warhol's art, in film and elsewhere, goes immediately to the

defining boundaries of the medium and brings these boundaries to concep-
tual awareness."[62] Danto goes on to specify, "To see *Empire* as film is to
shelve as inessential a lot of what theorists have supposed to be central to
film, all of which Warhol unerringly subtracted."[63] In that way, Rosenberg
was right to label what Warhol does as "de-defining art," though if we
think of this within the context Danto offers, Warhol's practices are aimed
at getting at the essential elements of art. Plot, character, camera movement—
none of these things appear in Warhol's early films. Even visibly discernible
movement is not essential to a film, so long as the film itself, frame by frame,
moves. The ways that *Empire* refuses to participate in those long-held
assumptions about what defines a film become the ways it calls forth our
expectations but then never meets those expectations. Most of all, the film
does not free us from time and space the way film can as the camera zooms
around and offers perspectives we could otherwise never have spatially and
temporally. Danto does not discuss what happens with this purity of cinema,
and yet I indicate that in the resulting openness other kinds of experiences
become available.

Watching Warhol's films, the audience becomes aware of being fixed in
space and feels time pass. Instead of passing time or escaping it—standard
reasons for taking time out of the day to go to a movie—*Empire* and the other
films call on us to *endure* time. The call on us is made, but the fact that the
consummation is held off means that the movie empties out the subjective
response it calls forth, the specific kind of response any other movie calls forth.
Our subjectivity coalesces around our expectations—we are attuned. The
boredom literally exhausts that specific form of our subjectivity but does not
relieve it. We might also say that it reveals subjectivity. I have in mind Douglas
Crimp's narrative of his experience with Warhol's film. Crimp writes,

> Watching *Empire*, what I found happened most was that the perspective of
> the building kept reversing itself, so that instead of a solid contour I seemed
> to be looking at a hollowed-out volume, as if I were seeing a cutaway of inte-
> rior space. When that happened, I would try in vain to turn concave back to
> convex, to get the building to become a solid exterior again. I'd stare at the
> lights on the right side of the image, the ones whose bottom edge, in correct
> perspective, should be moving away from me, into space, to delineate the west
> side of the tower. But when that edge appeared to move toward me, making
> me look *into* the shape, I couldn't trick my eye into correcting the image to
> get it to read again as the solid form of the familiar building.[64]

He goes on to state, "The image eventually becomes so abstract that you begin to want to read it like a Rorschach test." In this description, we hear echoes of Porter's claims about the abstraction that is immanent within realism, when he said that Alex Katz "is not overwhelmed by nature but stands outside it; it is outside him and includes his subjectivity."[65] The difference might be that with *Empire*, the viewer's subjectivity is both included and excluded. Crimp's comments about seeing Warhol's movie as a Rorschach test seem akin to Wright's idea that comedy is the process of watching his own mind. In fact, Ondine, an actor in underground films who frequented the Factory and was one of Warhol's "superstars," once said something remarkably similar to Wright's comments: "Your brain seems to be apparent when you're on camera. It seems as if—when you look at yourself on the screen—it seems as if your brain is working. Like, to me, I can tell what people are thinking by what they look like on the screen."[66] These sympathetic resonances support the expressivist view of art that addresses the everyday domain.

The impasse of subjective response becomes an even more complicated issue in thinking about Warhol's *Empire* because what is present on the screen correlates with a reality located at a specific address in New York City; there is an already established relationship between the viewer and the object on the screen. The film offers a visual reality identical to that experienced by someone watching the building for the same amount of time. The boredom caused by one would be equivalent to the boredom caused by the other, even if, as I described earlier, the locus of the boredom would be judged differently. That change of locus is an important one, for it is one of the experiential factors in delineating the difference. Therefore, it is not accurate to say that *Empire* is a representation of the Empire State Building—leastwise that is not the film's most important feature—since the context rather than the accuracy of its visual correlation to the building is how we would think about the film. But the relationship of the two is nonetheless an important aspect of the work, even if that relationship is not the same as, say, the one between a still life and a table with fruit on it. That an object is able to be represented in such a way that an experience of the representation doubles the experience of the thing itself would suggest a basic, stable, consistent essence, though conceptually this is not the case. Not only are the senses not enough to give us a point of difference, but neither is the af-

fective experience enough. This in itself would begin to offer a skeptic the means to throw into question the certainty that either the building or the movie could offer.

If *Empire* and *Brillo Boxes* work against one of the most important traditional criteria of art—the accuracy of representation, a fidelity of mimesis—then we might wonder about how Warhol recontextualizes more conventional seeming practices. Warhol's famous *Screen Tests*, a project Warhol undertook from 1964 to 1966, serves as portraits of certain people drawn largely from the arts communities of New York or anyone else who dropped by Warhol's studio (the famous Silver Factory)—from Lou Reed, Bob Dylan, and Salvador Dali to John Ashbery, Mario Montez, and Edie Sedgwick—shown in relative close-up for four minutes (the length of a one hundred-foot reel of film, screened at a slightly slowed-down speed), more or less, at a time. Hal Foster notes that although the films are not actual screen tests in the sense that there is no scripted movie being planned for which the "screen test" provides an advance indication of how a given actor would look on celluloid, they are tests of a kind. "Indeed, without ulterior motive, they are pure tests of the capacity of the filmed subject to confront a camera, hold a pose, present an image, and sustain the performance for the duration of the shooting."[67] Warhol made close to five hundred of these films.

The faces in these cinematic portraits display a range of responses, from amusement to embarrassment and perhaps even shame. For instance, the film of Ann Buchanan, a friend of Allen Ginsberg's and other Beat writers, shows the lovely bohemian woman looking dead-on into the camera with a fairly blank, inscrutable expression on her face. She never blinks. Suddenly, 1'38" into her screen test, a tear forms in her left eye and rolls down her cheek. Thirty seconds later another forms in her right eye.[68] The effect is haunting in part because it is a situation so hard to read. Why is she crying? one wants to ask. And, more importantly in this context, how is it that her face offered no indication that the tears were forthcoming?

No matter the subject on-screen, the viewers' eyes meet and seemingly hold the gaze of the person captured on film. We see them looking at us as we look at them, but even though it appears otherwise, those eyes literally do not see us back. They look without seeing, which very often is the case when we look at others. Self-consciousness, all too often, averts our eyes. According to Callie Angell, "some subjects [of *Screen Tests*] seem overcome with

self-consciousness, squinting into the bright lights, swallowing nervously or visibly trembling, while others rise to the occasion with considerable force of personality and self-assurance, meeting the gaze of Warhol's camera with equal power. As the collection of *Screen Tests* grew, these provoked responses gradually became the overt purpose or content of the films, superseding the original goal of the achieved, static image."[69] All that Ann Buchanan, Lou Reed, and others are within the duration of the film, that measure of time, are images, and the viewer, the seeming recipient of those reflective stares, is not there for them. It is as if *Screen Tests* conjures a viewer and the viewer conjures the filmed portraits, with the mutual gazes crossing from the *Lebenswelt* to the art world and back again. At the same time, the films also constantly point out that the audience is not real and is not present to the filmed subject, and the sitter, despite his or her gaze, is not actually present to the viewer except across time. This is where Warhol's films begin to manifest the skeptical condition Cavell describes as being so intrinsic to film, yet here the skepticism is paradoxically reciprocal. The sitter looks into the future for a viewer; the viewer looks into the past for a trace of the sitter. It is an incalculable distance between.

The Livable Aesthetics of the Everyday Domain

Danto describes in general the poetics of Warhol's work, at least throughout the 1960s: "Warhol's intuition," Danto contends, "was that nothing an artist could do would give us more of what art sought than reality already gave us."[70] In other words, by bringing "mere real things" into the domain of art, Warhol was able to make manifest his intuition about reality in that it yielded experience meaningful enough for attention. Rather than escaping familiarity, Warhol, as well as others of the generation that followed the Action Painters, saw that the ordinary could indeed become the locus for the very meaningfulness that art reckons. Such things are where we live; they frame the space we inhabit. To deny the everyday is to deny one's self and its immediate milieu. "And in the end," writes Danto, "this transfiguration of a commonplace object transforms nothing in the artworld. It only brings to consciousness the structures of art which, to be sure, required a certain historical development before that metaphor [of Brillo-box-as-metaphor] was

possible."[71] Readiness is all, we might say. What we can add to this assessment is that structures of art also illuminate structures of the mind, or, rather, structures that the mind uses to order experience. The consciousness of structures of art is historical and narrative and to know that story is to see art's being tied to other forms of consciousness, particularly philosophy. To extend Danto's thinking we can say that if Warhol's work brings to consciousness the structure of art, those structures then reverberate back into the everyday world to indicate that the ordinary can reveal the structures of everyday life that are just as much open to metaphor, meaning, and questioning as art itself, if seen correctly.

Warhol's intervention, a kind of intuition, was to bring the commonplace into a space formed and maintained at every turn by interpretation. The work Warhol created recognizes the phenomenological import of everyday things and realizes a context that allows for meaning to become legible. That context is art, which does not exist as art without the grappling with interpretation. Rather than being burdensome or imposing limits, things from the everyday become carriers or containers—like cans, like boxes—for metaphoric, felt possibilities of representing, of concretizing the interior experience of the human life. Warhol's efforts made it possible to see how we express the world to ourselves through the images and products with which we surround ourselves.

At the most fundamental level, Warhol brought elements of homely life—in the form of press photos, soup cans, and Brillo boxes—into art, countering the thinking that art is an escape from the daily. He famously said—or notoriously, depending on one's view—that he chose to paint soup cans because he ate Campbell's soup each day for lunch. Rather than becoming blinded by routine, he found the value of banality. He allowed the ordinary to become his work so as to let everyone who saw it begin to ask questions about art and life and what it means to think about the life one is living. In permitting the ordinary to enter the art world as such, Warhol leads us back to the everyday domain by creating a space in which the ordinary regains its capability for meaning. I hope to have shown this as a recurring tendency in the figures I have discussed. What they share is the belief that with sustained engagement to the ordinary, one's attention is able to enter into and interact with objects as part of an interpretative economy trying to gain purchase, however passing, on the totality of things and one's relationship to it.

Warhol's work makes clear that the ordinary itself is a context, and this becomes apparent when adjustments are made such that the boundaries of that context are made evident. Art, he showed, is the context by which we can see and engage the ordinary, even though that move requires estranging the ordinary from its environment. In short, Warhol's difference from Cavell, Wright, and Ashbery is that he focused not on the alienation of the self from the ordinary but on the ordinary's estrangement from itself. Despite the critique and irony so many find in it, Warhol's work also enacts a generosity and openness that receives similarity as a way to reveal difference through attention to content and its minute particulars as well as to things themselves.

The ontological question of the difference between art and mere real things doubles back on us and, to use Heidegger's language, attunes thinking. What I hope to have added to Danto's thinking about Warhol is the claim that in fundamental terms, this move allows human beings to invest themselves in objects of the most ordinary and familiar kind and to be better equipped to discern the threads of life. Warhol, in whatever else he did, teaches us how to see the world as an artist does—that all things can, potentially, bear expressivist meaning that reveals beliefs, associations, and values of anyone who gives their attention. The discovery of meaning is the creation of value. There are other names this may go by, but it remains a way of leading people to what might be called *home*. Novalis once aphorized, "Philosophy is really homesickness—the desire to be everywhere at home," and it is through such a lens that arguments that the work of Warhol's art enacts a form of philosophy take on their most powerful resonances.[72] In that, Warhol's work and philosophy come together as they offer the means of perpetually countering the estrangement and loss that Cavell identified as being part of the ordinary. Warhol's is also the counterexample to Wright's alienated apartment—Warhol shows how belongings can, in fact, belong. The key difference between Warhol's response to the ordinary and that of the others is that although for Warhol, like the others, the everyday needs to be perpetually rediscovered, in Warhol's work one rarely notes that need as a loss to be overcome. In Warhol's work, acts of acknowledgment do not fear or struggle with repression. They accept it. They acknowledge their own acknowledgment. Warhol's boxes and soup cans take to heart Ashbery's aphorism from "Homeless Heart": "Best not to dwell on our situation, but to dwell in it is deeply refreshing."

In demanding art be *about* beauty, to give but one example of a traditional criterion for art, one loses art's responsiveness to a lived life that is as revealing, and deeply mysterious, as watching someone else sleep for five hours. While that sounds Romantic, in reality the mystery is no less than the call to address the mystery and to move through it to some deeper possibility of knowledge and consciousness. As intimate as that activity of, for example, watching another sleep may be—and it is profoundly intimate—no one is really any closer to another's interiority for having endured it. The effect of Warhol's art is not to illuminate some interior space but rather to forge possibilities for visualizing the everyday to others in the form of art. This art in turn offers a vehicle for the act of thinking, thinking about the self and about the self in relation to the world.

The claim for the philosophical implications of Warhol's work, or Wright's comedy, or Ashbery's poems, or screwball comedies and film more generally is ambitious, certainly, but then art is not an isolated, singular endeavor, wholly separate from actual lives, which allows it to have a pedagogical dimension. These things model not the world but ways that one might find to respond and be responsible for the world. Art, in whatever form, is a means by which human beings grapple with the very nature of being, and what is this but an intense practice of finding the way back to the paradoxes latent within the ordinary. The ambition it enacts is a form of inclusivity, which becomes evident in reviewing the work of the figures I have discussed in the previous chapters. Art becomes an occasion for philosophy, as Cavell, Danto, Wollheim, and even Fairfield Porter argue. More specifically, however, we can see artistic and philosophical engagement with the ordinary as an opportunity for thought to turn toward itself and toward that which gives rise to the very conditions of thinking, of value, and of imagination. These acts of attention lay bare the structures of art, and this is no small thing, but by extension the structures of experience, of the mind itself, might be made visible. To know more about how the mind encounters the most everyday objects, the most ordinary objects, the wager goes, is to learn more about how human beings go about finding a world to take part in. In this conflation, we see the places where the discursive boundaries between and among philosophy, art, literature, comedy, and cinema become porous, which makes a case for the ways that all these figures seek to overcome the limitations of particular discourse-bound perspectives. The most usable paradox remains that one needs to be outside one's life to examine it, even as the process of

examination is how one works, if one works, to overcome the emotional, psychological, and even spiritual distances the self is heir to so as to learn anew every day what it means to live an ordinary life and to find one's self at home within a world of estranged and estranging things and among other alienated and alienating selves.

NOTES

Preface

1. Ralph Waldo Emerson, "Self-Reliance," vol. 2 of *The Collected Works of Ralph Waldo Emerson: Essays: First Series,* ed. J. Slater, A. R. Ferguson, and J. F. Carr (Cambridge, MA: Belknap Press of Harvard University Press, 1979), 40.

2. Friedrich Nietzsche, *On the Genealogy of Morals,* ed. W. Kaufmann, trans. W. Kaufmann and R. J. Hollingdale (New York: Vintage Books, 1989), 15.

3. Writes James, "You must bring out of each word its practical cash-value, set it at work within the stream of your experience. It appears less as a solution, then, than as a program for more work, and more particularly as an indication of the ways in which existing realities may be *changed.*" *Pragmatism* in *William James: 1902–1910,* ed. Bruce Kuklick (New York: Library of America, 1988), 509.

4. Pierre Hadot, *Philosophy as a Way of Life: Spiritual Exercises from Socrates to Foucault,* ed. Arnold Davidson, trans. Michael Chase (Malden, MA: Blackwell Publishing, 1995), 253.

5. Richard Wollheim, *The Thread of Life* (New Haven, CT: Yale University Press, 1999), 10.

6. Richard Kostelanetz, *Conversing with Cage* (New York: Limelight Editions, 1987), 41.

Introduction

1. Wollheim, *The Thread of Life*, 2.

2. There are two principal philosophers whose focus is clearly the ordinary but who nonetheless are not at the center of *Art of the Ordinary*: Ludwig Wittgenstein and J. L. Austin. There are a number of reasons for this. To begin with, I take up the thinking of both of these figures in my previous book, *Listening on All Sides*, and my interest now is to create a context for three of our most influential contemporary philosophers: Cavell, Danto, and Wollheim. Wittgenstein in particular is crucial to these three figures, and for that reason his ideas are part of the very fabric of the conversation, if not made entirely explicit.

3. Herbert Read, "Abstraction and Realism in Modern Art," in *The Philosophy of Modern Art* (London: Faber, 1964), 88.

4. Fairfield Porter, "A Realist," in *Art in Its Own Terms*, ed. Rackstraw Downes (Boston: MFA Publications, 2008), 90.

5. Porter is a useful focus because of his somewhat unique position in the fraught moment of the late 1950s and 1960s when abstraction and realism were placed at odds, yet both had aesthetic currency. Although he was resolutely what we would call "realist," he was insistent that abstraction was still informing how we experience "the real." Although his discourse does not necessarily fall back on loaded terms, Porter's thinking about art was profoundly philosophical in his sense that it shapes how we understand and experience the world. For him, aesthetics is a kind of epistemology.

6. This line of thinking is also central to Ralph Waldo Emerson and is present in a number of his essays. Consider this passage from "Art": "Because the soul is progressive, it never quite repeats itself, but in every act attempts the production of a new and fairer whole. This appears in works both of the useful and the fine arts, if we employ the popular distinction of works according to their aim, either at use or beauty. Thus in our fine arts, not imitation, but creation is the aim. In landscapes, the painter should give the suggestion of a fairer creation than we know. The details, the prose of nature he should omit, and give us only the spirit and splendor. He should know that the landscape has beauty for his eye, because it expresses a thought which is to him good: and this, because the same power which sees through his eyes, is seen in that spectacle; and he will come to value the expression of nature, and not nature itself, and so exalt in his copy, the features that please him." In *The Collected Works of Ralph Waldo Emerson: Essays: First Series*, vol. 2, ed. J. Slater, A. R. Ferguson, and J. F. Carr (Cambridge, MA: Belknap Press of Harvard University Press, 1979), 209.

7. Unfortunately, Porter's essay contains an error. The painting that Porter discusses is actually titled *4 PM*. A piece titled *10 AM* (and not spelled out as Porter has it) was painted around the same time by Katz and appeared in the same exhibition that Porter attended. It depicts the same room and the same woman, but the light and the color palette are wholly different. The image that accompanies Porter's essay (and which has been periodically reprinted) also reflects this misidentification. Everything else Porter says in the essay is otherwise sound and correct.

8. Porter, "A Realist," 91.

9. This is, of course, a manner of speaking since in reality what human beings take as a projection or "aura" of an object is in actuality supplied by the viewer.

10. Harold Rosenberg, *The Tradition of the New* (New York: Horizon Press, 1959), 25.

11. John Ashbery, *Fairfield Porter: Realist Painter in an Age of Abstraction* (Boston: MFA Publications, 1989), 7.

12. Ibid., 13.

13. The philosophical elements of Porter's thinking have a real pedigree: he studied with Alfred North Whitehead while a student at Harvard in the 1920s.

14. Ludwig Wittgenstein, *Tractatus Logico-Philosophicus*, trans. D. F. Pears and B. F. McGuinness (London: Routledge, 1974), 67.

15. John Ashbery, "Respect for Things as They Are," in *Fairfield Porter: Realist Painter in an Age of Abstraction* (Boston: Museum of Fine Art, 1982), 13.

16. Porter, "A Realist," 91.

17. Fairfield Porter, "Letter to Arthur Giardelli Great Spruce Head Island, Maine August 3, 1968," in *Material Witness*, ed. Ted Leigh (Ann Arbor: University of Michigan Press, 2005), 254–55.

18. Charles Kahn, *The Art and Thought of Heraclitus* (Cambridge: Cambridge University Press, 1989), 31.

19. Oral history interview with Fairfield Porter, June 6, 1968, Archives of American Art, Smithsonian Institution, http://www.aaa.si.edu/collections/interviews/oral-history -interview-fairfield-porter-12873.

20. Karl Jaspers, "Heraclitus," in *The Great Philosophers*, vol. 2, ed. Hannah Arendt, trans. Ralph Mannheim (New York: Harcourt Brace Jovanovich, 1974), 19.

21. Emerson, "Self-Reliance," in *Essays: First Series*, 40.

22. Nietzsche, *On the Genealogy of Morals*, 15.

23. Ralph Waldo Emerson, "Experience," in *The Collected Works of Ralph Waldo Emerson: Essays: Second Series*, vol. 3, ed. J. Slater, A. R. Ferguson, and J. F. Carr (Cambridge, MA: Belknap Press of Harvard University Press, 1983), 27 (hereafter cited as *ESS*).

24. Friedrich Nietzsche, "On Truth and Lies in a Nonmoral Sense," in *The Nietzsche Reader*, ed. Keith Ansell Pearson and Duncan Large (Malden, MA: Blackwell Publishing, 2006), 121–22.

25. Ralph Waldo Emerson, "The Poet," in *ESS*, 17.

26. Ibid., 18.

27. In chapter 4, I put this in terms of Wittgenstein's concept of *Lebensform*.

28. Ralph Waldo Emerson, "Considerations by the Way," in *The Collected Works of Ralph Waldo Emerson: The Conduct of Life*, vol. 6, ed. J. Slater and D. E. Wilson (Cambridge, MA: Belknap Press of Harvard University Press, 2003), 148.

29. Stanley Cavell, *This New yet Unapproachable America: Lectures after Emerson after Wittgenstein* (Albuquerque, NM: Living Batch Press, 1989), 47.

30. John Ashbery, *Three Poems* (New York: Viking, 1972), 53.

31. Ashbery, "The New Spirit," in *Three Poems*, 3.

32. Arthur Danto, *Philosophizing Art* (Berkeley: University of California Press, 1999), 80. A very nuanced parsing of the insights as well as the limitations of Danto's claim can be found in Garry Hagberg's *Art as Language: Wittgenstein, Meaning, and Aesthetic Theory* (Ithaca, NY: Cornell University Press, 1995). Hagberg considers the

claim in terms of how it sets a late Wittgenstein against an early Wittgenstein, with Danto revealing a partiality to what Wittgenstein sought to work against in his subsequent thinking. See especially pp. 137–49.

1. Leading an Ordinary Life

1. Wollheim, *The Thread of Life*, 20.

2. Michael Levine, in his essay "Wollheim's Ekphrastic Aesthetics: Emotion and Its Relation to Art," suggests that Wollheim's investment in psychoanalytic models has led to an imbalance in the ways that his philosophy is received. Levine writes, "Given the connection between [Wollheim's] account of emotion and psychoanalysis, and the centrality of psychoanalytic theory to Wollheim's aesthetics and to his theory of emotion, it seems odd that seeing-in has garnered a far greater amount of philosophical attention than his more aesthetically (and psychologically) significant account of emotion" (242). While investigating the reasons for that imbalance is beyond the scope of the present study, I will say that I am sympathetic to Levine's reading and do in fact seek to bring to the fore these aspects in large part because, as Levine insists, they are all interconnected. Levine's essay is part of a generative collection focused on Wollheim's concept of seeing-in. In *Wollheim, Wittgenstein, and Pictorial Representation: Seeing-as and Seeing-in*, ed. Gary Kemp and Gabriele M. Mras (New York: Routledge, 2015), 241–67.

3. Wollheim's powerful combining of ethics, aesthetics, and psychology makes him an important figure in this context given his efforts to expand the possibilities open to philosophy. Danto, in a relatively critical review, nevertheless praises Wollheim because "he differs from the philosophers with whom it is most natural to group him— with what, roughly, are designated 'analytical philosophers'—in his resolution to turn what defines him as an intellectual into philosophy. Indeed, Wollheim has succeeded in this in a philosophical atmosphere in which aesthetics was widely scorned as dreary and marginal, and in which psychoanalysis was felt, by those philosophers who deigned to notice it, to be lacking in scientific credibility, and to lie as far as can be imagined from the kind of philosophy of mind philosophers have tended to find congenial— some kind of structure analogous to a very sophisticated computer." He goes on to explain, "Wollheim's distinctiveness is to treat as philosophical problems the subjects that touch him most deeply as a man, and to compel the admiration of other philosophers who would not touch those subjects with a pole of any length." This capaciousness that Danto describes is characteristic of not only Wollheim but also of himself and Cavell as well, and is to some degree a model for the kind of breadth of approaches necessary to engage the everyday in order to reveal its complexity. Danto believes that Wollheim's arguments ultimately become limited to representational art and could not engage more abstract work, so they cannot actually serve as the universal theory of art that Wollheim seeks to develop. See "Art's Infancy," review of *The Mind and Its Depths*, by Richard Wollheim, and *Psychoanalysis, Mind and Art: Perspectives on Richard Wollheim*, edited by Jim Hopkins and Anthony Savile, *London Review of Books* 15, no. 8 (1993): 17–18.

4. Wollheim, *The Thread of Life*, 130.

5. Ibid., 283.

6. In a certain way, the exception I am taking here is simply about the force of Wollheim's use of "understanding" bringing with it an implication that the process can be brought to an end. Elsewhere in *Thread of Life* he refers to the "process" of "leading the life of a person" as being an "embodied mental process," which is much closer to the open and ongoing, developing activity that I am foregrounding (144).

7. Moving from a consideration of a philosophy of life to a philosophy of art to show how these are actually mutually reflective is a development that Wollheim himself prepares. Alexander Nehamas offers the clearest description of the close interaction of these two sides of Wollheim's work. Nehamas writes, "In the philosophy of mind [such as that constructed in *Thread of Life*] Wollheim considers the process of leading the life of a person primary, and, in turn, considers the ability to take on different roles and thus affect that life essential to the process. Similarly, in his philosophy of art [as investigated in Wollheim's *Painting as an Art*], he emphasizes the primacy of the process of painting, and argues that it is essential to this process that a person engaged in it assume both the role of the artist and that of the spectator." "Painting as an Art," in *Psychoanalysis, Mind, and Art: Perspectives on Richard Wollheim*, ed. Jim Hopkins and Anthony Savile (Oxford: Blackwell, 1992), 246. My point, then, is that in considering the ordinary, one is both leading the life and acting as spectator, or reader, of that process. Worth noting is that the essays presented by Hopkins and Savile give the fullest overview of Wollheim's body of work.

8. Stanley Cavell, "Something Out of the Ordinary," in *Philosophy the Day after Tomorrow* (Cambridge, MA: Harvard University Press, 2005), 12.

9. Bertrand Russell, *The Problems of Philosophy* (Oxford: Oxford University Press, 1967), 1.

10. Another thing that Cavell, Wollheim, and Danto share is a development of the course of their careers away from adhering to the parameters of a strict analytic philosophical mode and toward the kinds of subjects and methods that account for what shapes their intellectual curiosity and their own creative lives.

11. William James, *Some Problems of Philosophy* (Cambridge, MA: Harvard University Press, 1979), 11.

12. Cavell's intervention, and its critique of philosophy's limited ability to engage how people live their lives, has had consequences. For many years Cavell's pressing against conventions—both in his distinctively stylized prose and in the specific subject matter to which he has given his attention—prevented his work from finding a wide audience within his field. Only within the last few years has that changed, and his arguments have become tellingly influential in a variety of fields, perhaps in part because of the general rise across the academy over the past few years in interdisciplinary studies. Indeed, it would be a compelling project to think about why it is that Cavell's work gained such traction so late in his career. What changes and developments made it become so persuasive at just the moment it did? Putting academic tastes aside, however, and sidestepping any insecurities about what its implications might have in regard to the discipline as a whole, Cavell's efforts have opened up a range of alternatives to traditional philosophy as he has questioned its self-imposed boundaries, as well as how those limitations express themselves. This tendency is at the crux of Cavell's implementation of methods drawn from psychoanalysis.

13. Despite its length, the whole passage from "The American Scholar" that contains these descriptors of the ordinary is worth including:

> One of these signs is the fact, that the same movement which effected the elevation of what was called the lowest class in the state, assumed in literature a very marked and as benign an aspect. Instead of the sublime and beautiful; the near, the low, the common, was explored and poetized. That, which had been negligently trodden under foot by those who were harnessing and provisioning themselves for long journeys into far countries, is suddenly found to be richer than all foreign parts. The literature of the poor, the feelings of the child, the philosophy of the street, the meaning of household life, are the topics of the time. It is a great stride. It is a sign,—is it not? of new vigor, when the extremities are made active, when currents of warm life run into the hands and the feet. I ask not for the great, the remote, the romantic; what is doing in Italy or Arabia; what is Greek art, or Provencal minstrelsy; I embrace the common, I explore and sit at the feet of the familiar, the low. Give me insight into to-day, and you may have the antique and future worlds. What would we really know the meaning of? The meal in the firkin; the milk in the pan; the ballad in the street; the news of the boat; the glance of the eye; the form and the gait of the body;—show me the ultimate reason of these matters; show me the sublime presence of the highest spiritual cause lurking, as always it does lurk, in these suburbs and extremities of nature; let me see every trifle bristling with the polarity that ranges it instantly on an eternal law; and the shop, the plough, and the leger, referred to the like cause by which light undulates and poets sing;—and the world lies no longer a dull miscellany and lumber-room, but has form and order; there is no trifle; there is no puzzle; but one design unites and animates the farthest pinnacle and the lowest trench.

Emerson: Essays and Lectures, ed. Joel Porte (New York: Library of America, 1983), 68–69.

14. Richard Eldridge, in his review of *Contending with Stanley Cavell*, a collection of essays edited by Russell Goodman, offers an impressively concise account of Cavell's use of the term. "According to Cavell, acknowledgement is the taking up, articulating, and registering of what in our experience calls for various routes of feeling and interest that we are also inclined to suppress. Among the things in our experience that may demand acknowledgment are, centrally, the pain of another, the independent personhood of another, our own finitude, and our possibilities for meaningful expression beyond the reach of conventions alone. A medium of art, according to Cavell, functions to carry out the work of acknowledgment, at least when its distinctive possibilities of notice and expression are masterfully developed." *Notre Dame Philosophical Reviews*, August 4, 2005, http://ndpr.nd.edu/news/24835-contending-with-stanley-cavell/.

15. Timothy Gould, *Hearing Things: Voice and Method in the Writings of Stanley Cavell* (Chicago: University of Chicago Press, 1998), 208.

16. Ibid.

17. Ibid., 208–9.

18. The film's title has a clear irony in that Amanda Bonner does not act that way toward her husband, Adam Bonner. She is a far cry from being simply "Adam's rib."

19. Cavell has indicated that traditional skepticism may be intrinsically masculine (and therefore masculinist) in its conceptions of knowledge. His discussion of *Adam's Rib* certainly investigates that pathos of gender. An insightful discussion of Cavell's complex and even problematic thinking on the gendered underpinnings of philosophy can be found in Ludger Viefhues-Bailey's *Beyond the Philosopher's Fear: A Cavellian Reading of Gender, Origin and Religion in Modern Skepticism* (Aldershot, UK: Ashgate, 2007).

20. Stanley Cavell, *Cities of Words: Pedagogical Letters on a Register of the Moral Life* (Cambridge, MA: Harvard University Press, 2004), 75.

21. Stanley Cavell, *The World Viewed: Reflections on the Ontology of Film: Enlarged Edition* (Cambridge, MA: Harvard University Press, 1979), 16–23.

22. Perhaps the most meticulous study of the foundation of Cavell's thinking on film is William Rothman and Marian Keane's *Reading Cavell's "The World Viewed": A Philosophical Perspective on Film* (Detroit, MI: Wayne State University Press, 2000).

23. Cavell, *The World Viewed*, 24.

24. Andrew Klevan, commenting on Cavell's thinking about film and the feeling of skepticism, notes an added poignancy by citing that "the consequence of this particular conjunction of presence and absence is that film allows us to see the world unseen, and, for Cavell, this sense of invisibility is an expression of modern privacy or anonymity: film makes plain a feeling we already know—that of feeling anonymous, of being trapped within our privacy." *Disclosure of the Everyday: Undramatic Achievement in Narrative Film* (Trowbridge, UK: Flicks Books, 2000), 19.

25. Cavell, *The World Viewed*, 188.

26. Stephen Mulhall, *Stanley Cavell: Philosophy's Recounting of the Ordinary* (Oxford: Clarendon Press, 1994), 228.

27. Stanley Cavell, *Themes out of School* (Chicago: University of Chicago Press, 1988), 173.

28. That the form of cinema is inseparable from its content demonstrates film's modernism. Cavell's brief chapter "Excursus: Some Modernist Painting" in *The World Viewed* investigates this feature of modernism. There Cavell writes, "Painting, being art, is revelation; it is revelation because it is acknowledgement; being acknowledgment, it is knowledge, of itself and of its world. Modernism did not invent this situation; it merely lives upon nothing else" (110). Clearly, if film is art, we can see that Cavell's comments apply to cinema. In a long footnote, Cavell cites his indebtedness to the art critic Michael Fried in terms of thinking about the role of medium within the viewer's experience of art, whatever its form or genre.

29. A useful recent discussion of films that dramatize the problem of skepticism is Philipp Schmerheim's *Skepticism Films: Knowing and Doubting the World in Contemporary Cinema* (New York: Bloomsbury, 2015). Also, Daniele Rugo's *Philosophy and the Patience of Film in Cavell and Nancy* (London: Palgrave, 2015) puts Cavell's thinking in conversation with Jean-Luc Nancy's aesthetic theories to show how film presents limit situations for philosophical discourse that force philosophy to develop beyond its limitations.

30. Cavell's many engagements with moral perfectionism are often most forcefully articulated in his readings of Emerson. See specifically *Conditions Handsome and Unhandsome: The Constitution of Emersonian Perfectionism* (Chicago: University of Chicago Press, 1990) and *Emerson's Transcendental Etudes* (Stanford, CA: Stanford University Press, 2003).

31. Actually, it is Amanda who might set up that double entendre. She insists that there is no difference between the sexes: "What I said was true, there's no difference between the sexes. Men, women, the same." She then allows that maybe there is a difference, "but it's a little difference." The earnestness of her delivery suggests that she is not making a joke, yet Adam shifts her statement into a flirtatious discourse of lovers. The line is ironic in its being simultaneously a political, an ontological, and a playfully seductive statement. Its irony is not the emptying of meaning; it is its excess of possible meanings.

32. Cavell, *Cities of Words*, 81.

33. Stanley Cavell, *Pursuits of Happiness: The Hollywood Comedy of Remarriage* (Cambridge, MA: Harvard University Press, 1981), 35.

34. Perhaps the most sustained investigation of this question regarding Cavell's methods can be found in Colin Davis's *Critical Excess: Overreading in Derrida, Deleuze, Levinas, Žižek, and Cavell* (Stanford, CA: Stanford University Press, 2010). Davis asks, "At what point does reading become overreading, and does the distinction help or matter?" (xii).

35. Cavell, *Pursuits of Happiness*, 37.

36. Arthur Danto, "Philosophy and/as Film and/as if Philosophy," *October*, no. 23 (Winter 1982): 8. Although Danto does not explicitly invoke Wittgenstein, he is clearly alluding to Wittgenstein's concept of *Lebensform*. Indeed, Danto's statement is an impressively concise paraphrase of Wittgenstein. At the very least, Danto's allusion signals Cavell's place within a Wittgensteinian inheritance.

37. Mulhall makes a compelling case for the presence of tropes of the fall in the work of Heidegger, Nietzsche, and Wittgenstein in *Philosophical Myths of the Fall* (Princeton, NJ: Princeton University Press, 2007). The study is certainly relevant, given the centrality of these three figures to Cavell's thinking. Mulhall finds that the three philosophers with whom he deals all incorporate a Christian perspective of humanity's need for redemption. In the case at hand, I am suggesting that Cavell offers a means of reframing—so that it is not redemption that is necessary but an ongoing discovery of what the human is and can be. In that way, there was never a need for redemption. With *Adam's Rib*, the contention is that women move from a status of possession to one of active agency. They do this by gaining control of the language that surrounds them. Again, the women are not in need of redemption, which transforms even the myth of the fall.

38. Wollheim, *The Thread of Life*, 90–91.

39. Wollheim distinguishes between mental states, which he describes as "episodic or transient phenomena," and mental dispositions, which are "persistent phenomena, which manifest themselves intermittently." Mental states can thus be categorized as events and include such things as thoughts, dizziness, dreams, and moments of terror or amusement. Dispositions are such things as beliefs and knowledge, skills, virtues, vices, habits, and the like. *Thread of Life*, 33–35.

2. Something Completely Different

1. Cavell is himself an acclaimed reader of Shakespeare. See especially his collection *Disowning Knowledge* (Cambridge: Cambridge University Press, 2003). Gerald L. Bruns offers an insightful view of Cavell's reading in his "Stanley Cavell's Shakespeare," in *Tragic Thoughts at the End of Philosophy: Language, Literature, and Ethical Theory* (Evanston, IL: Northwestern University Press, 1999), pp. 181–97. Also valuable is David Rudrum's *Stanley Cavell and the Claim of Literature* (Baltimore: Johns Hopkins University Press, 2013) and his extensive discussion of Cavell, who, in essence, makes Shakespeare's plays, along with the work of other literary authors, into a series of philosophical conceptual forces, as does Lawrence Rhu in *Stanley Cavell's American Dream: Shakespeare, Philosophy, and Hollywood Movies* (New York: Fordham University Press, 2006).

2. Cavell, *Pursuits of Happiness*, 1–2.

3. Some of my thinking about the important differences between crafted comedy and spontaneous jokes is informed by Suzanne K. Langer's "The Great Dramatic Forms: Comic Rhythm," in *Feeling and Form: A Theory of Art Developed from Philosophy in a New Key* (New York: Scribner's, 1953), 326–50. Although she focuses on comic theater, her interest in the structure and form of jokes is illuminating in other contexts as well.

4. In her essay " 'Surface' as an Expression of an Intention: On Richard Wollheim's Conception of Art as a Form of Life," Gabriele M. Mras describes the shared recognition of context as being indicative of *Lebensform*. That is, the artist, in this case Wright, and the audience do not share only affective recognition, but rather the whole context for recognition is shared and indicates the ties of the group. She begins her claim by stating that the "dominant view in the philosophy of art holds that in coming to understand a painting in front of us we become acquainted with and linked in a particular way with the *subjectivity* of the artist." She states further, "We find in successful pictorial depiction a particular expression of a conception of human beings as persons—a recognition of something essential to our nature as human beings.

"But, if so, we do not just recognize that in seeing a painting we *share* perceptions. We recognize that we are like her or him by perceiving what is put in front of us as painting" (167). This claim can be expanded to other forms of art as well, including comedy. In *Wollheim, Wittgenstein, and Pictorial Representation*, ed. Gary Kemp and Gabriele M. Mras (New York: Routledge, 2015), 160–69.

5. Although he comes from a very different perspective, Noël Carroll offers a concise but remarkably comprehensive overview of philosophical approaches to comedy and their historical context in *Humour: A Very Short Introduction* (Oxford: Oxford University Press, 2014).

6. Steven Wright, *I Have a Pony* (Burbank, CA: Warner Bros. Records, 2005), CD.

7. Peter Keepnews, "A Strange Career Takes an Odd Turn," *New York Times*, February 10, 2008, AR 28.

8. For an extended consideration of Keaton by Cavell, see "What Becomes of Things on Film," in *Themes out of School* (Chicago: University of Chicago Press, 1984), 173–83.

9. Track 5, 3'11"–3'18," from Wright, *I Have a Pony*.

10. Track 7, 2'23"–2'31," from Wright, *I Have a Pony*.

11. Track 8, 1'12"–1'19," from Wright, *I Have a Pony*.

12. 30'30"–30'38," from Steven Wright, *A Steven Wright Special*, dir. Walter Miller (Burbank, CA: Warner Home Video, 2009), DVD.

13. I make specific mention of this because, from Plato to Roger Scruton, there has been a long-standing superiority theory of comedy that holds comedy is dependent on an asymmetrical dynamic between what is perceived as comic and the perceiver. John Morreall offers a useful and concise overview of the primary theories of comedy in *Comic Relief: A Comprehensive Philosophy of Humor* (Malden, MA: Wiley-Blackwell, 2009). Morreall compiles excerpts in his anthology, *The Philosophy of Laughter and Humor* (Albany, NY: SUNY Press, 1987). An altogether divergent but not unrelated approach to stand-up and power dynamics can be found in John Limon's *Stand-Up Comedy in Theory, or, Abjection in America* (Durham, NC: Duke University Press, 2000).

14. Emerson, *ESS*, 5, 13.

15. An important survey of the history of stand-up comedy in America is Kliph Nesteroff's *The Comedians: Drunks, Thieves, Scoundrels and the History of American Comedy* (New York: Grove Press, 2015). Nesteroff devotes a chapter to the factors contributing to this important era in the history of comedy.

16. For example, consider this old street joke: For his birthday, a man receives a new tie as a gift from his son, but after a few days takes it back to the shop to exchange it. The salesman asks him what the problem might be—does he not like the color? "The color's fine," the man replies, "it's just that one end is longer than the other." It is hard not to hear this joke and not start wondering if a tie is not simply a strange thing for anyone to wear.

17. Guy MacPherson, "Conversations in Comedy: Steven Wright," December 16, 2015, http://www.guymacpherson.ca/interview-archives/2015/steven-wright.

18. Noël Carroll, "On Jokes," in *Beyond Aesthetics* (Cambridge: Cambridge University Press, 2001), 317–35. Carroll's characteristically deft, clear essay ought to be essential reading on the philosophical elements of jokes and humor. However, Carroll stops short of holding jokes alongside art, arguing that although both require interpretive activity by an audience, jokes can be exhausted after that initial interpretation, whereas art rewards an ongoing process, or at least multiple interpretations. If that is true, then this quality shows why Wright is distinct from so many of his peers. However, one could make further distinctions between "street jokes" and jokes that have been crafted and honed by professionals. Not all of these withstand interpretation, and most, if not all, lose their sense of being funny the more one analyzes. Yet, perhaps, as I believe is the case with Wright, the funny gives way to a deeper sense of the aesthetic possibilities of what is comic.

19. Track 9, 2'00"–2'44" from Steven Wright, *I Still Have a Pony* (Burbank, CA: Warner Bros. Records, 2007), CD.

20. Track 7, 1'31"–1'59," from Wright, *I Have a Pony*.

21. Of course, it hardly needs to be said that what Wright says on stage is not exactly a true claim about his own feelings or experiences. What he says is akin to a dramatic character saying something. What Wright says is therefore like a fictional truth rather than an experiential one. At the same time, that feeling is recognizable by the audience, and furthermore one is still given to asking what the conditions are that would generate

such a statement. If one does not do this, fictional characters never give audiences and readers anything to think about.

22. Nietzsche, *On the Genealogy of Morals*, 15.

23. Wollheim, *The Thread of Life*, 38.

24. Immanuel Kant, *Critique of Pure Reason*, trans. and ed. Paul Guyer and Allen W. Wood (Cambridge: Cambridge University Press, 1998), 121.

25. Simon Critchley, in *On Humour* (London: Routledge, 2002), describes his ideas about jokes in a way that I find useful here. Critchley has a two-part claim: "First, that the tiny explosions of humour that we call jokes return us to a common, familiar domain of shared life-world practices, the background meanings implicit in a culture. This is what is meant by humor as a form of *sensus communis*, where jokes can be seen to raise intersubjective validity claims. . . . However, second, I want to claim that humor also indicates, or maybe just adumbrates, how those practices might be transformed or perfected, how things might be otherwise. That is, humor might be said to project another possible *sensus communis*, namely a *dissensus communis* distinct from the dominant common sense. In laughing at a joke I am also consenting to an ideal image of the world" (90).

26. This is as good a place as any to acknowledge that many will be growing impatient with the amount of weight being placed on a few lines from a comic's routine. In *Ludwig Wittgenstein: A Memoir,* Norman Malcolm reports Wittgenstein once stated, "a serious and good philosophical work could be written that would consist entirely of jokes" (Oxford: Oxford University Press, 1962), 29. Be that as it may, Wright has always been known as a "comic's comic," one whose delivery and craft are an essential part of his comedy. A good comic is as attentive to form, cadence, inflection, and intonation as any other performer. Moreover, comedians tend to be acutely aware of the multiple enfoldings and unfoldings of language. It is the very structure that makes comic timing and surprise even possible. In that way, I suggest that a talented comic should merit as much attention as a talented author. Of course, what should be clear is that I am also indicating the ways that philosophical occasions can be found at hand, that they are part of and not apart from the everyday, from things that do not ordinarily sound like philosophy. The most wonder-provoking thing is that wonder can occur anywhere.

27. Sigmund Freud, "Der Humor," in *Gesammlte Werke*, vol. 14 (Berlin: S. Fischer, 1968), 384. The translation is my own.

28. *Jokes and Their Relation to the Unconscious* is, of course, the most famous of Freud's responses to the comic, but that work is also notoriously caught between its speculation as theory and its desire to make general psychological observations. At the very least, in *Jokes and Their Relation to the Unconscious* Freud is more invested in spontaneous humor and the way it registers latent or repressed content. In "Humor," however, Freud himself acknowledges limitations for that earlier book and changes direction in the more concise yet perhaps ultimately more generative essay "Humor." At the very least, "Humor" is more applicable to crafted examples of jokes and comedy of the order that stand-up offers.

29. Emerson insists there is a way that such dissonance is unavoidable within any collective, and this dissonance causes him to say of others, "Every word they say chagrins us" ("Self-Reliance," in *Essays: First Series*, 32). Emerson offers a curse against conformism,

but his language also notes complicity: "they," all of them, use the words "we," the community of language users, share in such a way that it causes irritation and resistance. But the lines between "they" and "we" are shifting.

30. Sigmund Freud, "The Uncanny," in *Collected Papers: Volume IV*, ed. Ernest Jones, trans. Joan Riviere (London: Hogarth Press, 1971), 375.

31. Stanley Cavell, "The Uncanniness of the Ordinary," in *In Quest of the Ordinary: Lines of Skepticism and Romanticism* (Chicago: University of Chicago Press, 1994), 154.

32. Nicholas Royle, *The Uncanny* (Manchester: Manchester University Press, 2003), 2.

33. Ted Cohen, *Jokes: Philosophical Thoughts on Joking Matters* (Chicago: University of Chicago Press, 1999), 50.

34. Jonathan Miller, "Jokes and Joking," in *Laughing Matters: A Serious Look at Humour*, ed. John Durant and Jonathan Miller (New York: Wiley, 1988), 15–16.

3. How to Dwell

1. Ashbery has often used collage as a poetic device in creating his poems. In recent years, however, he has also become a collagist of visual materials and has had several shows at the Tibor de Nagy Gallery in New York City.

2. A. Poulin Jr., "The Experience of Experience: A Conversation with John Ashbery," *Michigan Quarterly Review* 20, no. 3 (1981): 247.

3. Three salient books usefully focus their attention on poetry and the everyday: Liesl Olson's *Modernism and the Ordinary* (Oxford: Oxford University Press, 2009); Siobhan Phillips's *The Poetics of the Everyday: Creative Repetition in Modern American Verse* (New York: Columbia University Press, 2010); and Andrew Epstein's often insightfully historicizing (and politicizing) *Attention Equals Life: The Pursuit of the Everyday in Contemporary Poetry and Culture* (New York: Oxford University Press, 2016). The most influential book on the question of poetry and the ordinary remains Marjorie Perloff's *Wittgenstein's Ladder: Poetic Language and the Strangeness of the Ordinary* (Chicago: University of Chicago Press, 1996), though Perloff is specifically interested in the ways that Wittgensteinian poetics as practiced by the avant-garde can critique grammar in its being a cultural construction that shapes cultural practices.

4. Granted, this statement by Bloom appears as part of a blurb from the jacket of Ashbery's collected poems and hence has a bit of hyperbole animating it. Still, the accolades, references, and so forth do seem to bear out Bloom's pronouncement.

5. John Koethe, "An Interview with John Ashbery," *SubStance*, vols. 11/12, issues 37–38 (1982/1983), 183.

6. Quoted in John Shoptaw, *On the Outside Looking Out: John Ashbery's Poetry* (Cambridge, MA: Harvard University Press, 1994), 1. The passage is a translation from Ashbery's French.

7. Roger Gilbert, "Ludic Eloquence: On John Ashbery's Recent Poetry," *Contemporary Literature* 48, no. 2 (Summer 2007): 200.

8. For whatever the worth, typing the terms "John Ashbery" and "opaque" into an Internet search engine (I will not name which one, but it is the "most used search engine on the world wide web") yields 57,500 results.

9. Shoptaw offers a compelling reading of Ashbery's poetics as "misrepresentative" (2) in the introduction to his monograph *On the Outside Looking Out*. Shoptaw places his argument against those who see Ashbery's poems as meaningless or simply parodic. He argues that Ashbery's "misrepresentations do not as a consequence rule out meaning, expression, and representation; they renovate them" (3).

10. John Ashbery, "The Impossible," review of *Stanzas in Meditation*, by Gertrude Stein," *Poetry* 90, no. 4 (July 1957): 250–51. Reprinted in Gertrude Stein, *Stanzas in Meditation: The Corrected Edition*, ed. Susannah Hollister and Emily Setina (New Haven, CT: Yale University Press, 2012), 51.

11. For an early reading of the surface effects of Ashbery's grammar, see Jonathan Holden's "Syntax and the Poetry of John Ashbery," in *The Rhetoric of the Contemporary Lyric* (Bloomington: Indiana University Press, 1980), 98–111. There Holden notes that for Ashbery "syntax in writing is the equivalent of composition in painting: it has an intrinsic beauty and authority almost wholly independent of any specific context" (99).

12. Gertrude Stein, *A Stein Reader*, ed. Ulla E. Dydo (Evanston, IL: Northwestern University Press, 1993), 569.

13. Stein, *Stanzas in Meditation*, 52.

14. Ibid., 171.

15. Ibid., 53–54.

16. John Ashbery, *Quick Question* (New York: Ecco, 2012), 42.

17. Martin Heidegger, "Letter on Humanism" in *Basic Writings from "Being and Time" (1927) to "The Task of Thinking" (1964)*, ed. David Farrell Krell, trans. Frank A. Capuzzi and J. Glenn Gray (New York: Harper Collins, 1993), 217.

18. The scholarship of Luke Carson on Ashbery is consistently illuminating, and this is especially true in the careful ways that he charts Hölderlin's influence and presence in Ashbery's work. See especially " 'Render unto Caesura': Late Ashbery, Hölderlin, and the Tragic," *Contemporary Literature* 49, no. 2 (2008): 180–208.

19. Peter A. Stitt, "John Ashbery, The Art of Poetry No. 33," *Paris Review*, no. 90 (Winter 1983): 30–60, https://www.theparisreview.org/interviews/3014/john-ashbery -the-art-of-poetry-no-33-john-ashbery.

20. Martin Heidegger, "The Origin of the Work of Art," in *Poetry, Language, Thought*, trans. Albert Hofstadter (New York: Harper, 1971), 17.

21. Surprisingly, given Ashbery's interest in Hölderlin and the indication that Ashbery was influenced by his reading of the German poet, there has not been extended or sustained discussions of how one might bring Heidegger to bear on Ashbery's work in the ways I have done. The philosopher Frank B. Farrell is one scholar who finds sympathetic connections to Heidegger in Ashbery's work when he considers Ashbery as a phenomenologist who "wants to make us aware of the space of possible meaningfulness" (111). Farrell writes, "Ashbery's stance is one of belatedly inhabiting a space in which certain experiences are no longer possible (though it was questionable whether they ever were)" (114). Farrell does not really address the particular question of "dwelling." See *Why Does Literature Matter?* (Ithaca, NY: Cornell University Press, 2004).

22. Andrew DuBois, in his monograph on Ashbery's poetics and the ways it challenges and thematizes the act of attention, places *Your Name Here* in a group of books he characterizes as Ashbery's "dotages," though he seeks to divest that word of its

pejorative implications. DuBois sees these books and their noted disruption of grammar or linearity as a performance of senility as well as an exploration that is simultaneously playful as well as informed by a palpable threat faced by an aging poet. "The black comedy of Ashbery's 'dotages' is this: ludic randomness delivered at a fast pace wards off meaning in such a way as to seem unserious, but the context of that randomness is the poet's potential dotage and, by implication, eventual death, serious matters indeed." *Ashbery's Forms of Attention* (Tuscaloosa: University of Alabama Press, 2006), 115.

23. In his estimable overview of Ashbery's later work, John Emil Vincent makes the persuasive case that in the period between 1987's *April Galleons* and 2002's *Chinese Whispers*, Ashbery's compositional process depended on seeing a book as the unit of meaning, such that the poems' effects were meant to be seen as participating in a larger measure for their meaning. See Vincent's *John Ashbery and You: His Later Books* (Athens: University of Georgia Press, 2007). For that reason, I am focusing on one specific volume, rather than trying to range through a larger swath of Ashbery's work. A very comprehensive overview of Ashbery's early and middle periods can be found in David Herd's *John Ashbery and American Poetry* (Manchester, UK: Manchester University Press, 2000.

24. Stitt, "Art of Poetry No. 33."

25. Bonnie Costello and John Emil Vincent make strong cases for reading Ashbery's use of "you" as leaving room for the reader, thereby allowing the reader to identify himself or herself as that "you." Along with Vincent's *John Ashbery and You*, see Costello's "John Ashbery and the Idea of the Reader," *Contemporary Literature* 23, no. 4 (Fall 1982): 493–514.

26. John Ashbery, *Other Traditions* (Cambridge, MA: Harvard University Press, 2000), 2–3.

27. John Ashbery, *Your Name Here* (New York: Farrar, Straus and Giroux, 2000), 76.

28. Poulin, "The Experience of Experience," 250.

29. Emerson, "Self-Reliance," 32.

30. In setting up his routine about the planetarium and his girlfriend, Wright offers a darkly comic preface in his typical affectless monotone: "It was the first time I was ever in love, and I learned a lot. Before that I never even *thought* about killing myself" (Track 9, 1'48"–1'51" *I Still Have a Pony*). Within this is the double motion of wanting to be apart and yet remain intimately connected to others.

31. Shoptaw, *On the Outside Looking Out*, 3.

32. Antoine Cazé offers a fascinating reading of the latent autobiographical elements in Ashbery's work in "'The End of Friendship with Self Alone': Autobiographical Erasures in John Ashbery's 'Fragment,'" *E-rea* 5, no. 1 (2007), http://erea.revues.org/176.

33. Ashbery, *Your Name Here*, 3.

34. Ibid., 126.

35. Vasilis Papageorgiou, "Interview with John Ashbery," April 5, 1989, http://chromatachromata.com/interview-with-john-ashbery/.

36. Karin Roffman's biography *The Songs We Know Best: John Ashbery's Early Life* (New York: Farrar, Straus and Giroux, 2017) will prove undoubtedly to be an invaluable resource for readers of Ashbery. On the subject of the death of Richard Ashbery, see pp. 44–48.

37. Ashbery, *Your Name Here*, 31.

38. Thomas Dumm, *Loneliness as a Way of Life* (Cambridge, MA: Harvard University Press, 2008), 34–35.

39. René Descartes, *Meditations on First Philosophy with Selections from the Objections and Replies*, ed. and trans. John Cottingham (Cambridge: Cambridge University Press, 1996), 21.

40. Ibid., 16.

41. David Lehman, in his group biography of Ashbery and his peers, describes Ashbery (in an often-cited line) as "certainly the least autobiographical of modern poets. No one's poems have less to do with the details of his life." *The Last Avant-Garde: The Making of the New York School of Poets* (New York: Doubleday, 1998), 94.

42. Ashbery, *Your Name Here*, 4.

43. It is possible, for instance, to read the crow that flew off as being another sidelong reference to the death of the poet's brother. Given the use of mythic or fairy tale material in the poem, this reading seems quite generative. My thanks to Ilan Ben-Meir for this suggestion.

44. Harold Bloom, *Figures of Capable Imagination* (New York: Seabury Press, 1976), 173.

45. Nietzsche, *Genealogy of Morals*, 57.

46. Another reason for seeing Anna as invoking, however indirectly, Anna Freud is that Little Hans is one of the case studies she discusses at length in *The Ego and the Mechanisms of Defense*, trans. Cecil Baines (London: Karnac Books, 1992). Little Hans projects his anxieties onto horses as a phobia. In Ashbery's poem, Hans's crows seem to serve not as triggers for a phobia but as the symbols for some deeper neuroses.

47. Poulin, "The Experience of Experience," 247.

48. See, for example, Cavell, *In Quest of the Ordinary*, 172.

49. For a long discussion of this meeting and how it came to pass, see *Freud's Requiem: Mourning, Memory, and the Invisible History of a Summer Walk*, by Matthew von Unwerth (New York: Riverhead Books, 2005). Freud's essay is also reprinted in its entirety in this book.

50. Sigmund Freud, "On Transience," in *Collected Papers Volume V*, ed. James Strachey, trans. Joan Riviere (New York: Basic Books, 1959), 79.

51. Ibid., 80.

52. Ibid., 79.

53. See Freud's "Mourning and Melancholia," in *Collected Papers Volume IV*, ed. Ernest Jones, trans. Joan Riviere (London: Hogarth Press, 1971), 152–72; see especially pp. 153–55.

54. Freud, "On Transience," 82.

55. Poulin, "The Experience of Experience," 245.

56. I recommend here the work of the poet and philosopher John Koethe. It seems surprising given Ashbery's stature in contemporary literature that he has not been taken up more often by philosophers, at least by those philosophers given to writing about poets and poetry at all. This is especially curious in that so many of the predecessors connected to Ashbery—Whitman, Emerson, and Stevens, for instance—are discussed frequently across disciplinary boundaries. Koethe has often written about Ashbery

with clear philosophical inflections. These essays are gathered (along with other essays dealing with poetry) in *Poetry at One Remove* (Ann Arbor: University of Michigan Press, 2000). I especially recommend his remarkable argument in "Poetry and the Experience of Experience" (67–88). While Koethe does mention Ashbery there, the essay does not directly deal with the moment in Poulin's interview I have cited. At the same time, Koethe's essay does take on the questions that pertain to this chapter as a whole—what is experience and how does poetry take on the impossible (though not improbable) task of representing it by creating an occasion for affective responses?

57. Ashbery, *Your Name Here*, 64–65.

58. Freud, "On Transience," 79.

59. Cavell, *In Quest of the Ordinary*, 127.

60. Freud, "On Transience," 80.

4. Artful Things

1. David Bourdon, "Warhol Interviews Bourdon," in *I'll Be Your Mirror: The Selected Andy Warhol Interviews*, ed. Kenneth Goldsmith (New York: Carroll and Graf Publishers, 2004), 8.

2. Arthur Danto, *Andy Warhol* (New Haven, CT: Yale University Press, 2009), 48.

3. Ibid., 45–46. Just prior to this claim, Danto cites Michael Fried's review of Warhol's Stable Gallery Show, to note Fried's response to the pictures of Marilyn Monroe. Fried confesses he is moved by Warhol's "feeling for what is truly human and pathetic in one of the exemplary myths of our time." Fried goes on to admit he is not sure "that even the best of Warhol's work can much outlast the journalism on which it is forced to depend." Danto thinks otherwise, clearly, about the ongoing significance of Warhol's work, but also compelling here is the way that Danto rhetorically counters (but does not quite contradict) Fried's use of the term "myth" with an emphasis on what Danto calls "the tragedy of the commonplace." In Danto's trope, the mythic exists by way of the everyday. See Fried's review, "New York Letter: Warhol," reprinted in *Art and Objecthood* (Chicago: University of Chicago Press, 1998), 287–88.

4. Danto began laying out the terms of this argument about Warhol since his essay "The Artworld" first appeared. See *Journal of Philosophy* 61, no. 19 (October 1964): 571–84. Warhol is Danto's exemplar for the ways that contemporary art has achieved Hegel's prediction that art would become a form of philosophy in action. It is worth pointing out that Danto's reading of Warhol first began to develop at a time when many critics were loath to see pop art as art at all.

5. *Brillo Boxes* is indeed iconic, and Michael J. Golec offers a very comprehensive book-length discussion of this particular work by Warhol in *The Brillo Box Archive* (Hanover, NH: Dartmouth University Press, 2008). Golec crosses various discourses—philosophy, aesthetics, and design—to make his case that Warhol's boxes create a site where all these different ways of addressing art meet. The boxes are a kind of case study for Golec by which he shows how differing ways of talking about the work are, over the years, brought to bear on it, shifting the ways its meaning and value are determined.

6. Danto's use of the term "art world" does not refer to just the social formations and milieu of the art community and its institutions and scenes. Rather, he has a more specialized sense of the term. For him, the word refers to a space where art objects exist conceptually (I also adopt this use). That is to say language and meaning surround the objects in this space in ways that do not happen with mere real things. He first uses this term in his essay "The Artworld." George Dickie has used this term in significantly different yet related ends in his discussions of the institutional theory of art.

7. This is a central question for Danto. See Arthur Danto, *The Transfiguration of the Commonplace: A Philosophy of Art* (Cambridge, MA: Harvard University Press, 1983), 1.

8. There are other names, to be sure, including Wayne Theibaud, Marisol, and Ed Ruscha. And pop art went by various other labels—from Neo-Dada to new realism. In any event, it is important to bear in mind that there was no monolithic style that all the pop artists shared. It is better to think of the work that these varied artists produced as sharing certain family resemblances.

9. Lawrence Alloway, *American Pop Art* (New York: Collier Books, 1974), 18.

10. Andy Warhol, *The Philosophy of Andy Warhol: From A to B and Back Again* (New York: Harcourt Brace Jovanovich, 1975), 101.

11. Danto is given to citing Henrich Wölfflin's observation that "not all things are possible at all times."

12. Arthur Danto, *Embodied Meanings: Critical Essays and Aesthetic Meditations* (New York: Farrar, Strauss and Giroux, 1994), xiii.

13. As should be clear in my references throughout *Art of the Ordinary* to Wittgenstein's term from *Philosophical Investigations*, this concept is central to my thinking. He certainly is of vital importance to Cavell, Danto, and Wollheim. While I have chosen not to focus on Wittgenstein so as to concentrate on these other figures, it should be evident that he stands behind many of the claims I make.

14. Danto, *Philosophizing Art*, 5.

15. Arthur Danto, *The Philosophical Disenfranchisement of Art* (New York: Columbia University Press, 1986), 151.

16. Arthur Danto, *After the End of Art: Contemporary Art and the Pale of History* (Princeton, NJ: Princeton University Press, 1997), 13.

17. This position is central to Danto's thinking. See, as a place to begin, Arthur Danto, "Approaching the End of Art," in *The State of the Art* (New York: Prentice Hall, 1987), 202–18.

18. G. W. F. Hegel, *The Philosophy of History*, trans. J. Sibree (New York: Willey, 1944), 19.

19. Although Danto's claim about "the end of art" is often misconstrued, there are salient challenges to his historical conception of art's philosophical development. Many of the strongest critiques appear in a special issue of *History and Theory* titled "Danto and His Critics: Art History, Historiography and After the End of Art," published in 1998 (vol. 37, no. 4). Noël Carroll, as but one example, offers a counterclaim based on what he feels is Danto's narrow emphasis on painting, "What Danto calls 'post-historical art' is not a philosophical category. Rather, it is a telling description of a significant,

though contingent, stylistic interlude" ("The End of Art?," 29). They would continue this generative disagreement for years, with Carroll offering a further reframing of Danto's position in "Danto, the End of Art, and the Orientational Narrative," in *The Philosophy of Arthur C. Danto*, ed. Randall E. Auxier and Lewis Edwin Hahn (Chicago: Open Court, 2013), 433–52. In his essay Carroll offers this: "Read as a scientific historical narrative, the end-of-art thesis falters. But reinterpreted as an orientational narrative advocating a new direction for criticism in the contemporary art world, it is quite astute" (452). What is compelling is Danto's response, in which he summarizes that Carroll notes a difference between the way that Danto practices art criticism and the way followers of Clement Greenberg practice it. According to Danto's restating of Carroll's estimation, Greenbergians write criticism that "undertakes to write the art history of the present—singling out those trends that belong to the master narrative of developmental progress" (458). Danto's method, however, is "to take up each piece of art as it comes along, and to try to understand it in terms of its meaning and how the meaning is embodied." Danto, in his reply appended to Carroll's essay, describes this as "criticism for a pluralistic art world" (458). In many ways, my discussions in this chapter—indeed, throughout the whole book—reflect that same impulse to treat both works of art and works of philosophy in a similar manner.

20. Hegel, *Aesthetics: Lectures on Fine Art*, trans. T. M. Knox (New York: Oxford University Press, 1975), 31–32.

21. Gretchen Berg, "Andy Warhol: My True Story," in *I'll Be Your Mirror: The Selected Andy Warhol Interviews*, ed. Kenneth Goldsmith (New York: Carroll and Graf Publishers, 2004), 90.

22. Alan Tormey's *The Concept of Expression: A Study in Philosophical Psychology and Aesthetics* (Princeton, NJ: Princeton University Press, 1971) contains an appendix that provides a brief annotated bibliography of a range of texts that offer a variety of views on expressivism. An extremely provocative engagement with expressivity is Charles Altieri's *Subjective Agency: A Theory of First-Person Expressivity and Its Social Implications* (Cambridge, MA: Blackwell, 1994).

23. This is a definition of art that Danto uses throughout his career. One of the best summations is found in his final book, *What Art Is* (New Haven, CT: Yale University Press, 2013).

24. Intentionality in works of art is, of course, a contentious subject. There are many arguments for and against the inclusion of intentionality as a primary concern of aesthetics. One of the most compelling advocates for intentionality being a necessary consideration when we deal with works of art is Noël Carroll. See especially *Beyond Aesthetics: Philosophical Essays* (Cambridge: Cambridge University Press, 2001).

25. These will no doubt come across as presenting a bias toward contemporary art. Be that as it may, I do not mean to minimize the complexities to be found in representational art. In *To Destroy Painting* (Chicago: University of Chicago Press, 1995), Louis Marin insists, "A beautiful and harmonious painting is an integrated whole made up of oppositions and differences, an ordering of diversity through the completion of a series of visual trajectories" (42). True enough, indeed. And yet, what Marin does is to reveal the complexities of representation that might otherwise go unnoticed. With contemporary art, the place for beginning the process of engaging the work is far less evi-

dent from the outset. It is complex before it is complicated by the theories brought to the work. Beyond that, the claims being made about art are not limited to contemporary practices but should be resonating through whatever form the art takes or has taken.

26. "Art now exists in the condition of philosophy," Cavell states in *The World Viewed*, which offers a point of contact with him and Danto (14). He does not say it *is* philosophy, though Cavell clearly feels it necessary to rehabilitate philosophy in such a way that it could be recognized as occurring in different guises and modes, as, for instance, film.

An engaging moment to see the connections and differences between Cavell and Danto occurs in an exchange found in *Action, Art, History: Engagements with Arthur C. Danto*, ed. Daniel Herwitz and Michael Kelly (New York: Columbia University Press, 2007), 24–42. In an essay titled "Crossing Paths," Cavell indicates that he and Danto separate on a variety of points including the value of Wittgenstein's *Philosophical Investigations* (which Danto finds exceptional as writing but hazy as philosophy) and perhaps matters of taste in art. Cavell prefers, for instance, the representation of boredom in Michangelo Antonioni's *L'Eclisse* over Warhol's *Empire*. Danto wonders if such preferences are, at bottom, temperamental rather than substantive. Nevertheless, Cavell insists that despite their differences the two share a sense that modernist art calls "increasingly, in some new way, for philosophy" (35). Danto, in his "Response," indicates that the differences between the two of them, particularly in terms of their respective preferences, are themselves legible in that they express something about their characters, their belief systems, their bank of experiences. He points out that their lives are not shaped by the philosophers each admires, but it is, in fact, the other way around (41–42). His doubts about later Wittgenstein perhaps notwithstanding, Danto in that moment sounds sympathetic to the idea that there are bedrock propositions that shape all else.

Danto's reply ends on what might otherwise be taken as sentimental in his noting of the intractable and indelible differences of souls being no barrier to his embracing Cavell "with a kind of love for his difference" (42). It is a surprising if not astonishingly intimate moment for the very fact that it occurs in a book of academic philosophical essays published by a university press. Yet, that gesture itself seems to validate Cavell's arguments about relationships and love, which I discussed in chapter 1. Love needs to acknowledge difference, not overwhelm it, absorb it, or negate it. Danto insists on difference and yet, in that moment, makes a gesture that is personally authentic as well as being a conceptual engagement with Cavell's ideas about what philosophy needs to accommodate.

27. Danto, *The Transfiguration of the Commonplace*, 189.

28. Joseph Margolis, *Selves and Other Texts: The Case for Cultural Realism* (University Park: Pennsylvania State University Press, 2001), 66.

29. A rich and thoughtful discussion of context and discourse in terms of defining art is offered in the rich and comprehensive study by David Davies titled *Art as Performance* (Oxford: Wiley-Blackwell, 2004).

30. Danto, *The Transfiguration of the Commonplace*, 170.

31. The most thoughtful discussion of Danto's thinking about the structure of metaphor can be found in Diarmuid Costello's "Danto and Kant: Together at Last?" found in *Danto and His Critics*, ed. Mark Rollins (Malden, MA: Wiley-Blackwell, 2012), 153–71.

32. Benjamin H. D. Buchloh, *Neo-Avantgarde and Culture Industry: Essays on European and American Art from 1955 to 1975* (Cambridge, MA: MIT Press, 2003), 485.

33. One can see the connection between Warhol and the rise of the conceptualism of artists such as Joseph Kosuth, Vito Acconci, and On Kawara that would take hold by the end of the decade. One key difference is that for Warhol, the art is not wholly dematerialized—there is still an actual painting. As aspects of his paintings and especially of his silk screens, Warhol welcomed small but random imperfections, accidents, and mistakes. These made the work more particularized and not simply concepts.

34. Gary Indiana, *Andy Warhol and the Can That Sold the World* (New York: Basic Books, 2010), 91.

35. Harold Rosenberg, "Warhol: Art's Other Self," in *Art on the Edge: Creators and Situations* (New York: Macmillan, 1975), 98–108.

36. Ibid., 98.

37. Ibid., 99.

38. Frank O'Hara, *Jackson Pollock* (New York: George Braziller, 1959), 22.

39. Robert Rauschenberg, "Artist's Statement," in *Sixteen Americans*, ed. Dorothy C. Miller (New York: Museum of Modern Art, 1959), 58.

40. In his seminal study of Warhol's work in film, *Stargazer: Andy Warhol's World and His Films* (London: Calder and Boyars, 1973), Stephen Koch acknowledges the way that although Warhol was always attuned to the specifics of whatever medium he used, he was invested in the way the medium might question itself. Koch observes, "Within the artistic ambience in which he emerged during the 1960's—painting (and especially Warhol's painting) had embarked on a set of concerns in which film as a medium seemed constantly on the verge of declaring itself. And so he turned to film, and it was declared" (19).

41. This changes fairly radically in the 1970s and 1980s when Warhol became much more focused on producing celebrity portraits that tended to be somewhat vulgarly aestheticized or kitschy. But even here there is arguably a connection between meaning and form. The celebrities themselves were crafted public icons of personality and power and so Warhol heightened that sense of artifice, that which we call glamour, and brought it to the fore. If his earlier work is "the New Realism," his later work might be considered a "New Baroque."

42. In "Andy Warhol's *Sleep*: The Play of Repetition," Branden W. Joseph dispels the notion that *Sleep* is simply one long take, and proves that the film is heavily edited, even if it still minimizes any sense of eventfulness in what is seen. *Masterpieces of Modernist Cinema*, ed. Ted Perry (Bloomington: Indiana University Press, 2006), 179–207.

43. Andy Warhol, "Notes on My Epic," in *Andy Warhol's Index Book* (New York: Random House, 1967), n.p.

44. This is certainly not true of all of Warhol's movies, since he increasingly wanted to emulate Hollywood films even as he satirized, parodied, and subverted them.

45. It bears noting that Ashbery is the subject of one of Warhol's *Screen Tests*. In *Andy Warhol, Poetry, and Gossip in the 1960s*, Reva Wolf traces the intersections of Warhol and the New York School of writers. Although these connections are largely social, Wolf provides evidence of Warhol's interest in their poetry and poetics (Chicago: University of Chicago Press, 1997).

46. Danto, *Andy Warhol*, 77.

47. Both images and things are in the world at large, but it should not need to be said that they are in it very differently.

48. Callie Angell provides a guide to the "events" of *Empire* in *The Films of Andy Warhol, Part 2* (New York: Whitney Museum of American Art, 1994), 18.

49. J. J. Murphy makes a compelling case for seeing gestures even in Warhol's early, minimalist films that "explore a broad range of narrative possibilities" (49), which is a perspective quite daring in its departure from the commonly held notion of Warhol's work being more lyric in its attention to protracted moments. See *The Black Hole of the Camera* (Berkeley: University of California Press, 2012), 15–49.

50. Andy Warhol and Pat Hackett, *POPism: The Warhol '60s* (New York: Harcourt Brace Jovanovich, 1980), 50.

51. In the essay "On Being Bored," Adam Phillips asks a generative, albeit rhetorical question, "So perhaps boredom is merely the mourning of everyday life?" (71). *On Kissing, Tickling, and Being Bored: Psychoanalytic Essays on the Unexamined Life* (Cambridge, MA: Harvard University Press, 1994), 68–78.

52. Danto, *Philosophizing Art*, 67.

53. Sol LeWitt states in his famous "Sentences on Conceptual Art," "Conceptual artists are mystics rather than rationalists. They leap to conclusions that logic cannot reach." In that regard, Warhol was not alone in his particular form of mysticism. "Sentences on Conceptual Art," *0–9*, 1969, http://www.altx.com/vizarts/conceptual.html.

54. Warhol and Hackett, *POPism*, 39.

55. Ibid., 41.

56. Danto, *The Philosophical Disenfranchisement of Art*, 151.

57. Warhol and Hackett, *POPism*, 41.

58. A fascinating (and lively) study of Warhol is Michael Angelo Tata's *Andy Warhol: Sublime Superficiality* (New York: Intertheory Press, 2010). Tata's argument passes through the portal of Danto's thinking but comes to the exact opposite conclusion, arguing that in Warhol's work the Romantic sublime achieves its full realization and subsequent culmination.

59. Martin Heidegger, "What Is Metaphysics?," in *Basic Writings from "Being and Time" (1927) to "The Task of Thinking" (1964)*, ed. David Farrell Krell, trans. Frank A. Capuzzi and J. Glenn Gray (New York: Harper Collins, 1993), 99.

60. A more contemporary and quite comprehensive engagement with boredom is Lars Svendsen's *A Philosophy of Boredom*, trans. John Irons (London: Reaktion Books, 2005). Svendsen includes a useful discussion of Heidegger's phenomenology of boredom as well as what he sees as Warhol's "anti-Romantic" (103) stance. The most ambitious survey of the cultural history of boredom is Peter Toohey's *Boredom: A Lively History* (New Haven, CT: Yale University Press, 2012). For an excellent resource book on statements largely by arts practitioners about the aesthetics of boredom, see *Boredom*, ed. Tom McDonough (Cambridge, MA: MIT Press, 2017).

61. Martin Heidegger, *The Fundamental Concepts of Metaphysics: World, Finitude, Solitude*, trans. William McNeill and Nicholas Walker (Bloomington: Indiana University Press, 1995), 103.

62. Danto, *Philosophizing Art*, 67.

63. Ibid., 71

64. Douglas Crimp, *"Our Kind of Movie": The Films of Andy Warhol* (Cambridge, MA: MIT Press, 2012), 137–40.

65. Porter, "A Realist," 91.

66. Koch, *Stargazer*, 12.

67. Hal Foster, *The First Pop Age: Painting and Subjectivity in the Art of Hamilton, Lichtenstein, Warhol, Richter, and Ruscha* (Princeton, NJ: Princeton University Press, 2012), 164. For Foster, the trials of the subjects of/in the screen tests open up the possibility of (intermittent) empathy by the viewer.

68. This film is readily found on YouTube; however, a version with an added soundtrack can be found on *13 Most Beautiful . . . Songs for Andy Warhol Screen Tests* (Pittsburgh, PA: Plexifilm, 2009), DVD.

69. Callie Angell, *Screen Tests: The Films of Andy Warhol Catalogue Raisonné*, vol. 1 (New York: Abrams, 2005), 14.

70. Arthur Danto, *Beyond the Brillo Box: The Visual Arts in Post-Historical Perspective* (New York: Farrar, Straus and Giroux, 1992), 139.

71. Danto, *The Transfiguration of the Commonplace*, 208.

72. Novalis, *Notes for a Romantic Encyclopaedia*, ed. and trans. David W. Wood (Albany, NY: SUNY Press, 2007), 155.

BIBLIOGRAPHY

Alloway, Lawrence. *American Pop Art* (New York, NY: Collier Books, 1974).

Altieri, Charles. *Subjective Agency: A Theory of First-Person Expressivity and Its Social Implications* (Cambridge, MA: Blackwell, 1994).

Angell, Callie. *The Films of Andy Warhol, Part 2* (New York, NY: Whitney Museum of American Art, 1994).

———. *Screen Tests: The Films of Andy Warhol Catalogue Raisonné* (Vol. 1) (New York, NY: Abrams, 2005).

Ashbery, John. "The Impossible," review of *Stanzas in Meditation*, by Gertrude Stein," *Poetry*, vol. 90, no. 4 (July 1957), pp. 250–54. Reprinted in Gertrude Stein, *Stanzas in Meditation: The Corrected Edition*, ed. Susannah Hollister and Emily Setina (New Haven, CT: Yale University Press, 2012), pp. 50–55.

———. *Other Traditions* (Cambridge, MA: Harvard University Press, 2000).

———. *Quick Question* (New York, NY: Ecco, 2012).

———. "Respect for Things as They Are," in *Fairfield Porter: Realist Painter in an Age of Abstraction* (Boston, MA: Museum of Fine Art, 1982), pp. 7–13.

———. *Three Poems* (New York, NY: Viking, 1972).

———. *Your Name Here* (New York, NY: Farrar, Straus and Giroux, 2000).

Berg, Gretchen. "Andy Warhol: My True Story," in *I'll Be Your Mirror: The Selected Andy Warhol Interviews*, ed. Kenneth Goldsmith (New York, NY: Carroll and Graf Publishers, 2004), pp. 85–96.

Bloom, Harold. *Figures of Capable Imagination* (New York, NY: Seabury Press, 1976).

Bourdon, David. "Warhol Interviews Bourdon," in *I'll Be Your Mirror: The Selected Andy Warhol Interviews*, ed. Kenneth Goldsmith (New York, NY: Carroll and Graf Publishers, 2004), pp. 6–14.

Bruns, Gerald L. "Stanley Cavell's Shakespeare," in *Tragic Thoughts at the End of Philosophy: Language, Literature, and Ethical Theory* (Evanston, IL: Northwestern University Press, 1999), pp. 181–97.

Buchloh, Benjamin H. D. *Neo-Avantgarde and Culture Industry: Essays on European and American Art from 1955 to 1975* (Cambridge, MA: MIT Press, 2003).

Carroll, Noël. *Beyond Aesthetics: Philosophical Essays* (Cambridge: Cambridge University Press, 2001).

——. "Danto, the End of Art, and the Orientational Narrative," in *The Philosophy of Arthur C. Danto*, ed. Randall E. Auxier and Lewis Edwin Hahn (Chicago, IL: Open Court, 2013), pp. 433–52.

——. "The End of Art?," in "Danto and His Critics: Art History, Historiography and After the End of Art," *History and Theory*, vol. 37, no. 4 (1998), pp. 17–29.

——. *Humour: A Very Short Introduction* (Oxford: Oxford University Press, 2014).

——. "On Jokes," in *Beyond Aesthetics: Philosophical Essays* (Cambridge: Cambridge University Press, 2001), pp. 317–35.

Carson, Luke. " 'Render unto Caesura': Late Ashbery, Hölderlin, and the Tragic," *Contemporary Literature*, vol. 49, no. 2 (2008), pp. 180–208.

Cavell, Stanley. *Cities of Words: Pedagogical Letters on a Register of the Moral Life* (Cambridge, MA: Harvard University Press, 2004).

——. *Conditions Handsome and Unhandsome: The Constitution of Emersonian Perfectionism* (Chicago, IL: University of Chicago Press, 1990).

——. "Crossing Paths," in *Action, Art, History: Engagements with Arthur C. Danto*, ed. Daniel Herwitz and Michael Kelly (New York, NY: Columbia University Press, 2007), pp. 24–36.

——. *Disowning Knowledge* (Cambridge: Cambridge University Press, 2003).

——. *Emerson's Transcendental Etudes* (Stanford, CA: Stanford University Press, 2003).

——. *In Quest of the Ordinary: Lines of Skepticism and Romanticism* (Chicago, IL: University of Chicago Press, 1994).

——. *Pursuits of Happiness: The Hollywood Comedy of Remarriage* (Cambridge, MA: Harvard University Press, 1981).

——. "Something Out of the Ordinary," in *Philosophy the Day after Tomorrow* (Cambridge, MA: Harvard University Press, 2005), pp. 7–27.

——. *Themes out of School: Effects and Causes* (Chicago, IL: University of Chicago Press, 1988).

——. *This New yet Unapproachable America: Lectures after Emerson after Wittgenstein* (Albuquerque, NM: Living Batch Press 1989).

——. *The World Viewed: Reflections on the Ontology of Film.* Enlarged edition (Cambridge, MA: Harvard University Press, 1979).

Cazé, Antoine. " 'The End of Friendship with Self Alone': Autobiographical Erasures in John Ashbery's 'Fragment,' " *E-rea*, vol. 5, no. 1 (2007), http://erea.revues.org/176.

Cohen, Ted. *Jokes: Philosophical Thoughts on Joking Matters* (Chicago, IL: University of Chicago Press, 1999).

Costello, Bonnie. "John Ashbery and the Idea of the Reader," *Contemporary Literature*, vol. 23, no. 4 (Fall 1982), pp. 493–514.

Costello, Diarmuid. "Danto and Kant: Together at Last?," in *Danto and His Critics*, ed. Mark Rollins (Malden, MA: Wiley-Blackwell, 2012), pp. 153–71.

Crimp, Douglas. *"Our Kind of Movie": The Films of Andy Warhol* (Cambridge, MA: MIT Press, 2012).

Critchley, Simon. *On Humour* (London: Routledge, 2002).

Danto, Arthur. *After the End of Art: Contemporary Art and the Pale of History* (Princeton, NJ: Princeton University Press, 1997).

———. *Andy Warhol* (New Haven, CT: Yale University Press, 2009).

———. "Approaching the End of Art," in *The State of the Art* (New York, NY: Prentice Hall, 1987), pp. 202–18.

———. "Art's Infancy," review of *The Mind and Its Depths*, by Richard Wollheim, and *Psychoanalysis, Mind and Art: Perspectives on Richard Wollheim*, edited by Jim Hopkins and Anthony Savile," *London Review of Books*, vol. 15, no. 8 (1993), pp. 17–18.

———. "The Artworld," *Journal of Philosophy*, vol. 61, no. 19 (October 1964), pp. 571–84.

———. *Beyond the Brillo Box: The Visual Arts in Post-Historical Perspective* (New York, NY: Farrar, Straus and Giroux, 1992).

———. *Embodied Meanings: Critical Essays and Aesthetic Meditations* (New York, NY: Farrar, Strauss and Giroux, 1994).

———. *The Philosophical Disenfranchisement of Art* (New York, NY: Columbia University Press, 1986).

———. *Philosophizing Art* (Berkeley, CA: University of California Press, 1999).

———. "Philosophy and/as Film and/as if Philosophy," *October*, no. 23 (Winter 1982), pp. 5–14.

———. "Reply to Noël Carroll," in *The Philosophy of Arthur C. Danto*, ed. Randall E. Auxier and Lewis Edwin Hahn (Chicago, IL: Open Court, 2013), pp. 453–58.

———. "Response [to Stanley Cavell]," in *Action, Art, History: Engagements with Arthur C. Danto*, ed. Daniel Herwitz and Michael Kelly (New York, NY: Columbia University Press, 2007), pp. 37–42.

———. *The Transfiguration of the Commonplace: A Philosophy of Art* (Cambridge, MA: Harvard University Press, 1983).

———. *What Art Is* (New Haven, CT: Yale University Press, 2013).

Davies, David. *Art as Performance* (Oxford: Wiley-Blackwell, 2004).

Davis, Colin. *Critical Excess: Overreading in Derrida, Deleuze, Levinas, Žižek, and Cavell* (Stanford, CA: Stanford University Press, 2010).

Descartes, René. *Meditations on First Philosophy with Selections from the Objections and Replies*, ed. and trans. John Cottingham (Cambridge: Cambridge University Press, 1996).

DuBois, Andrew. *Ashbery's Forms of Attention* (Tuscaloosa, AL: University of Alabama Press, 2006).

Dumm, Thomas. *Loneliness as a Way of Life* (Cambridge, MA: Harvard University Press, 2008).

Eldridge, Richard. "Review: Contending with Stanley Cavell; Russell Goodman (ed.), *Contending With Stanley Cavell* (New York: Oxford University Press, 2005)," *Notre Dame Philosophical Reviews* (August 4, 2005), http://ndpr.nd.edu/news/contending -with-stanley-cavell/.

Emerson, Ralph Waldo. "The American Scholar," in *Emerson: Essays and Lectures*, ed. Joel Porte (New York, NY: Library of America, 1983), pp. 51–72.

——. "Art," in *The Collected Works of Ralph Waldo Emerson: Essays: First Series* (Vol. 2), ed. J. Slater, A. R. Ferguson, and J. F. Carr (Cambridge, MA: Belknap Press of Harvard University Press, 1979), pp. 207–18.

——. "Considerations by the Way," in *The Collected Works of Ralph Waldo Emerson: The Conduct of Life* (Vol. 6), ed. J. Slater and D. E. Wilson (Cambridge, MA: Belknap Press of Harvard University Press, 2003), pp. 129–48.

——. "Experience," in *The Collected Works of Ralph Waldo Emerson: Essays: Second Series* (Vol. 3), ed. J. Slater, A. R. Ferguson, and J. F. Carr (Cambridge, MA: Belknap Press of Harvard University Press, 1983), pp. 25–50.

——. "The Poet," in *The Collected Works of Ralph Waldo Emerson: Essays: Second Series* (Vol. 3), ed. J. Slater, A. R. Ferguson, and J. F. Carr (Cambridge, MA: Belknap Press of Harvard University Press, 1983), pp. 1–24.

——. "Self-Reliance," in *The Collected Works of Ralph Waldo Emerson: Essays: First Series* (Vol. 2), ed. J. Slater, A. R. Ferguson, and J. F. Carr (Cambridge, MA: Belknap Press of Harvard University Press, 1979), pp. 25–51.

Epstein, Andrew. *Attention Equals Life: The Pursuit of the Everyday in Contemporary Poetry and Culture* (New York, NY: Oxford University Press, 2016).

Farrell, Frank B. *Why Does Literature Matter?* (Ithaca, NY: Cornell University Press, 2004).

Foster, Hal. *The First Pop Age: Painting and Subjectivity in the Art of Hamilton, Lichtenstein, Warhol, Richter, and Ruscha* (Princeton, NJ: Princeton University Press, 2012).

Freud, Anna. *The Ego and the Mechanisms of Defense*, trans. Cecil Baines (London: Karnac Books, 1992).

Freud, Sigmund. "Der Humor," in *Gesammlte Werke* (Vol. 14) (Berlin: S. Fischer, 1968), pp. 383–92.

——. "Mourning and Melancholia," in *Collected Papers Volume IV*, ed. Ernest Jones, trans. Joan Riviere (London: Hogarth Press, 1971), pp. 152–72.

——. "On Transience," in *Collected Papers Volume V*, ed. James Strachey, trans. Joan Riviere (New York, NY: Basic Books, 1959), pp. 79–82.

——. *The Standard Edition of the Complete Psychological Works of Sigmund Freud: Jokes and Their Relation to the Unconscious* (Vol. 8), trans. James Strachey (London: Vintage, 2001).

——. "The Uncanny," in *Collected Papers Volume IV*, ed. Ernest Jones, trans. Joan Riviere (London: Hogarth Press, 1971), pp. 368–408.

Fried, Michael. "New York Letter: Warhol," reprinted in *Art and Objecthood* (Chicago, IL: University of Chicago Press, 1998), 287–88.

Gilbert, Roger. "Ludic Eloquence: On John Ashbery's Recent Poetry," *Contemporary Literature*, vol. 48, no. 2 (Summer 2007), pp. 195–226.

Golec, Michael J. *The Brillo Box Archive* (Hanover, NH: Dartmouth University Press, 2008).

Gould, Timothy. *Hearing Things: Voice and Method in the Writings of Stanley Cavell* (Chicago, IL: University of Chicago Press, 1998).

Hadot, Pierre. *Philosophy as a Way of Life: Spiritual Exercises from Socrates to Foucault*, ed. Arnold Davidson, trans. Michael Chase (Malden, MA: Blackwell Publishing, 1995).

Hagberg, Garry. *Art as Language: Wittgenstein, Meaning, and Aesthetic Theory* (Ithaca, NY: Cornell University Press, 1995).

Hegel, G. W. F. *Aesthetics: Lectures on Fine Art*, trans. T. M. Knox (New York: Oxford University Press, 1975).

——. *The Philosophy of History*, trans. J. Sibree (New York: Willey, 1944).

Heidegger, Martin. *The Fundamental Concepts of Metaphysics: World, Finitude, Solitude*, trans. William McNeill and Nicholas Walker (Bloomington, IN: Indiana University Press, 1995).

——. "Letter on Humanism," in *Basic Writings from "Being and Time" (1927) to "The Task of Thinking" (1964)*, ed. David Farrell Krell, trans. Frank A. Capuzzi and J. Glenn Gray (New York, NY: Harper Collins, 1993), pp. 213–66.

——. "The Origin of the Work of Art," in *Poetry, Language, Thought*, trans. Albert Hofstadter (New York, NY: Harper, 1971), pp. 15–86.

——. "What Is Metaphysics?," in *Basic Writings from "Being and Time" (1927) to "The Task of Thinking" (1964)*, ed. David Farrell Krell, trans. Frank A. Capuzzi and J. Glenn Gray (New York, NY: Harper Collins, 1993), pp. 89–110.

Herd, David. *John Ashbery and American Poetry* (Manchester, UK: Manchester University Press, 2000).

Holden, Jonathan. "Syntax and the Poetry of John Ashbery," in *The Rhetoric of the Contemporary Lyric* (Bloomington, IN: Indiana University Press, 1980), pp. 98–111.

Indiana, Gary. *Andy Warhol and the Can That Sold the World* (New York, NY: Basic Books, 2010).

James, William. *Pragmatism* in *William James: 1902–1910*, ed. Bruce Kuklick (New York: Library of America).

——. *Some Problems of Philosophy* (Cambridge, MA: Harvard University Press, 1979).

Jaspers, Karl. "Heraclitus," in *The Great Philosophers: The Original Thinkers* (Vol. 2), ed. Hannah Arendt, trans. Ralph Mannheim (New York, NY: Harcourt, Brace & World, 1966), pp. 11–18.

Joseph, Branden W. "Andy Warhol's *Sleep*: The Play of Repetition," in *Masterpieces of Modernist Cinema*, ed. Ted Perry (Bloomington, IN: Indiana University Press, 2006), pp. 179–207.

Kahn, Charles, *The Art and Thought of Heraclitus* (Cambridge: Cambridge University Press, 1989).

Kant, Immanuel. *Critique of Pure Reason*, trans. and ed. Paul Guyer and Allen W. Wood (Cambridge: Cambridge University Press, 1998).

Keepnews, Peter. "A Strange Career Takes an Odd Turn," *New York Times*, February 10, 2008, AR 28.

Klevan, Andrew. *Disclosure of the Everyday: Undramatic Achievement in Narrative Film* (Trowbridge, UK: Flicks Books, 2000).

Koch, Stephen. *Stargazer: Andy Warhol's World and His Films* (London: Calder and Boyars, 1973).

Koethe, John. "An Interview with John Ashbery," *SubStance*, vols. 11/12, issues 37–38 (1982/1983), pp. 178–86.

———. *Poetry at One Remove* (Ann Arbor, MI: University of Michigan Press, 2000).

Kostelanetz, Richard. *Conversing with Cage* (New York: Limelight Editions, 1987).

Langer, Suzanne K. "The Great Dramatic Forms: Comic Rhythm," in *Feeling and Form: A Theory of Art Developed from Philosophy in a New Key* (New York, NY: Scribner's, 1953), pp. 326–50.

Lehman, David. *The Last Avant-Garde: The Making of the New York School of Poets* (New York, NY: Doubleday, 1998).

Levine, Michael. "Wollheim's Ekphrastic Aesthetics: Emotion and Its Relation to Art," in *Wollheim, Wittgenstein, and Pictorial Representation: Seeing-as and Seeing-in*, ed. Gary Kemp and Gabriele M. Mras (New York, NY: Routledge, 2015), pp. 241–67.

LeWitt, Sol. "Sentences on Conceptual Art," *0–9* (1969). http://www.altx.com/vizarts/conceptual.html

Limon, John. *Stand-Up Comedy in Theory, or, Abjection in America* (Durham, NC: Duke University Press, 2000).

MacPherson, Guy. "Conversations in Comedy: Steven Wright" (December 16, 2015). http://www.guymacpherson.ca/interview-archives/2015/steven-wright.

Malcolm, Norman. *Ludwig Wittgenstein: A Memoir* (Oxford: Oxford University Press, 1962).

Margolis, Joseph. *Selves and Other Texts: The Case for Cultural Realism* (University Park, PA: Pennsylvania State University Press, 2001).

Marin, Louis. *To Destroy Painting* (Chicago, IL: University of Chicago Press, 1995).

McDonough, Tom, ed. *Boredom* (Cambridge, MA: MIT Press, 2017).

Morreall, John. *Comic Relief: A Comprehensive Philosophy of Humor* (Malden, MA: Wiley-Blackwell, 2009).

———. *The Philosophy of Laughter and Humor* (Albany, NY: SUNY Press, 1987).

Miller, Jonathan. "Jokes and Joking," in *Laughing Matters: A Serious Look at Humour*, ed. John Durant and Jonathan Miller (New York, NY: Wiley, 1988), pp. 5–16.

Mras, Gabriele M. "'Surface' as an Expression of an Intention: On Richard Wollheim's Conception of Art as a Form of Life," in *Wollheim, Wittgenstein, and Pictorial Representation: Seeing-as and Seeing-in*, ed. Gary Kemp and Gabriele M. Mras (New York, NY: Routledge, 2015), pp. 160–69.

Mulhall, Stephen. *Philosophical Myths of the Fall* (Princeton, NJ: Princeton University Press, 2007).

———. *Stanley Cavell: Philosophy's Recounting of the Ordinary* (Oxford: Clarendon Press, 1994).

Murphy, J. J. *The Black Hole of the Camera* (Berkeley, CA: University of California Press, 2012).

Nehamas, Alexander. "Painting as an Art," in *Psychoanalysis, Mind, and Art: Perspectives on Richard Wollheim*, ed. Jim Hopkins and Anthony Savile (Oxford: Blackwell Publishing, 1992), pp. 239–50.

Nesteroff, Kliph. *The Comedians: Drunks, Thieves, Scoundrels and the History of American Comedy* (New York, NY: Grove Press, 2015).

Nietzsche, Friedrich. *On the Genealogy of Morals*, ed. Walter Kaufmann, trans. Walter Kaufmann and R. J. Hollingdale (New York, NY: Vintage Books, 1989).

———. "On Truth and Lies in a Nonmoral Sense," in *The Nietzsche Reader*, ed. Keith Ansell Pearson and Duncan Large (Malden, MA: Blackwell Publishing, 2006), pp. 114–23.

O'Hara, Frank. *Jackson Pollock* (New York, NY: George Braziller, 1959).

Olson, Liesl. *Modernism and the Ordinary* (Oxford: Oxford University Press, 2009).

"Oral history interview with Fairfield Porter, 1968 June 6." Archives of American Art, Smithsonian Institution. http://www.aaa.si.edu/collections/interviews/oral-history -interview-fairfield-porter-12873.

Papageorgiou, Vasilis. "Interview with John Ashbery" (1989). http://chromatachromata .com/interview-with-john-ashbery/.

Perloff, Marjorie. *Wittgenstein's Ladder: Poetic Language and the Strangeness of the Ordinary* (Chicago, IL: University of Chicago Press, 1996).

Phillips, Adam. "On Being Bored," in *On Kissing, Tickling, and Being Bored: Psychoanalytic Essays on the Unexamined Life* (Cambridge, MA: Harvard University Press, 1994), pp. 68–78.

Phillips, Siobhan. *The Poetics of the Everyday: Creative Repetition in Modern American Verse* (New York, NY: Columbia University Press, 2010).

Porter, Fairfield. "Letter to Arthur Giardelli Great Spruce Head Island, Maine August 3, 1968," in *Material Witness*, ed. Ted Leigh (Ann Arbor, MI: University of Michigan Press, 2005), pp. 254–55.

———. "A Realist," in *Art in Its Own Terms*, ed. Rackstraw Downes (Boston, MA: MFA Publications, 2008), pp. 90–91.

Poulin, A., Jr. "The Experience of Experience: A Conversation with John Ashbery," *Michigan Quarterly Review*, vol. 20, no. 3 (1981), pp. 242–255.

Rauschenberg, Robert. "Artist's Statement," in *Sixteen Americans*, ed. Dorothy C. Miller (New York, NY: The Museum of Modern Art, 1959), pp. 58–63.

Read, Herbert. "Abstraction and Realism in Modern Art," in *The Philosophy of Modern Art* (London: Faber, 1964), pp. 88–104.

Rhu, Lawrence. *Stanley Cavell's American Dream: Shakespeare, Philosophy, and Hollywood Movies* (New York: Fordham University Press, 2006).

Roffman, Karin. *The Songs We Know Best: John Ashbery's Early Life* (New York, NY: Farrar, Straus and Giroux, 2017).

Rosenberg, Harold. "The American Action Painters," in *The Tradition of the New* (New York, NY: Horizon Press, 1959), pp. 23–39.

———. *Art on the Edge: Creators and Situations* (New York, NY: Macmillan, 1975).

Rothman, William, and Marian Keane, *Reading Cavell's "The World Viewed": A Philosophical Perspective on Film* (Detroit, MI: Wayne State University Press, 2000).

Royle, Nicholas. *The Uncanny* (Manchester: Manchester University Press, 2003).

Rudrum, David. *Stanley Cavell and the Claim of Literature* (Baltimore, MD: Johns Hopkins University Press, 2013).

Rugo, Daniele. *Philosophy and the Patience of Film in Cavell and Nancy* (London: Palgrave, 2015).

Russell, Bertrand. *The Problems of Philosophy* (Oxford: Oxford University Press, 1967).

Schmerheim, Philipp. *Skepticism Films: Knowing and Doubting the World in Contemporary Cinema* (New York, NY: Bloomsbury, 2015).

Shoptaw, John. *On the Outside Looking Out: John Ashbery's Poetry* (Cambridge, MA: Harvard University Press, 1994).

Stein, Gertrude. *Stanzas in Meditation: The Corrected Edition*, ed. Susannah Hollister and Emily Setina (New Haven, CT: Yale University Press, 2012).

——. *A Stein Reader*, ed. Ulla E. Dydo (Evanston, IL: Northwestern University Press, 1993).

Stitt, Peter A. "John Ashbery, The Art of Poetry No. 33," *Paris Review*, no. 90 (Winter 1983), pp. 30–60.

Svendsen, Lars. *A Philosophy of Boredom*, trans. John Irons (London: Reaktion Books, 2005).

Tata, Michael Angelo. *Andy Warhol: Sublime Superficiality* (New York, NY: Intertheory Press, 2010).

Toohey, Peter. *Boredom: A Lively History* (New Haven, CT: Yale University Press, 2012).

Tormey, Alan. *The Concept of Expression: A Study in Philosophical Psychology and Aesthetics* (Princeton, NJ: Princeton University Press, 1971).

Viefhues-Bailey, Ludger. *Beyond the Philosopher's Fear: A Cavellian Reading of Gender, Origin and Religion in Modern Skepticism* (Aldershot, UK: Ashgate, 2007).

Vincent, John Emil. *John Ashbery and You: His Later Books* (Athens, GA: University of Georgia Press, 2007).

Von Unwerth, Matthew. *Freud's Requiem: Mourning, Memory, and the Invisible History of a Summer Walk* (New York, NY: Riverhead Books, 2005).

Warhol, Andy. "Notes on My Epic," in *Andy Warhol's Index Book* (New York, NY: Random House, 1967), n.p.

——. *The Philosophy of Andy Warhol: From A to B and Back Again* (New York, NY: Harcourt Brace Jovanovich, 1975).

——, [dir.] *13 Most Beautiful . . . Songs for Andy Warhol Screen Tests* (Pittsburgh, PA: Plexifilm, 2009), DVD.

Warhol, Andy, and Pat Hackett. *POPism: The Warhol '60s* (New York: Harcourt Brace Jovanovich, 1980).

Wittgenstein, Ludwig. *Philosophical Investigations*, trans. G. E. M. Anscombe (Oxford: Blackwell Publishing, 1963).

——. *Tractatus Logico-Philosophicus*, trans. D. F. Pears and B. F. McGuinness (London: Routledge, 1974).

Wolf, Reva. *Andy Warhol, Poetry, and Gossip in the 1960s* (Chicago, IL: University of Chicago Press, 1997).

Wollheim, Richard. *The Thread of Life* (New Haven, CT: Yale University Press, 1999).

Wright, Steven. *I Have a Pony* (Burbank, CA: Warner Bros. Records, 2005), CD.

——. *I Still Have a Pony* (Burbank, CA: Warner Bros. Records, 2007), CD.

——. *A Steven Wright Special*, dir. Walter Miller (Burbank, CA: Warner Home Video, 2009), DVD.

INDEX

abstraction, 3–6, 9, 29, 31, 34, 55–56, 81, 120, 135, 147

"Abstraction and Realism in Modern Art", 3

Action Painters, 6, 147, 151, 162

Adam's Rib, 34–44, 47, 50, 120

Alloway, Lawrence, 124, 132, 157

Andreas-Salomé, Lou, 113

Angell, Callie, 161–62

Aristotle, 29

Ashbery, John: alienation, 20–21, 90, 92, 105–6, 119, 164; ambiguity, role of, 86, 89–90, 106–7; aphoristic style, 21, 90, 110; art as projection of emotion, 7, 17, 86, 96, 115; art writing background, 78; colloquial language usage, 84, 94; comic dimension, 80, 92, 99, 111–12; "Crossroads in the Past", 94–97; democratic inclusivity, 80, 83, 97; emotional distance, 20, 92, 98, 103, 105, 112; experience of experience, 114–15, 122, 138–39, 151; Fairfield Porter, critique of, 6–8, 17, 78, 130–31; Gertrude Stein,

critique of, 81–84, 96–97, 103; Harold Bloom reviews, 79–80, 108; "History of My Life, The", 101–3; "Homeless Heart", 85–91, 95, 164; "If You Said You Would Come With Me", 105–11, 114, 117; "Impossible, The", 81, 96–97; influential range, 79–80; Martin Heidegger, references to, 86–87; melancholic aspects, 112–18; memory, role of, 107–9, 115; mortality as subject, 85–87, 90–91, 102–3; naming paradoxes, 33, 87–100, 105–6, 111–12, 115, 117, 119; ordinary, representations of, 17, 80–81, 92–93, 98, 105, 117; *Other Traditions*, 94; Pierre Martory dedication, 97–98, 100, 105, 112; "Respect for Things as They Are", 6–7, 130; skepticism, role of, 80, 99–100, 104–5, 112–13, 117; *Some Trees*, 79; "System, The", 20–21; textual difficulty, 21, 81–82, 96; "They Don't Just Go Away, Either", 115–17; "This Room", 98–101, 103, 107; *Three Poems*, 20–21; *Your Name Here*, 20–21, 91–105, 112, 115, 117

Ashbery, Richard, 102, 105
Astaire, Fred, 29
Athena, 15
Attinger, Doris, 35
Aurelius, Marcus, 10

Beckett, Samuel, 55
Bed, 131
Berg, Gretchen, 133
Bible, 34, 94, 139
Bloom, Harold, 79–80, 108
Bonner, Adam and Amanda, 34–39,
 41–43, 49, 120
Bottle, Cup, and Newspaper, 135
Brillo Boxes, 122–23, 125, 130–31, 134, 136,
 144–45, 147, 149, 154, 158, 161, 163
Buchanan, Ann, 161–62
Buchloh, Benjamin, 142–43

Calling of Saint Matthew, The, 131
Campbell's Soup, 22, 122–23, 134, 136–37,
 154, 163
Caravaggio, 131
Carlin, George, 54–55
Carroll, Noël, 60, 93
Cavell, Stanley: *Adam's Rib*, critique of, 34–37,
 40–44, 47, 50; Arthur Danto, relations with,
 18–19, 45–46; *Cities of Words*, 34, 44, 46;
 daily choices, role of, 27–28, 43–44, 47, 51;
 human separateness, 33, 41–42, 119–20, 151;
 marriage, views on, 33–36, 40, 43, 46;
 moral perfectionism, 41, 51, 90; music
 apprenticeship, 19; ordinary, acknowl-
 edgment of, 31–32, 35–36, 45, 120, 164;
 ordinary, definition of, 28–29; philosophy,
 role of, 19, 28–31, 44, 51, 148; *Pursuits of
 Happiness*, 34, 45; reading as art, 46–50,
 77, 84; remarriage comedies, 33–36, 40,
 47, 52–53, 74, 77, 120; self-consciousness
 emphasis, 44–45, 48–49, 74; Shakespearean
 comedy critique, 52–53; Sigmund Freud,
 influence of, 44–45, 113; skepticism, role
 of, 20, 32–33, 38–40, 44, 47–48, 52–53,
 66, 73, 75, 116, 119–20, 162; uncanniness
 of the ordinary, 73–74; *World Viewed,
 The*, 34
Chamberlain, Wynn, 155
Cities of Words, 34, 44, 46
Coca-Cola, 22, 123, 130, 148

Cohen, Ted, 74
comedy: audience identification, 69–70;
 familiar, dislodging of, 42–43, 53–54,
 57–59; Jerry Seinfeld contributions, 55,
 59–60; Noël Carroll interpretations, 60, 93;
 observational style, 58–59; philosophy,
 connections with, 54, 56, 58–63, 165;
 remarriage comedies, 33–36, 40, 47, 52–53,
 74, 77, 120; Shakespearean romantic
 comedies, 52–53; Sigmund Freud critique,
 53, 70, 74, 92; surprise, role of, 2, 17, 20, 53,
 56; uncanniness of the ordinary, 33, 63–65,
 68, 72; word composition, 56. *See also*
 Wright, Steven
Conduct of Life, The, 18
Crimp, Douglas, 159–60
Critique, 66–67
"Crossroads in the Past", 94–97
Cukor, George, 34

Dali, Salvador, 161
Dance Diagrams, 142–44, 146
Dangerfield, Rodney, 55
Danto, Arthur: Andy Warhol, critique
 of, 19, 22, 121–23, 125, 129, 152, 155,
 158–59, 162–64; art inclusivity, 131–33;
 daily choices, role of, 28; "end of art"
 model, 132, 139–40; Hegelian influence,
 132; Joseph Margolis, critique by,
 140–41; metaphors, use of, 140–41;
 painting apprenticeship, 19; *Philosophizing
 Art*, 122, 129; philosophy, role of, 22,
 129–33, 165; shared meanings, 126,
 133–34; Stanley Cavell, relations with,
 18–19, 45–46; tragedy of the common-
 place, 135
Death and Disaster, 22, 134–35
De Certeau, Michel, 11
De Kooning, William, 124, 131, 148
Del Monte Boxes, 122–23
Democratic Vistas, 80
Descartes, 66, 104–5, 129
DIA Beacon, 145
Dine, Jim, 123
Do-It-Yourself, 127–28
Duchamp, Marcel, 57, 124–25
Dumm, Thomas, 103–4, 112
Dydo, Ulla, 82
Dylan, Bob, 161

Eat, 149–51, 154, 158

Emerson, Ralph Waldo: *Conduct of Life, The*, 18; continual change, 13; everyday experience descriptions, 18, 31; "Experience", 14–15; Heraclitus admiration, 13; intellectualism, 6; language connection, 16–18, 57, 97; literary style, 13, 29; new artists creation, 130; ordinary, complex encounters with, 14–16, 18; philosophy, role of, 29; poetry reflections, 16–18, 57; reading as art, 47; self-conscious art, 131; self-estrangement, 14–15; "Self-Reliance", 97

Empire, 22, 134, 152–54, 157–61

Empire State Building, 134, 152–53, 155, 157–58, 160

"Experience", 14–15

expressionism, 4, 6, 147

Family Romance, 19

Figures of Capable Imagination, 108

Film, 55

Fisher, Eddie, 134

Foster, Hal, 161

Foucault, Michel, 11

Fountain, 124

Freud, Anna, 108

Freud, Sigmund: comedy, critique of, 53, 70, 74, 92; "Humor", 70; memory repression, 108; mourning, views on, 113–14; "On Transience", 113, 116–17; ordinary, complex encounters with, 17, 119; other, oneself as, 64; repression analysis, 20; Richard Wollheim, influence on, 19, 24, 44–45, 49; skepticism, role of, 75; Stanley Cavell, influence on, 44–45, 113; uncanny, role of, 72–73, 119; wish as form of desire, 49–50

Friedman, Tom, 131

Frye, Northrop, 52

Get Out, 67

Gilbert, Roger, 80

Ginsberg, Allen, 161

Giorno, John, 149

Glass and Bottle of Suze, 135

Gould, Timothy, 32–33

Greenberg, Clement, 147

Guest, Barbara, 4

Hadot, Pierre, 103

Hegel, G. W. F., 132–33

Heidegger, Martin, 86–87, 157, 164

Heinz Boxes, 122–23

Hepburn, Katharine, 34–35

Heraclitus: aphoristic style, 12–13, 21; continual change, 13; Karl Jaspers critique, 12, 21; language connection, 12, 17; limited documentation, 12; mystery of the ordinary, 10–14, 31, 149; Ralph Waldo Emerson reflections, 13; stoicism, 68

"History of My Life, The", 101–3

Hockney, David, 131

Hölderlin, Friedrich, 43, 86

Holliday, Judy, 35

"Homeless Heart", 85–91, 95, 164

"Humor", 70

"If You Said You Would Come With Me", 105–11, 114, 117

I Have a Pony, 55

"Impossible, The", 81, 96–97

In Advance of a Broken Arm, 124

Indiana, Gary, 146

Indiana, Robert, 149, 158

Invasion of the Body Snatchers, 67

I Still Have a Pony, 55

James, William, 29

Jaspers, Karl, 12, 21

Kafka, Franz, 110

Kant, Immanuel, 43, 66–67, 147

Katz, Alex: abstraction, use of, 9–10; art as projection of emotion, 17; color choices, 9–10; Fairfield Porter, critique by, 4–9, 14, 17, 77–78, 81, 160; figurative paintings, 4; multiple perspectives, 7–10, 19, 160; realism, role of, 4–5, 8–10, 81. See also *Ten O'Clock*

Keaton, Buster, 55

Keats, John, 115

Keepnews, Peter, 55

Koch, Kenneth, 4

Koch, Stephen, 96

Koethe, John, 80

Lebensform, 69, 126, 156

Lebenswelt, 162

Leno, Jay, 55, 58
Lichtenstein, Roy, 123
Listening on All Sides, 18

Malanga, Gerard, 155–56
Margolis, Joseph, 140–41
marriage, 26, 33–36, 40–43, 46, 52–53.
 See also remarriage comedies
Martory, Pierre, 97–98, 100, 105, 112
McGuiness, B. F., 8
Mead, Taylor, 155
Miller, Jonathan, 75
Monroe, Marilyn, 134, 145
Montez, Mario, 161
Moore, Marianne, 6, 131
Mulhall, Stephen, 38
Museum of Modern Art, 127, 145

National Gallery, 145
Natural Born Killers, 55
Newman, Barnett, 124, 148
New York School artists, 4, 148, 151
Nietzsche, Friedrich: *On the Genealogy of
 Morals*, 14, 108; gods, role of, 15–16;
 Heraclitus, critique of, 14–15; language
 connection, 17; memory, role of, 108;
 new artists creation, 130; "On Truth and
 Lies in the Nonmoral Sense", 15;
 ordinary, complex encounters with,
 15, 17, 153; revaluation of values, 146;
 self-estrangement, 14, 64; *Untimely
 Meditations*, 108
Novalis, 164

O'Hara, Frank, 147–48
Oldenburg, Claes, 123, 128
Onassis, Jacqueline Kennedy, 134
Ondine, 160
On the Genealogy of Morals, 14, 108
"On Transience", 113, 116–17
"On Truth and Lies in the Nonmoral
 Sense", 15
Other Traditions, 94

Pears, D. F., 8
Peisistratus, 15
Philosophizing Art, 122, 129
Philosophy as a Way of Life, 103
Picasso, 135

Plato, 29
"Poet, The", 16, 57
Poetry, 81
poetry: alienation emphasis, 20–21, 92,
 97–103; dictionary metaphor, 56–58, 63;
 experience of experience, 114–15, 122;
 language, role of, 18, 21, 56–58, 78–80,
 83–84, 97, 114; naming contexts, 57; new
 perspectives, 7, 16, 56, 79, 86, 92; New York
 School poets, 4; ordinary, representations
 of, 17, 78–80, 114; Ralph Waldo Emerson
 reflections, 16–18, 57; surprise, role of, 21,
 79, 92; textual difficulty, 81–84; uncanni-
 ness of the ordinary, 20; usable paradoxes,
 91. *See also* Ashbery, John
Pollock, Jackson, 124, 147–48
POPism, 21–22, 154
Porter, Fairfield: Alex Katz, critique of,
 4–9, 14, 17, 77–78, 81, 160; art as projection
 of emotion, 17, 77; John Ashberry,
 critique by, 6–8, 17, 78, 130–31; Ludwig
 Wittgenstein references, 8; mystery of the
 ordinary, 10–11; order, role of, 8, 78;
 ordinary, role of, 10, 31; painting as
 philosophy, 7, 165; painting skill, 6;
 realism, views on, 4–6, 8–10, 46, 81,
 120, 160; self-consciousness emphasis,
 13, 131; usable paradoxes, 9–12, 78,
 86, 140
Poulin Jr., A., 78, 96, 109, 115
Pound, Ezra, 136–37
Pryor, Richard, 55
Pursuits of Happiness, 34, 45

Raphael, 131
Rauschenberg, Robert, 131, 135, 148
Read, Herbert, 3
realism, 3–6, 8–10, 46, 81, 84, 120, 160
"Realist, A", 4
Reed, Lou, 161–62
Reiser, Paul, 55
remarriage comedies, 33–36, 40, 47, 52–53,
 74, 77, 120
Reservoir Dogs, 55
"Respect for Things as They Are",
 6–7, 130
Rilke, Rainer Maria, 113–14
Rivers, Joan, 55
Rosemary's Baby, 67

Rosenberg, Harold, 6, 147, 159
Rosenquist, James, 123, 128
Rothko, Mark, 124, 148
Royle, Nicholas, 73–74
Russell, Bertrand, 28

Samsa, Gregor, 67
Schuyler, James, 4
Screen Tests, 22, 161–62
Sedgwick, Edie, 161
Seinfeld, Jerry, 55, 59–60
"Self-Reliance", 97
Shakespearean romantic comedies,
 52–53
Shoptaw, John, 98
Sleep, 22, 149–51, 154, 158
Socrates, 10–12, 54, 145
Some Trees, 79
Stable Gallery, 122, 145
Stanzas in Meditation, 81–84
Stein, Gertrude, 81–84, 96–97, 103
Stevens, Wallace, 1, 6–7, 79, 89, 92
Stitt, Peter, 92
Stone, Oliver, 55
"System, The", 20–21

Tarantino, Quentin, 55
Taylor, Elizabeth, 124, 134
Ten O'Clock, 4–5, 7–10, 12, 14, 19
"They Don't Just Go Away, Either",
 115–17
"This Room", 98–101, 103, 107
Thoreau, Henry David, 6, 29, 131
Thread of Life, The, 25, 49
Three Poems, 20–21
Tonight Show, The, 54
Tractatus Logico-Philosophicus, 8
Tracy, Spencer, 34–35
Transfiguration, The, 131
Tunafish Disaster, 134–38

uncanny, 20, 33, 38, 63–68, 72–74, 104,
 119–20, 137
Untimely Meditations, 108
Untitled (Eraser Shavings), 131

Warhol, Andy: Arthur Danto, critique by, 19,
 22, 121–23, 125, 129, 152, 155, 158–59,
 162–64; boredom, role of, 150, 152–60;
Brillo Boxes, 122–23, 125, 130–31, 134, 136,
 144–45, 147, 149, 154, 158, 161, 163;
Campbell's Soup paintings, 22, 122–23,
 134, 136–37, 154, 163; Catholic background,
 127; celebrity representations, 22, 125–26,
 134–35, 145, 148–49, 161; Coca-Cola
 paintings, 22, 123, 130, 148; cow wallpaper,
 146, 148; *Dance Diagrams* series, 142–44,
 146; *Death and Disaster* series, 22, 134–35;
Del Monte Boxes, 122–23; *Do-It-Yourself*,
 127–28; Douglas Crimp, critique by,
 159–60; *Eat*, 149–51, 154, 158; *Empire*,
 22, 134, 152–54, 157–61; Harold Rosen-
 berg, critique by, 147, 159; *Heinz Boxes*,
 122–23; image metaphoricity, 22, 125–27,
 134–36, 142–43, 162–63; inclusivity,
 124–26, 138, 155, 157; influence, 121; irony,
 use of, 127–28, 143–46, 164; *Lebensform*,
 126, 156; media awareness, 22, 126–29,
 133, 137, 139–40; ordinary, attraction to
 the, 22, 121–22, 125–26, 136–37, 142–51,
 156, 163–64; philosophy, role of, 22,
 121–23, 125, 129–31, 138, 157, 164–65;
POPism, 21–22, 154; *Screen Tests*, 22,
 161–62; self-consciousness, 125, 137,
 152–55; serial repetition, 22, 137, 149,
 153; silk screen process, 122–23,
 125–26, 134–35, 137, 145, 149; *Sleep*, 22,
 149–51, 154, 158; Stable Gallery exhibit,
 122; transformative effect, 121–22,
 125, 146, 156–57; *Tunafish Disaster*,
 134–38
Whitman, Walt, 80
Wittgenstein, Ludwig: Fairfield Porter
 references, 8; *Lebensform* concept, 126;
 ordinary, complex encounters with, 17;
 philosophy, role of, 8; Richard Wollheim,
 influence on, 19
Wollheim, Richard: *Family Romance*, 19;
 leading a life, process of, 2, 23–27,
 30–32, 44, 75, 79, 119; Ludwig
 Wittgenstein, influence of, 19; self,
 representations of, 26–27, 31; Sigmund
 Freud, influence of, 19, 24, 44–45, 49;
Thread of Life, The, 25, 49; understanding
 of life, 2, 25–26, 78, 119; wish as form of
 desire, 49–50
Woman I, 131
World Viewed, The, 34

Wright, Steven: abstraction, 55–56; acknowledgment of the incomprehensible, 59, 64, 68, 71, 74; alienation response, 70–75, 103, 111, 119, 121, 160; audience relationship, 69–70, 120; dictionary as poem joke, 56–58, 63; distinctive style, 54–57, 60, 67–68; early years, 54–55, 58; familiar, dislodging of, 64–66, 75; George Carlin, influence of, 54–55; *I Have a Pony*, 55; *I Still Have a Pony*, 55; irony, use of, 55–57, 61–63, 67; *Lebensform*, 69; movie cameos, 55; naming contexts, 56–61, 63, 97; planetarium joke, 61–63, 85; skepticism, role of, 61, 63, 66–67; surprise, role of, 20, 53, 56; uncanniness of the ordinary, 33, 63–65, 68, 72, 74, 119–20; usable paradoxes, 20, 33, 54, 56, 61, 66, 97

Youngman, Henny, 55
Your Name Here, 20–21, 91–105, 112, 115, 117

CPSIA information can be obtained
at www.ICGtesting.com
Printed in the USA
BVHW03*0347070418
512010BV00008B/3/P